Art in Action

American Art Centers and The New Deal

edited by
John Franklin White

The Scarecrow Press, Inc.
Metuchen, N.J., & London
1987

Library of Congress Cataloging-in-Publication Data

Art in action : American art centers and the New Deal / edited
 by John Franklin White.
 p. cm.
 Includes index.
 ISBN 0-8108-2007-2
 1. Art centers--United States. 2. Federal aid to the
 arts--United States--History--20th century. 3. United
 States. Work Projects Administration. 4. New Deal,
 1933-1939. 5. United States--Politics and government--
 1933-1945. I. White, John Franklin, 1933- .
 NX800.A78 1987 87-16500
 700'.973--dc19

For Judy, Melissa, and Justin

CONTENTS

FOREWORD

There are many people to thank for the research, writing, and preparation of this collection. Each contributor can provide a long list of contemporary individuals and agencies deserving appreciation. Much is owed to those artists, state and federal administrators, and local citizens who first organized America's WPA/FAP art centers. My own expressions of gratitude would go to Francis V. O'Connor, whose early encouragement and counsel were important, and to Northern Kentucky University for providing clerical assistance.

The contributors hope this collection will serve as an encouraging guidepost to further research.

J. F. W.

INTRODUCTION

John Franklin White

Few Americans can recall when they first saw an original work
of art. Today we take such things for granted. But this
was not always the case in America, and that is what this
book is all about. The importance of art in the lives of Amer-
icans was certainly not an unwelcome idea to the early leaders
of the American republic and somehow the arts were always
essential in American life and custom. But if a thread of fed-
eral patronage for the arts has always been present and vis-
ible, it has not always been thick in the woven cloth of the
people. In the 1930s, the circumstances of the American de-
pression resulted in the largest public programs for art in
history and greatly increased the opportunity for personal
experiences with creativity. Federal programs were intent
upon spreading and developing the cultural wealth of America,
and the art centers of the New Deal were at the heart of the
matter.

The idea of the art center had been around for some
time, and Harry Gottlieb had sounded a call for municipal
art centers at the First American Artists' Congress in New
York in February 1936. But there was something about the
WPA's ambitious geographical dimension, the desire to reach
those populations without the opportunity for personal exper-
ience with creativity that reflected the sense of mission at
both local and national levels. The New Deal's penchant for
experiment and exploration was clear enough. By 1940 there
were more than 100 art centers and museums that owed their
existence and success to federal assistance. That is a small
number in comparison to the 5,000 museums that exist through-
out the United States today. Importantly, however, today's
center and museum establishments continue to benefit from
the New Deal's art center efforts of a half-century ago.

1

When Daniel Defenbacher coined the phrase "art in action" it seemed an appropriate appellation for a vital segment of the New Deal's cultural programs, namely the WPA's community arts centers. It summed up the vitality, the movement, of a process intent upon bringing art to the people just as it intended to improve upon the traditional role of the gallery or museum in the community. With the clear intention to assist the American artist directly and simultaneously stimulate community cultural life, the art centers attempted to reverse the geographical patterns of cultural life in America. The rhetoric of the Washington office was duly inspired and strongly asserted by Holger Cahill, Thomas Parker, and Daniel Defenbacher:

> The draining off of America's best talent from the native soil of the small town to the strange pavements of the big city--a process that has been going on for generations--has inundated certain sections of America and left others high and dry as potential cultural wastelands. It seems essential for the best interests of American cultural life that this process now be reversed.... It seems likely that the artists of the future who are born and raised in communities like Greensboro, Charleston, Memphis, Sioux City, and Norris, will be less inclined to trade their birthright for the tenuous glories of the big city. The provinces of America may yet become as important to the cultural life of America as the provinces of France and Germany are to their respective cultures.

When Daniel Defenbacher coined the term "art center," he implied motion and activity that worked for the community's common cultural good. Community participation was underscored as was the "great need for cultural centers ... and their enormous potential service as an integrating educational force (and) ... the creation of a large and appreciative audience."

Washington officials spoke of "this healthy and necessary balance between production and consumption," and overtones of economic recovery and experiment that so dominated New Deal political philosophy in general were self-evident. In down-to-earth terminology, the art center program was also forward-looking and there was talk of "a firm foundation for future generations of Americans who will no longer look upon

art as something remote from their daily lives but as an essential element of survival no less vital than adequate food or shelter."

In Thomas Parker's words, the idea of the art center was basic to American life.

It has captured the imagination of the public. It is a movement which devotes itself to providing channels through which the fine arts may serve the American people on a broad and democratic scale. And it devotes itself to establishing a hospitable environment for American art, in which the artist may work with a sense that he is useful to society, and that society needs him.... The community art centers ... are part of a large, highly varied program, seeking to return the American people to a sound relationship to the arts, reaching all classes and all sections of the country.... It is my firm belief that ultimately art in America will become an ideal of living and will no longer be merely a detached esthetic experience.

The following essays were chosen as a representative cross-section of the art center experiences during the New Deal period, and the writers document the excitement and the energy. The essays detail what there was in the policy statements, the speeches, the working philosophies of the local programs. A litany of common concerns emerges. Promotion and fund-raising cut across the need for public/private collaboration. Community involvement was not without political overtones. Advisory committees fostered cultural leadership on a scale that had not been seen before. Local artists were recognized and discovered at the same time that broader educational programs were undertaken. Art centers even went to war. Indeed, the list of similarities is long; yet the uniqueness of each center experience comes through to us.

The advisory impulse tapped the resources of experienced and successful community leaders just as it reached out for broader representation, often from nontraditional quarters. The range of occupations and diversified social strata represented on early art center boards meant an oblique departure from the practices of existing and traditional galleries and museums. The diversity was also evidence of the

drive to democratize the advisory function. We realize that
such democratic practice was new on the 1930s' cultural scene,
and importantly, as the essays demonstrate, we point to this
democratic urge as a major (and continuing) New Deal center
accomplishment. Judged by today's standards, the necessary
funding raised through local subscription was small. But
what comes through in the essays is the relatively great
amount which was raised through voluntary action.

Perhaps one of the biggest myths about the broad spec-
trum of WPA cultural experience is that the success of make-
work activity could be counted only in terms of numbers em-
ployed. What is now understood (and today's communities
continue to reap the benefits) is that as countless numbers
of volunteers brought their time and energy to the art cen-
ters, they made a lasting imprint on community cultural life
and broke new ground in their untiring fund-raising efforts.
The essays attest to the importance of local financial support
through private donation during the New Deal--a significant,
if heretofore overlooked chapter in the American book on
fund-raising for cultural purposes. Then, and now, the sup-
port of the private donor is important.

The freshness, the currency of nationally arranged ex-
hibitions echoed the New Deal's laboring for better times and
for more widespread cultural awareness throughout America.
Whether traditional exhibitions or shows that presented the
best of contemporary (including WPA work) artists, center
goers saw the best from their own and other regions. Trav-
eling exhibitions came to be integral to center activity and the
interdependence of the Exhibition Section and the center net-
work is emphasized in Mildred Holzhauer Baker's recollections
for this volume. Today we note another strong influence of
this alliance: Other public and private museums in the United
States drew example from the public following and success of
the center exhibitions of the New Deal Era. Little noted, but
influential in the regionalist movement, is that centers quite
often broke new cultural ground when they began to exhibit
local artists, many of whom found exhibition opportunities for
the first time. This stress on local production may have done
more than anyone realizes to cultivate and extend community
pride in local artists, as well as aid the professional growth
of the artists themselves. Today we look back at the period
and see that the idea of exhibiting local talent has far out-
lasted the regionalist movement and that no national exhibitions

have even been as widely circulated as those of the Exhibi-
tion Section through the cooperating centers across the land.

The essays do not overlook the political problems that
beset the operations of the centers. There was constant
bureaucratic tugging and challenge for control and direction
between the individual center and the Washington office.
Still, most centers were able to work out successful, colla-
borative efforts with the Washington authorities. Centers
invariably reflected the problems that faced the national
office, but they differed in the way they met and resolved
national issues. This became even more apparent as centers
developed their own individual approaches to center a philos-
ophy in spite of a more rigid position in Washington that did
not encourage individual departure. On a higher level, the
agreements or contractual arrangements that were struck be-
tween the national office and projected centers were as cul-
tural convenants in which a bond of assistance would provide
economic assistance so long as communities would support the
opportunity to enhance local cultural life and perspective.
But one also notices a national philosophy of public participa-
tion and experience in the arts; the essays cite numerous
ways in which Washington's broad perspectives assisted local
goals.

Competition with existing cultural institutions was appar-
ent and not unexpected. Competing political philosophies
were always close at hand, and even more in view because
of the publicity given the periodical harangue associated with
federal appropriations. Not all of the neighboring museums
extended helping hands to the fledgling centers. Just as
centers faced administrative hurdles and fund-raising feats,
established galleries, museums, and associations could, and
did, withhold support. If anything, the essays' political
overtones dispel any notions that centers grew without effort
or stress from cultural seeds borne by gentle federal winds.

As art centers grew, so did public favor, especially in
those communities being served. But as part of a larger
WPA effort the centers drew expected criticism on a regular
basis, largely from a conservative press. Little observed is
the fact that the Washington office raised constant internal
questions and this self-examination of the program did much
to sharpen and improve its services. Consider the far-
reaching implications of the following memo out of Washington:

What is the population of the community in relation
to art center attendance? What are the major in-
dustries of your community and how are the activities
at the art center related to those industries? What
efforts are made to interest industrial workers? What
is being done educationally to clarify the relationship
between the folk arts and the machine arts? What is
the total of sponsors' contributions? Does it come
from individuals or organizations? What are some
human interest episodes that reveal the character of
community participation? The names and political af-
filiations of the newspapers in your community carry-
ing stories on the activities of the project? Which
activities are most popular? Least popular? What is
being done to stimulate active as opposed to visual
participation in the work of the center? How is the
average visitor converted from a spectator into a par-
ticipant? To what extent has the work of the art
center served to revive indigenous cultural patterns
that heretofore lay dormant?

Reports out of Washington spoke of the art center as
an "integrating educational force." Indeed, educational con-
cerns are pervasive in the wealth of center activity. For
these efforts the centers drew welcome encouragement from
local public schools that were either intent on beginning art
instruction programs or in resuscitating existing ones. Center
activities aimed at youth drew high priority, and children's
sections and galleries worked hand-in-hand with local art
educators. Great strides were made to reach ethnic and mi-
nority populations. The achievements of the People's Art Cen-
ter in St. Louis and the South Side Art Center in Chicago
are high points in the New Deal's efforts to spread education-
al opportunity. Art centers thus served as supportive agents
of educational change in addition to the cultural influence they
rendered in the community. Both fine and practical arts were
present and often worked in tandem to achieve educational ob-
jectives. If a definitive history of the multifaceted WPA ex-
perience has not yet arrived, it is also true that a thorough
study of the WPA's educational accomplishments is still to be
done. Certainly the educational imperatives of the art centers
are close to the heart of New Deal educational directions.

The essays reveal much about the integrative role of
the centers in bringing various federal programs into working

relationships with each other. The success attained by certain of the writers', music, and theatre projects was often aided by an art center's willingness to assist a range of cultural interests. Whether a theatrical presentation, an orchestral demonstration, or a mural production, there was diversity in programming at the centers, and always something that would benefit artist and public alike.

In 1940 Holger Cahill proudly hailed the many successes of the art center idea:

> The art center program represents new adjustments of art production and art education to the needs of communities which heretofore have had little in the way of these activities. There is little in the way of precedent for this type of community art activity, and a great deal of pioneering work in the planning of program, the coordination of information, integration of research, the gathering of art material, and the development of community workshop activities in the arts has been undertaken.

But time ran out on the centers. The end of federal assistance meant new problems for the institutions that numbered more than a hundred in 1943. There were other centers or WPA galleries, of course: those Project activities that never achieved formal center status but functioned to provide art instruction and exhibition space in areas that did not have full-blown community art centers. But obvious kinship could never be doubted. One may surmise there might have been still more federally assisted art centers if the New Deal had not been brought to an end. One may just as easily surmise that the local and regionally supported centers that emerged after 1943 drew inspiration from those still fresh and alive in public view. Indeed, we know that what mattered to the art centers did not cease with the exit of federal assistance. If programs and community-oriented concepts could not immediately bridge the loss of financial support, there was enough appreciation and expectation established among the cultural leaders of the communities to guarantee sustaining local support. And even if the federal withdrawal resulted in a move (in some cases a reversion) to private sector administration, it was clear the new arrangement could benefit from an established community following that had been strongly assisted by public support.

The centers clearly left their cultural mark, as the essays testify, and the untold hundreds of thousands of people who were present at creation of this New Deal experiment bore active, supportive, and continuing witness across the land. In retrospect we ponder the beauty of one of the New Deal's cultural moments, that point in time when the creative experience is made somehow personal at the same moment that it becomes a matter of public responsibility. What happens when Americans view original art for the first time? If it is a continuing question, it is one which provides joy in the asking, and we fervently hope that it is a question that Americans will forever try to answer.

THE WALKER ART CENTER:
A CROWNING ACHIEVEMENT

John Franklin White

Cultural life in Minnesota dawned bright on that day in 1927 when a newly reorganized Walker Art Gallery opened its doors. Mr. T. B. Walker's extensive private collection was placed on exhibition in new and lavish surroundings, and prospects seemed good for the foreseeable future. But when the throes of an economic depression forced the Gallery to reckon with everyday existence, many of the museum's hopes were substantially lessened. There are various accounts of the initial development of the Walker Gallery and the combined efforts of the Walker family stand as a monument to private art patronage and museum formation in the United States.[1] However, the story of the development of the Walker Art Center would not be complete without an understanding of its accomplishments during the years of the WPA Federal Art Project in America. Through concerted trial and effort, local citizens joined with national and state WPA officials in the development of the Walker--perhaps the most symbolic of the success of the federal art center movement.

In 1938, a group of civic-minded and promotion-oriented Minnesotans formed a Minnesota Arts Council which provided for exhibition of the work of contemporary Minnesota artists.[2] This young and vigorous organization encouraged regional artists by arranging exhibitions at the Walker Gallery. Later, when federal funds were made available for art center development, the Minnesota Arts Council began the search for needed local sponsorship funds totaling $5,500. Rolf Ueland, a Minneapolis lawyer and amateur painter, led the move for local support in 1938-39.[3] The difficulties he faced are fully documented in correspondence between Ueland (later elected President of the Minnesota Arts Council) and Daniel S. Defenbacher,

then of the WPA Federal Art Project in Washington, D.C.
Early in a fund drive he recounts something of the obstacles
faced but not without a lasting optimism that grew out of
his own persistence.

> We have received ... contributions from about 550
> separate persons, so you can see there is a fairly
> widespread popular interest in the project.... About
> 70% of all the teachers in one of our larger high
> schools gave something.... Our wealthy people have
> been responding too, but not with large gifts.... I
> think the principal reason for smallness of gifts from
> the wealthy is simply that Minneapolis has been simply
> swamped with a preposterous series of drives ...
> Community Fund, YMCA, Northwestern Hospital
> ($500,000), Minnesota Union Building ($300,000),
> Symphony Orchestra ($130,000). Our Junior Associ-
> ation of Commerce, which voted to raise our fund
> for us, ran out of gas and simply quit after six weeks,
> producing exactly $22.50.... Besides having 550 con-
> tributors on our books, many things could be said
> which prove to me that the "common people" really
> want the Art Center and want it badly.[4]

Clement Haupers, Director of the Federal Art Project in
Minnesota, also assisted in the Council's public-minded activ-
ity.[5] His experiences as State Director came through on more
than one occasion. In a letter to Thomas Parker he sought
to reduce the difficulty of required donations by suggesting
the possibility of "in-kind" contributions from the firms that
would be the likely furnishers of raw materials. The sug-
gestion was subsequently approved by Washington, Incorpo-
rated in the Walker sponsorship drive, and adopted as a use-
ful idea at other American art centers.[6] The Council also
promoted a wide variety of sales, auctions, and benefits that
helped bring together the waiting facilities of a tottering
Walker Gallery and a new federal concept for the arts in
America.

Meetings on the Walker issue began in 1938, and Ruth
Lawrence, then director of the University of Minnesota Gal-
lery, later recalled an early May meeting at the home of Mrs.
Archie Walker, who "asked several of us to come to her home
to talk over the possibility of reviving the Walker Galleries
which at this time was practically defunct."[7] At a later, more

formal meeting at the Walker Galleries, Mrs. Lawrence pre-
sided and led fourteen people in discussions that strongly
evidenced a desire for local exhibitions.

> It could be in the form of a permanent gallery, but
> with changing exhibitions. These could run all year,
> with shows changing perhaps each month. Thus it is
> that Mr. and Mrs. Walker have very kindly offered
> the space in the Walker Galleries. They have made
> it clear that they want no actual responsibility, but
> want the artists to know that they are willing to
> donate the space to groups of artists of Minnesota
> for this sort of a program. It will not be under the
> Walker Foundation's sponsorship, but rather under
> the sponsorship of a Board of Trustees. This plan
> is being laid in the belief that this will not in any
> way be in competition with the Institute of Art of
> which we are so proud, nor with the "Little Gallery"
> at the University, even though our Twin City Show
> is a yearly event at the Institute.
>
> There was a question of dealers, with some artists
> feeling it would be taking the bread and butter out of
> their mouths. That is actually no problem because
> this should not interfere--the dealers could go along
> with their same program. Actually the exhibitions
> should stimulate the level of the public's taste; actual-
> ly help to create a market as familiarity with the works
> was achieved.
>
> Certainly in this community we are not going to run
> into competition with the Institute and Minneapolis
> Symphony Orchestra trying to raise funds in a com-
> munity which is asked to support these cultural ac-
> tivities. We should be able to work out some sort of
> financial arrangements which would not be a burden.
> This should be thought of as a venture and we hope to
> keep expenses to a minimum. It has been suggested
> that the artists take on all arrangements and the man-
> agement of the shows--that there could be selected a
> group of artists from the various associations, chosen
> to act as a jury, to be in entire charge of the details
> of each show, publicity, etc. These services should
> be donated by the artists for the good of the com-
> munity. This should be a community project which
> will not only benefit the artists themselves but will

develop appreciation in the local people for the artists
in their own community.

All one has to do is to read the lists of names of
artists who have gone away from the Twin Cities to
other parts of the country because they could not
find support here, to realize the rather tragic state
of our own support. Adolf Dehn, Paul Manship,
Arnold and Lucille Blanch, Wanda Gag, Carl Walters,
and many, many others. Iowa has given support to
its artists and art flourishes. Another outstanding
example is Cleveland, to mention only two. It seems
to me a very worthy project that Minneapolis and St.
Paul should consolidate to build something together
in this project.

The idea of setting aside rooms at the Walker Art Gal-
leries for the exhibition of works by Minnesota artists drew
strong Minnesota Artists Union support and helped pave the
way for the Walker Art Center idea. By October 1938, three
monthly exhibitions of "Living Minnesota Artists" had been
presented. And no less important, the move to a new art
center concept, especially one that would not look past Min-
nesota area artists, drew strength from the small but opera-
tional WPA Art Project Centers in Minneapolis and St. Paul.
These centers, as gathering places for state WPA art activi-
ties, had exhibited Minnesota Project artists since 1935 (Min-
neapolis) and 1936 (St. Paul).[9]

Promotion and Direction

D. S. Defenbacher recognized the Walker Gallery's
"Art Center" potential, and his close working relationship
with Holger Cahill, the head of the FAP, placed him in a
position to influence fund allocations to hopeful communities.
He was aware of the problems in organizing community-wide
cultural activities, but was hopeful for a successful community
art center in Minneapolis.

Both Defenbacher and Haupers attended the federally-
sponsored conference on community art centers in Chicago
on August 27, 1938, and the minutes of that incisive meeting
reveal four broad and significant proposals.

1) That the Federal Art Project concentrate on

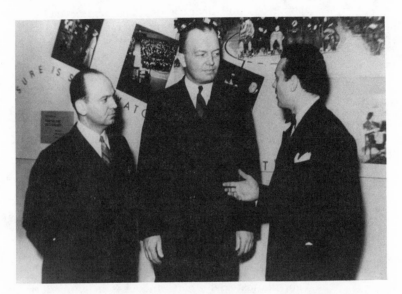

Left to right: State WPA Administrator S. L. Stolte, Governor Harold E. Stassen, Director Daniel S. Defenbacher at Walker Art Center.

community art center activity in the Middle West for a six months' period, the Washington office assisting the various state directors in organizing the program.

2) That the aim of the art center program must be to make it possible for the average man to participate actively in the experience of art. That the program stress actual participation rather than passive appreciation.

3) That personnel for the large art centers in the East be loaned to the various community art center projects. That the local community act as host, whenever possible, providing board and lodging for the artists.

4) That the Federal Art Project continue to broaden the base of its community art center program, as is now being done in Sioux City, Iowa; Spokane,

Washington; and Sacramento, California, where
music, theater, hobby, and other club groups are
working with the art centers. It was suggested
that art center directors invite music and theater
groups, literary societies, dance groups, garden
clubs, hobby groups, men's and women's clubs,
school groups, and others to participate in the
community art center program, retaining always the
fullest consciousness that the primary concern of
the Federal Art Project is a visual arts program.[10]

In November 1938, Defenbacher's cultural statesman-
ship emerged in a letter to Rolf Ueland.

After a thorough survey of the art situation in Min-
neapolis, I am convinced that there is no better op-
portunity in America to establish a useful and much
needed community meeting place for art and people.
The excellent building of the Walker Art Gallery and
the valuable material which it houses is lying dormant
as a potential cultural force in the life of the city.
The opportunity to build around this existing struc-
ture and reservoir of art a program which would
weave it into the lives of the people of Minneapolis
is one that should not be lost.[11]

Daniel Defenbacher's name came up in WPA circles as a
possible first director even before he made the decision to
leave his important Washington position. Ruth Lawrence had
first proposed Defenbacher's appointment in a conversation
with Audrey McMahon, Regional Director for the Federal Art
Project in New York, at a meeting of the Western Arts Asso-
ciation.

I had a talk with Mrs. Lawrence ... and she men-
tioned the fact that it would be essential to the suc-
cess of this gallery to have a director ... who would
be a person of some caliber. She recommended that
Mr. Defenbacher be given this as an assignment....[12]

Defenbacher's decision to leave Washington for Minne-
apolis and the Directorship of the new Walker Art Center was
strongly influenced by his Minnesota reception in 1939.[13]
But he maintains his "building" experiences in other American
cities helped him to see Walker's potential. There were "key

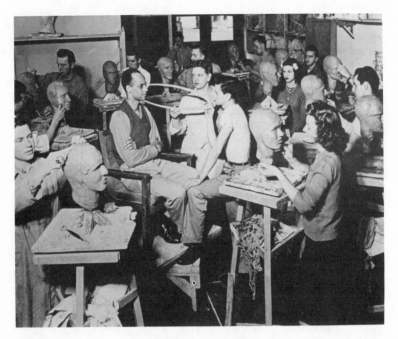

Sculpture class at the Walker Art Center.

art centers that led up to the development of the Walker Art
Center.... It was through those experiences that I began
to shape up the actual form of the Walker Art Center." For
Defenbacher, the Walker Art Center "was the culmination of
the whole art center program." After seeing its potential he
"decided early on ... to retire from Washington and take on
the directorship."[14]

He well knew the inherent administrative difficulties in
inaugurating an art center within an already-established
Minnesota Federal Art Project program of statewide activity.
Defenbacher also realized the wide scope of the proposal and
understood the necessity of enjoying a good relationship with
local sponsors. Clement Haupers extolled Defenbacher's ap-
pointment as the first director of the Center, but underscored
the importance of working within the cooperative bounds of the
newly established Minnesota Arts Council.[15]

Defenbacher drew up "A Proposal of Federal Art Project

Sponsorship for an Art Center at the Walker Art Galleries."
Basically, the new alliance would include changing exhibitions
in the galleries that then housed a permanent collection, and
circulating other fine art. Workshops, study courses, lec-
tures, were provided for, and extension services were to be
made available to other institutions and cities in Minnesota.[16]

Mr. Archie Walker, son of T. B. Walker, represented
the T. B. Walker Foundation when that body approved the
proposal and stipulated the degree of community involvement
and governance.

The Foundation was quite concerned with the role of
the Minnesota Arts Council, the care and use of the building
and its contents, and disposition of personnel.

> It must be understood that the Foundation is not
> hereby granting to the Council or anybody else any
> estate or interest in the building or any property of
> the Foundation and is merely extending to the Coun-
> cil revocable permission to make use of the building
> and contents as stated above. The Foundation is not
> committing itself to extend such permission for any
> particular period of time. However, the Foundation
> is aware that the Council and its members will devote
> considerable time and effort to establish and arouse
> public interest in the proposed program and to raise
> funds for the purpose, among others, of improving
> and furnishing equipment in the galleries. Accord-
> ingly, it is the present expectation of the Founda-
> tion to extend the permission indefinitely upon the
> assumption that the program will be pursued sub-
> stantially as now proposed and with reasonable use
> and care of the building and contents, all for the
> benefit of the general public.

In effect, the T. B. Walker Galleries opted for federal as-
sistance since this assured continued existence as a cultural in-
stitution. But as with the philosophy of the Art Center pro-
gram, the Foundation was also concerned with public interest
and benefit in the arts.

Rolf Ueland continued to express his many hopes for
the Center in his lengthy correspondence with Defenbacher.
But the tireless fund-raising efforts were not without

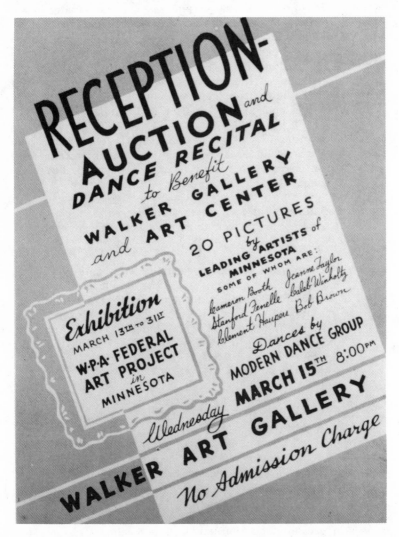

Art Center promotion by Minnesota Artists' Union, March 1939.

obstacles. There is evidence of opposition to Walker Art
Center promotion, but this owed less to an anticipated chal-
lenge to area art schools than it did to new fund-raising
activities for cultural purposes. The opposition was rarely
open, however, and one can surmise that the area's principal
existing institution, The Minneapolis Institute of the Arts,
probably challenged the overtures made to its own important
sources of private patronage. Clement Haupers cautiously
alluded to this challenge in a letter to Defenbacher in 1939:

> Confidentially, I am of the belief that there is a con-
> siderable undercover opposition emanating from the
> source you can readily imagine. Do not believe, how-
> ever, there is any question of the outcome.[18]

Defenbacher now allows that there was decided opposi-
tion with the Institute, but it was between the governing
bodies.

> There was friction between the Art Center and the
> Minneapolis Art Institute. Russell Plimpton was the
> director. Russell and I spoke and were friendly but
> the Board of the Institute was not very friendly to
> the Minnesota Arts Council and the Walker Art Center.
> There was a good deal of rivalry. I think they were
> very much afraid that we were going to take some of
> their money away from them.[19]

Ueland succeeded in raising the required $5,500 fund,
no small amount for the arts in 1939, and observed "a tre-
mendous and widespread enthusiasm for the Art Center on
the part of the middle class and underprivileged people."[20]
Here was the basis for the success of the collaborative effort
and a harbinger of later community acceptance of cultural
activities on such a large scale.

The fear that government support would be short-lived
was also present from the start. Defenbacher attempted to
allay this doubt and stressed the community advantages in
any eventuality:

> Perhaps the best way to answer ... is to assume that
> the WPA will fold up before the first year is out and
> show by a careful analysis of the situation that you
> have lost nothing and gained everything. You would

> have, first of all, a thoroughly organized group uni-
> fied and committed to the operation of an art center
> program. You would have a plan of operation worked
> out and you would have taken some direct action
> toward the operation of the plan. No matter how
> much it would be necessary to retrench, you would
> have taken, at the time of the Federal Art Project
> withdrawal, forward steps which would be worth
> many times your investment.... Let me assure you
> that I would not approve the Walker proposal if I
> felt for one moment that we could not carry through
> with it.[21]

Federal Assistance Opens the Doors of a New Center

The evening of January 4, 1940, reached gala propor-
tions when the Walker Art Center--new in concept and mis-
sion--opened its doors to Minnesotans. Great numbers turned
out and Governor Stassen, Minneapolis' Mayor Leach, as well
as museum directors from other cities were among the guests
present for the inauguration festivities.[22] The celebration
featured a 16-piece, string ensemble of the Minnesota WPA
Music Project and events were broadcast by station WCCO.
Those who could remember the "old" Walker could quickly
see several basic innovations: 1) new equipment had been
constructed by WPA workers, and new exhibition methods
were employed under the direction of J. Leroy Davidson;
2) four opening shows aimed at a diversified Minnesota pub-
lic, and included a children's gallery; 3) a large new work-
shop-classroom had been added.[23]

In an interview immediately preceding the opening,
Defenbacher spoke eloquently on the Center's purpose.
There was a clear educational direction in his statement,
ever-mindful of the Center's potential for the Twin Cities
community, but there was also a concerted awareness of the
importance of exhibitions.

> By our new methods of presentation a trip through
> the galleries becomes an experience in which the past
> is related to the present and the present is projected
> as a recognizable reality. We have placed ancient
> and modern art side by side to show that each is
> equally related to human meaning and to our own
> experience.[24]

Today, Defenbacher maintains that "exhibition planning was one of the Center's chief accomplishments. We did a lot in exhibition techniques and design, and developing light and equipment. The installation of the T. B. Walker Chinese Collection was quite remarkable, really a handsome show."[25]

The Minneapolis Tribune formally recorded what was no doubt the community's most democratic cultural event of the year:

> Art surrenders to the masses as Walker Gallery opens its new center to public.... Art dipped its uplifted nose in surrender to the masses last night. Art's co-hosts, painting and sculpture and all their fellows ended an aloof, age-long exclusiveness and bowed before the average man, his wife and family.... Each found something to praise in the WPA-assisted decorating schemes, the lively arrangements of paintings, drawings, and photographs, the new racks for art objects, and the big workrooms.[26]

Perhaps the most telling, and democratic comment came from Thomas Hart Benton, the honored artist-guest for the occasion.

> It's an exciting idea, one which seeks not to educate the people, but to bring art down off its pedestal. Your art center is distinctive. Although there are other institutions of its kind in the country, there is none other which has such a widely-known collection behind it.[27]

Support came from other quarters of the community in 1940 and 1941. On April 3, 1940, radio station WTCN devoted the seventh program in the "Minneapolis Marches On" series to cultural affairs. Mr. William McNally of the Minneapolis Tribune interviewed various area artists and museum directors, including Defenbacher, who recalled how 4,000 people turned out in ten degrees below zero weather for the opening of the Walker Art Center and stated that 1,583 people were then

[Opposite:] "Experts at the Inquisition," March 1940; left to right: J. LeRoy Davidson, Brenda Ueland, LeRoy Turner, Daniel Defenbacher, Mrs. Irving Clark, J. D. Holtzerman.

attending classes.[28] The following day, the Minneapolis
Tribune recognized the cultural impact of the Center during
the year. An editorial by John K. Sherman entitled "Art
Faces the 40's" emphasized the Center's community-wide com-
mitment:

> The interest which Minneapolis takes in art is more
> than a mere cultural pose. Tuesday night's broad-
> cast, seventh in the series arranged by the Tribune
> Newspapers, pointed out, among other things, how
> 4,000 local residents helped open the Walker Art
> Center January 4--a night when the temperature was
> ten below zero. And the interest was not a passing
> one, taken in an opening display. There are 1,583
> persons regularly attending classes at the Center now.
>
> The curators of art collections were not the only
> ones contributing to Tuesday night's view of Minnea-
> polis art as it faces a new decade. Artists them-
> selves were heard along with those who devote their
> careers to art education. The prophecy that Minnea-
> polis would find a steadily widening interest in art
> during the decade to come was based on demonstrable
> trend in that direction during recent years. Art is
> being made a more vital part of daily life, and there
> is impressive growth in the capacity of the average
> man and woman to appreciate major cultural values of
> the society in which they are factors.[29]

Just as exhibitions and art instruction drew Twin Citians
to the Center, so also did demonstrations of new developments
and processes. Perhaps the most important technical achieve-
ment of the Federal Art Project was the development of the
silk screen process. By November 1940, Harry Gottlieb, a
former Minnesotan but a member of the WPA/FAP in New York,
was in the Twin Cities to help popularize the silk screen proc-
ess and to help celebrate National Art Week, a program ar-
ranged by the FAP's Exhibition Section. He lectured and dem-
onstrated at the Minneapolis School of Art, the Walker Art
Center, and the University of Minnesota Gallery. He made
ample use of WPA-produced brochures and a WPA-produced
film which he directed.

In February 1941, as a direct result of Gottlieb's ac-
tivities, the University of Minnesota Gallery, with WPA as-
sistance, held the first exhibition on the silk screen process

ever held in Minnesota. The exhibition included sections of
work collected by Gottlieb, and a section by Minnesota Proj-
ect artist George Beyer, who was teaching other artists about
the medium at the Walker Art Center. [30]

The American Artists Professional League had sponsored
an "American Art Week" on earlier occasions, but this was
the first concerted move to involve the American public on a
grand scale. Community museums and centers cooperated,
and assistance came from such less traditional agencies as
the nation's department and furniture stores. [31] In Minnesota
there was little specific publicity provided for National Art
Week, but that is not to say that many of its purposes and
directions were not carried out. The record of activity and
participation at the Walker Art Center was remarkably high
in its first year under new sponsorship, and if anything,
it sought to achieve the goals of National Art Week every
week of the year. When a Second Annual National Art Week

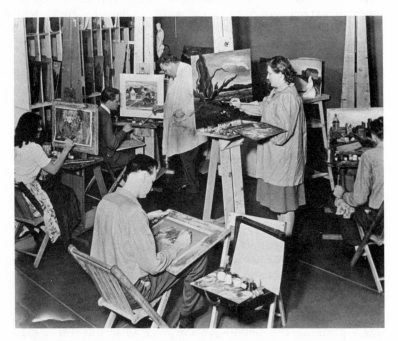

Arthur Kerrick's painting class.

was arranged in November 1941, Minnesota's response was
visibly high and more directly in tandem with the Washington
effort. Art centers were encouraged to join with department
stores "to promote" a greater public interest in the work of
American artists and designers."[32] Responding to the strife
and war of the period, the national headquarters chose
"American Art for American Homes and for Our Defense
Forces" as an official slogan for the event. In Minneapolis,
the Walker Art Center encouraged city-wide displays that
demonstrated the role of art in American life--from kitchen
utensils to outdoor sculpture. An auction at the Center
offered 100 paintings and other art work done by Minnesota
artists, and coincided with the annual Twin Cities Artists'
Exhibition at the Minneapolis Institute of the Arts.

Art Education for the Community

 The Center's educational directions also developed along
practical and utilitarian lines. The "Everyday Gallery" pro-
vided exhibitions in a "useful gifts" vein, and principles of
good industrial design were presented in holiday shows which
exhibited new home appliances (e.g., electric irons, toasters),
fabrics and textiles, glassware, silver, furniture, and auto-
mobiles. Another educational direction involved the use of
photography in exhibits. Indeed, extended use of the camera
aided in the promotion of contemporary design, part of Defen-
bacher's plan to develop a "design" awareness among Minne-
sota citizens. Aesthetic and mercantile interests often went
hand in hand, and in this case, principles of good design were
promoted with a practical view, one that provided a stimulus
for retail marketing.

 One of the most interesting and in some way the cul-
mination of the "everyday" emphasis occurred in 1941 when
an Idea House, a house with contemporary furnishings, was
constructed on the Walker property where today's Tyrone
Guthrie Theatre stands. Such a concept for an exhibition
was not new to Minnesota since the Minnesota State Art Society
had promoted house plans for rural and suburban communities,
and had constructed a large farm house on the state fair-
grounds as early as 1915. Without utilizing WPA funds, the
Center planned the house "as an educational exhibit of art in
home planning and building," and over 40 businesses and labor
organizations cooperated in its construction:

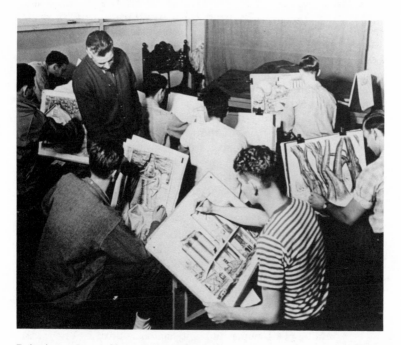

Painting class, Walker Art Center.

> Although no one person will want to use all of the
> ideas, it is hoped that the "Idea House" will stimulate
> more people.... If this hope is fulfilled, the Walker
> Art Center will have made a valuable contribution to
> many lives. [33]

The exhibit lasted from June to December 1941, and by August of that year over 25,000 people had attended the exhibition. [34]

The state WPA administration hesitated to be associated with the Idea House, fearing that close association with industrial contributors would be politically unwise. But the WPA was involved in the sense that it had aided the rebirth of the Walker Art Center, and had thus made this and other ideas possible. Defenbacher called the Idea House "a very successful venture for the Art Center, bringing in much needed support from businessmen and thousands of people who otherwise would not visit an art center." [35]

With so much community interaction, the Center's educa-
tional directions were marked by a proliferation of its creative
services. In 1940, over 350 civic organizations were served
by the Extension Department, and 220 community groups were
given Center tours. Lectures were offered around the com-
munity and throughout the state, and the success of these
ventures owed much to Clement Haupers, who was able to
draw upon an established network of statewide WPA cultural
relationships.[36] But as with most other American art centers
that drew support from Washington and local sponsors, it
was the immediate community that began to see just how far
everything had come in a few months. Mac LeSueur, an ac-
complished Minnesota Project artist who taught painting at
the Center, recollected something of the change-over in
everyday terms:

> The Walker was just nothing. They had some old
> forged paintings in there, and one guy who just sat
> there. There weren't more than a hundred people
> there in a month. There was absolutely nothing.
> Then when they really organized the Walker, they
> cleaned it up because it was such a dismal place.
> Defenbacher was a good promoter and he had the
> whole place repainted and made modern. They took
> half of those old paintings out of there, and started
> to have exhibits. They never had exhibits before.
> It was just a collection.[37]

Indeed, the new emphasis of local and traveling exhibitions
combined the Walker's tradition of gallery shows with a pro-
gram of exhibitions for out-of-state residents. A 1940 Center
pamphlet entitled "Adventures in Art," outlined eight exhibi-
tions for prospective sponsors:

> For the first time, planned exhibitions, incorporating
> actual museum pieces, are available to any community
> which has thirty feet of suitably-located wall space
> available. The exhibitions are planned for the layman.
> They are aimed at people with no specific art training,
> for today, more than ever, everyone needs to be con-
> scious of the cultural heritage which is ours to pre-
> serve. Everything in the exhibitions is discussed from
> the point of view that the arts are a reflection of the
> age in which they are produced.[38]

In "The Face of Minnesota," watercolors by Minnesota artists were presented to "foster a keener appreciation of the everyday scenes of our region." In this manner, the earlier dream of the Arts Council became reality with the exhibition of Minnesota art work in central and traveling exhibits. Minnesota artists also took part in a selection process that echoed the other democratic elements of WPA art activity. Such a plan for an open forum allowed new or unrecognized area artists the opportunity to exhibit. Regionalism, that descriptive cultural term so often applied to American painting in the 1930s, was thus promoted and enhanced with WPA-Arts Council cooperation. Indeed, if the pattern of American art history was often democratic by design, and oriented to local conditions, it could be readily observed at the Walker Center in the matter of exhibition selection.

In "Trends in American Art," an exhibition which portrayed "the currents which are moving American art today," the Center's educational direction was clear.[39] Prospective sponsors were advised that "each picture will represent one trend and all will be explained for the layman," and that " ... material from the Minnesota Federal Art Project is used for this analysis of the direction of painting in the United States."[40] The use of Minnesota Project work to illustrate national trends is significant in that local artistic expression was a "miniature" of a larger, national cultural experience. Making use of the national WPA-executed work for traveling exhibitions, the Walker Art Center exhibited "Art in Present Day America," with a showing of representative watercolorists from other Federal Arts Projects throughout the country.

In January 1941, W. L. Stolte, the Minnesota WPA Administrator, replied to a request from Florence Kerr, Assistant WPA Commissioner in Washington, for an outline of ways in which the Art Center could address the needs of national defense. It fell to Daniel Defenbacher to reflect on defense possibilities at the Walker, and he approached the subject from several perspectives, ever mindful that he did not want to detract from already-established programs. He stressed the importance of the Center as a "meeting place for the public," and probably the most efficient in reaching and serving the general public.[42] The Center was clearly not to be turned into a technical laboratory at the exclusion of the public.

Somewhere in between was the answer, since Defenbacher
wanted to maintain existing programs that were admittedly
"a strong force in maintaining civilian morale," and yet turn
toward more direct defense measures.[43] He offered a three-
part plan for defense use:

> 1) A series of workshops could be arranged for the
> making of innumerable objects useful in army
> offices, barracks, hospitals, and recreation
> centers. A partial list might include clothes,
> ash trays, curtains, draperies, lamp shades, rugs,
> furniture covers, decorative objectives, and fur-
> niture.... Other workshops might produce out-
> lines for plays, musicals, and group activities
> which would assist recreational officers ... in the
> cantonments. Other workshops ... to encourage
> women and men in making clothes and objects for
> their own use.... A special promotional campaign
> ... to get women and men from industrial areas

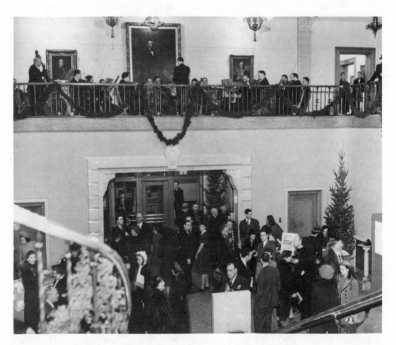

Opening Night, Walker Art Center, January 4, 1940, with
Minnesota WPA Symphony Orchestra.

to join these groups. These workshops would
encourage participation by the public in the de-
fense program, and ... produce useful objects.

2) A sizeable committee of citizens could be formed
to collect books, records, games, periodicals,
and works of art which could then be given or
loaned to cantonments. This committee could
operate on a statewide basis, having subcommit-
tees in all the major towns. It is possible that
the Art Center could establish a nationwide activ-
ity of this kind by enlisting the cooperation of
community art centers throughout the nation and
by acting as a clearinghouse and source of infor-
mation.

3) The Art Center is immediately available for the
dissemination of information by means of its
exhibition facilities.... Inasmuch as other de-
fense agencies are already equipped to prepare
information ..., the Art Center ... should make
its services available to these other agencies.
The Art Center might prepare special exhibitions
of a defense nature:

a. Europe and American--1940. A graphic com-
parison for social changes and advantages.
Presented in cooperation with newspapers.

b. Soldiers in uniform. Pictures of all periods
of soldiers in different types of uniform.

c. Posters. An exhibition and contest for
posters of a defense character.

d. Camouflage and the artist.

e. Verboten. Great works by refugee artists
showing the effect of totalitarianism upon
culture.

f. Freedom and American art. Works by Ameri-
can artists demonstrating the freedom of ex-
pression which American democracy permits.
WPA material.[44]

The plans were thoughtfully laid and replete with Art
Center philosophy as the Walker joined a defense cum war
effort. The continuing Walker echoes of community, of useful

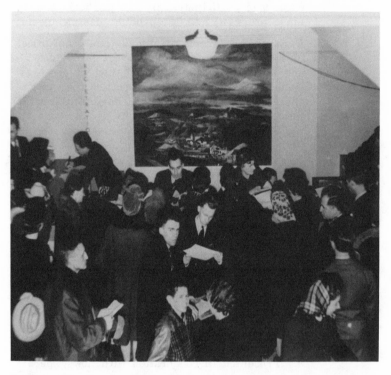

Registration for workshop classes, Walker Art Center.

objects, of practical needs, of wide participation, and of
inter-agency cooperation resounded in patriotic and willing-
to-serve anticipation.

The Walker War Effort

 In September 1941, the Walker Art Center visibly turned
from peacetime concerns to an exhibition entitled "America
Builds For Defense," a show that mirrored the growing num-
ber of community defense efforts in Minnesota. A review
parade of 950 military personnel opened the exhibition, which
consisted of scaled models depicting military and defense
activities. Visitors to the Center could see a model of the
New Brighton, Minnesota, ammunition plant and could climb

into a mock-up plane fuselage and look down upon an 18- by
20-foot model of Fort Riley, Kansas. An editorial in the
Minneapolis Star praised the effort and singled out another
Walker first:

> The Army Construction quartermaster show at the
> Walker Art Center is a new departure in military
> procedure. It is the first show of its kind in the
> entire history of the United States Army. And it is
> also the most intelligent, clear-cut, straight forward
> job of telling an army story that we have ever seen.45

The miniature army cantonment was produced under the
joint direction of Lt. Malcolm Lein and J. L. Davidson, As-
sistant Director of WPA Art Projects at the Walker. Twenty
artists and other WPA personnel worked for weeks in the
completion of the many murals and small-scale models of the
exhibition.

U.S. Marine recruitment was given a boost a year later
in an exhibit entitled "Halls of Montezuma." Held in conjunc-
tion with "Be A Marine" month, the exhibit featured a display
of amphibious equipment.46 All of these activities demon-
strated the Center's worth to various governmental and com-
munity agencies during the war period. The "war" works of
many Minnesota Project members were exhibited locally, in
various area exhibition halls. In addition, project water-
colorists such as Sydney Fossum, Arthur Kerrick, Lynn Kep-
man, LeRoy Butscher, Bob Brown, Miriam Ibling, Edwin Holm,
and Bertrand Old, were represented in shows of the National
Exhibition Section of the Federal Art Project. Similarly, paint-
ings by Arthur Kerrick, Alexander Masley and others were
selected for display in Washington, D.C. as an aid in the de-
fense activities of the Office of Emergency Management.47

In 1942, Center activity was marked by various com-
munity services for the war effort. Materials processed by
the Minnesota Visual Aids Graphic Production Unit were used
by War Information Services. Other contributions included
items such as war information posters, scrap book covers,
the U.S. Naval Station news sheet Nor'wester, the Service
Men's Center Weekly bulletins for Minneapolis and St. Paul,
the Mill City Entertainment Bulletin, and the War Information
Center Parade. 43

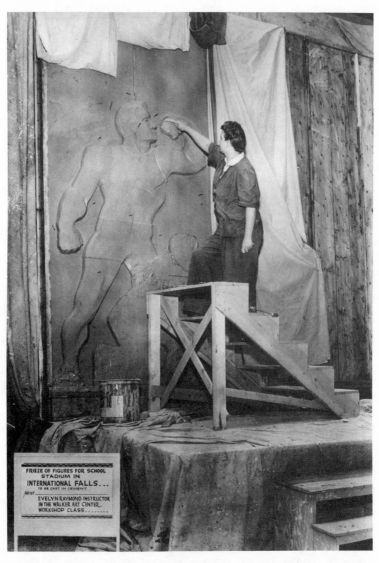

FRIEZE OF FIGURES FOR SCHOOL
STADIUM IN
INTERNATIONAL FALLS...
TO BE CAST IN CEMENT
ARTIST____
EVELYN RAYMOND INSTRUCTOR
IN THE WALKER ART CENTER
WORKSHOP CLASS.........

Evelyn Raymond, sculptor, at work in Walker Art Center on
project for International Falls, Minnesota.

Just as it responded to the war effort through exhibitions and production, the Center also reflected continuing developments in the "parent" Minnesota Federal Art Project. The larger, statewide work relief program for artists and artisans had begun to alter its course in light of changing and improved economic conditions. Many work assignments were phased out as artists and technicians enlisted in the armed forces or moved to other employment such as defense production. As a result, the Project evolved to the "Graphic Services" phase of the War Services project in 1942, a project extension which drew wide praise for its training efforts in the use of artistic skills for the war efforts.

When President Roosevelt ordered all WPA activity concluded in December, 1942, the Walker Art Center took steps to bring its many federally-sponsored projects to a close. By March 1943, Center activities such as clerical assistance, civilian defense training, and graphic arts were phased out.

When the WPA finally left the Minnesota cultural scene, there was no salutary fanfare. Minnesotans were generally concerned with wartime emergencies, and cultural programs were necessarily given another, less important priority. But then, as today, few Minnesotans realize the cultural benefits which grew out of federal assistance. The Walker's "federal-state" period from 1940 to 1943 helped lay the philosophical groundwork of the present Walker Art Center, and had played a major role in the artistic consciousness-raising of the larger community. There were to be other changes, other programs, and other leaders. But the WPA was present at the Walker Art Center's birth, and rendered vital assistance through the first years of exciting growth. When the Walker Art Center reverted to a pattern of local support and private patronage with the departure of the Federal Art Project in 1943, it was clear that "art" service to the community and state had been forever enriched by the presence of government patronage.

Over a decade later, Ruth Lawrence noted that "... it was with this aid of the government through WPA that the Walker actually 'got its feet' and became the grand work which has evolved in the succeeding years."[49]

Notes

1. For a general account of the history of the Walker Gallery Art Center, see Philip Larson's "Thomas Barlow Walker, From Private Collection to Public Center," Hennepin County History, Spring-Summer 1971, p. 5-13.

2. Rolf Ueland, Minnesota Artist, Vol. I, No. 1, November 1938. The Arts Council was organized in the summer of 1938, with an initial membership of 21 persons.

3. Personal Interview with Rolf Ueland, Minneapolis, December 4, 1962.

4. Letter, Rolf Ueland to Daniel S. Defenbacher, April 28, 1939.

5. Ueland Interview.

6. Letter, Clement Haupers to Thomas Parker, April 20, 1939.

7. Report, meeting at the Walker Galleries, May 20, 1938.

8. Ibid.

9. Minutes, Minnesota Artists Union, April 5, 12, 19; May 3, 10, 24, 31; June 7, 14, 21; July 5, 1938.

10. Minutes, Chicago Conference on Community Art Centers, Federal Art Project, August 27, 1938.

11. Letter, Daniel S. Defenbacher to Rolf Ueland, November 22, 1938.

12. Letter, Audrey McMahon to Thomas Parker, May 10, 1939.

13. Interviews with Sydney Fossum (November 10, 1962), Mac LeSueur (November 29, 1962); Letter, Thomas C. Parker, WPA Art Program, to Archie Walker, October 31, 1939.

14. Interview, Daniel S. Defenbacher.

15. Letter, Clement Haupers to Thomas Parker, September 5, 1939.

16. "A Proposal of Federal Art Project Sponsorship for an Art Center at the Walker Art Galleries," Daniel S. Defenbacher, 1938.

17. Letter, Archie D. Walker (for the T. B. Walker Foundation) to Rolf Ueland, December 28, 1938.

18. Letter, Clement Haupers to Daniel S. Defenbacher, March 22, 1939.

19. Defenbacher Interview.

20. Letter, Rolf Ueland to Daniel S. Defenbacher, March 22, 1939.

21. Letter, Daniel S. Defenbacher to Rolf Ueland, December 12, 1938.

22. Minneapolis Tribune, January 5, 1940.

23. Ibid. In a letter, Daniel S. Defenbacher to Thomas C. Parker, November 17, 1939, specific plans were made: "The opening program featured three major exhibitions: one, a survey for the layman of paintings from the Middle Renaissance to the present day called 'Ways to Art;' second, an exhibition called 'Parallels in Art' covering Oriental art and; third, a show called 'American Leisure' convey the place of arts in leisure time today. The latter is a collaboration with Life magazine." Parker visited the refurbished Walker Art Center on December 15, 1939 and termed it one of the best. Minneapolis Star Journal, December 16, 1939.

24. Minneapolis Tribune, January 3, 1940.

25. Defenbacher Interview.

26. Minneapolis Tribune, January 5, 1940.

27. Ibid.

28. Minneapolis Tribune, April 4, 1940.

29. Minneapolis Tribune, April 4, 1940.

30. Silk Screen Process, Ruth Lawrence, Exhibition Catalogue, University Gallery (Minnesota), February 1941.

31. William F. McDonald, Federal Relief Administration and the Arts, Columbus, 1969, p. 479.

32. Minneapolis Daily Times, November 5, 1941; Ueland Interview.

33. Minneapolis Tribune, June 1, 1941.

34. Holger Cahill, August 14, 1941.

35. Ibid.

36. Walker Art Center Membership Pamphlet, "Adventures in Art." Minneapolis, 1941. Classes were available in the following areas: painting, drawing, sculpture, fashion design, textiles, interior design, lettering, silk screen process, ceramics, publicity, lithography, metal, jewelry, leather, woodworking, weaving. Mac LeSueur states that every high school in the Twin Cities area was "reached" by a team of artists (one lectured as one painted) on a painting-lecture circuit.

37. Interview, Mac LeSueur, December 1962.

38. Pamphlet, "Circulating Exhibitions and Lectures for Your Community," The Walker Art Center of the Minnesota Arts Council, a WPA Project, Minneapolis, 1940.

39. Op. cit., Pamphlet, "Circulating Exhibitions...."

40. Op. cit., McDonald, p. 316.

41. Letter, Stolte to Kerr, January 15, 1941.
42. Ibid.
43. Ibid.
44. Minneapolis Star, Editorial, September 3, 1941.
45. Minneapolis Star, September 8, 1942.
46. Minneapolis Star, February 11, 1942.
47. Letter, Stolte to Kerr, October 7, 1942. Some of
the training aids were for use by U.S. Navy, and these
were also produced under the auspices of the Minnesota War
Services Project, the Graphic Services Phase. These in-
cluded the production of 40-inch diameter world globes.
48. Notation, Attached to (Report of Meeting at Walker
Art Galleries, May 20, 1938) dated March 26, 1957.

THE FEDERAL GALLERY SYSTEM IN OKLAHOMA:
A SUCCESSFUL EXPERIMENT

Nicholas A. Calcagno and Barbara K. Scott

In 1976 Nan Sheets left $50,000 as her legacy to the project which had absorbed many of her energies since that day in late December 1935 when she was hired to direct Oklahoma's Experimental Art Gallery in Oklahoma City. Today's Oklahoma Art Center can confirm its 50th anniversary in 1985 and celebrate its first show which opened January 5, 1936, as a gift from Dr. and Mrs. Fred Sheets to the people of Oklahoma. The exhibit of 27 paintings was the work of Will Stevens, Director of Art, Newcomb College, New Orleans.[1]

Throughout its first full year, 1936, the Experimental Gallery operated from cramped quarters in a one-room storeroom in the Commerce Exchange Building provided free of charge by the Oklahoma City Chamber of Commerce. By the end of 1936 the Gallery had outgrown these quarters: this was a promise of the future and an indication that the experiment was evolving into a true art center. From its 1937 home, where it continued to thrive, attract support, and expand, it was moved in early January 1938 to the Municipal Auditorium to remain there for the next twenty years. Here the Federal Art Center could provide a wide variety of exhibits in five spacious galleries and offer classes and other services in classrooms, workshops and offices furnished by the city. In 1958 the now-named Oklahoma Art Center moved to its present site at the Oklahoma City Fairgrounds. Today the Center is a three-facility complex with year-round exhibits, art classes, a library and bookstore, and a sales and rental gallery. It also maintains a permanent collection for the state of Oklahoma.

This kind of active and full-grown art center must have

37

been the dream of the federal planners in 1936 when the con-
cept of community art centers became an important part of
Federal Project No. 1. Because many states in the South,
the West, and the Middle West lacked the experience of art,
National Director Edgar Holger Cahill felt experimental art
galleries could eventually bring art to those who wanted to
enjoy it.[2] He appointed Thomas C. Parker to assist him in
the national project and to oversee the southern region of the
country. Other regions--the West Coast, the Rocky Mountain
States, the Midwest, New England, Metropolitan New York
and New Jersey--had their own directors.[3]

 The Federal Government had set a bold precedent when
it dared to initiate a series of art programs in the thirties to
afford relief for artists and to institute a national art policy.
One of the programs was the Works Progress Administration
Federal Art Project No. 1. As a broad national program it
was devoted to music, art, writers' and theatre projects, and
the historical records survey for state and local communities.
Its goal was to offer federal support to local communities for
cultural programs which would eventually generate local spon-
sorship to assume the entire funding when federal funds were
withdrawn. The government coined the phrase "demonstra-
tion policy" to explain the process.[4] It was the hope that
community art centers and extension galleries as WPA service
projects could accrue enough local support, after demonstrat-
ing their value to the communities, to generate funds for con-
tinued operation of services including classes, exhibits, and
public education in appreciation of the arts. Under the aus-
pices of these programs communities such as Oklahoma City
could have a variety of cultural programs as the offspring of
federal parentage--a symphony, a community theatre, and a
public art gallery.

Laying the Groundwork in Oklahoma

 Regional Director Thomas C. Parker, whom Cahill had
placed in charge of developing community art centers, was
aware of the importance of art education when he traveled
through Kansas, Oklahoma and Texas to canvass potential
sites. While en route he visited with Nan Sheets, whose
reputation as an artist and a teacher was well established.
Her career and interests guaranteed that she was the type
of leader Parker and Cahill were looking for to organize and

direct the Oklahoma Experimental Gallery. Since the time
she and her husband had settled in Oklahoma City in the
twenties her reputation on the local and national art scene
had continued to grow. She had won numerous awards,
taught private classes in her studio, opened her own gallery
--The Elms--to the public on many occasions, held private
shows of reputable works, traveled and exhibited extensively,
written articles on art for the Daily Oklahoman, and encour-
aged the cultural development of Oklahoma City at every op-
portunity. She had earlier served on the Public Works of
Art Project in the capacity of administrator and juror with
Dr. Oscar Jacobson, Chairman of the growing Art Department
at the University of Oklahoma.[5] Her personal collection of
articles culled from various art journals and newspapers in-
dicate a sincere interest in the establishment of local public
art galleries.[6] Her energy and social and artistic connections
affirmed that she was indeed the Oklahoman for the job at
hand.

When Parker first approached Sheets with his art center
proposal she thought that the whole idea was a joke, or per-
haps that he was not entirely serious. "If Parker was seri-
ous," she was known to recall, "it was too good an opportuni-
ty to miss."[7] One of the basic requirements for setting up
an art center, he told her, was for Oklahoma City to supply
a rent-free space. As usual, then and now, Oklahoma City
had no extra funds, and unless Sheets could find a sponsor
like the Chamber of Commerce, she knew the opportunity
would be lost. A sponsor such as the Chamber of Commerce
would fulfill another requirement that the co-sponsor repre-
sent community interests. Other requirements were a central
location, and availability of support personnel, primarily
trained and credentialed art teachers, most of whom could
qualify for relief programs. Further, the room or rooms
housing the center must be clean, attractive and large.[8]

The project was not initiated by Christmas of 1935 as
anticipated by Parker and Homer Heck, Director of the State
Professional and Service Projects, simply because the hiring
of Sheets and artists took a few days longer than expected.[9]
Negotiations for an Oklahoma project began sometime in Novem-
ber 1935. Sheets was selected by Heck on December 7, ap-
proved by Parker December 15, officially hired December 30,
and the first show took place a few days later in early January,
1936--a remarkably fast-paced chain of events.[10] "A most

delightful place," donated through assistance of the secretary
of the Chamber of Commerce, and some furnishings were soon
put to use as the exhibition program and art school were im-
mediately organized. Actually, preparations were underway
as soon as Sheets was selected and before she was officially
hired. [11]

Functions of the Art Center

Before the manual Federal Sponsored Community Art
Centers was issued in October of 1937, Daniel S. Defenbacher,
Parker's assistant, had established centers in North Carolina
and Oklahoma (the second center to be established) and had
helped to form others elsewhere. At his North Carolina cen-
ters, all of which had galleries, exhibits were scheduled from
private, state, and national collections. Sheets' program fol-
lowed this format. In addition, lectures on the exhibits were
offered, art demonstrations given, and art classes for both
children and adults were held. Again, this is the format fol-
lowed by Sheets. Parker and Defenbacher stated the official
policy in the Art Center Manual which they coauthored:

> The art center program should be directed not only
> toward building larger audiences for the arts, but
> also toward guiding and encouraging group activities
> and group expression leading to more complete com-
> munity sharing in the experience of art. [12]

The heart of the community art center movement lay in
its educational activities--lectures, demonstrations, and free
art classes. With these kinds of activities Holger Cahill prom-
ised to orient the art center program more and more in the
direction of public education, art appreciation, and community
participation in art activities.

Actual operation of the art center program and the
policies underlying the concept seem to have been developed
concurrently. Therefore, it is not surprising that a consid-
erable amount of confusion about the use of various terms so
casually mentioned in letters, memos, and other communiques
existed for those implementing the programs, and for histori-
ans who attempt to reassemble the events. Although the
Oklahoma Federal Gallery and Art Center was referred to as
the WPA museum in a few contemporary news articles, it was

in fact neither a WPA-sponsored museum nor a museum
school.

> The town art center is not a museum where pictures
> are hung and emphasis is placed on the past, and
> where it is fashionable to be seen.... A town center
> is where the people who live on both sides of the
> tracks get together and paint what they like, or
> hear lectures on phases of art, or listen to music,
> or study photography, or do sculpture. [13]

Sheets was under some local pressure, both public and
private, to use the federal support of the project to estab-
lish a permanent museum. [14] In an exhibition catalogue of
1939 Sheets' use of the museum concept was severely criticized
by Defenbacher whose letter to Sheets prompted a series of
heated exchanges involving several people. Sheets wrote:

> The objective for the Center Director has been to
> utilize the help which the Federal Government, through
> the Works Progress Administration, provided to build
> the cultural foundations for a permanent museum for
> the city and the state. [15]

Defenbacher objected to the word "museum" in a two-
page letter and accused her of attempting to build a tradition-
al museum for painting and sculpture, rather than developing
a program which would reach out to the greatest number of
people. Given Sheets' other statements, summary reports,
memos, and news releases, it is likely her use of the term
implied an institution which could endure the inevitable with-
drawal of federal funds rather than the traditional storehouse
of valuables.

The functions of the Community Art Center were more
inclusive than a series of exhibits hung in succession. An
almost crusading spirit to educate the public to the benefits
of art was afoot. It was only when the art centers had
habituated their communities to art that the exhibition program
of the Federal Art Project could achieve its fulfillment. Nan
Sheets was aware of this mission. She believed that Oklahoma
City needed a more thorough appreciation and understanding
of art before it could adequately support an art gallery. "We
are not sufficiently art conscious as yet," she stated in the
early months of 1936. "What we need as much as we need a

structure to house an art collection are more exhibits and more lectures on art subjects."[16] The Chamber of Commerce Committee on Education, which had been created to support the objectives of the Gallery, focused civic interest on plans for a municipal gallery and a strong art education program.[17]

Reflecting the federal confusion about proper terms for the art centers, Oklahoma's art center shifted through several name changes: WPA Experimental Art Gallery, Oklahoma Federal Art Center, Municipal Auditorium Federal Art Center, Oklahoma WPA Art Center, and finally, when federal funds were withdrawn, the Oklahoma Art Center. Sometimes the improper use of a name or lack of proper credit could evoke as much ire as the use of the forbidden "museum." A sign outside the gallery which simply read "Federal Art Center, Open Daily 9-5, Sunday 2-5" failed to credit the WPA--an oversight which merited the delivery of the offending announcement with an accompanying photograph to the Director of the Professional and Service Projects Division. Armed with this bit of information, Mrs. Leo G. Spofford, Chief Regional Supervisor of Professional and Service Projects, planned to call a meeting of the Federal Directors of Oklahoma Music and Art Projects and explain to them "that these projects are part of the state program and are subject to the procedures and policies of the State Administrator."[18] Remonstrations like this and the storm over the use of "museum" make it clear that regional and national levels were apprehensive of the judgment of local administrators.

Though terminology mirrors the guiding philosophy, attention was focused more on programs than on recurring national vs. local skirmishes. Sheets was eager to implement a program which would assure the objectives of the national program. The Oklahoma City WPA Art Gallery report of September 1936, clarifies a program consisting of exhibits, a research division, a poster division, and public classes.[19] By 1940 the summary report filed by Homer Heck as General Superintendent of the Oklahoma Art Project lists the following phases of the art project:

1. The Exhibition program (Art Center and Extension Galleries)

2. The Informal Education Program

3. The Art Center Schools

4. Public Services[20]

The Exhibition Program

The first exhibition at the experimental art gallery consisted of the Stevens paintings mentioned above and 24 etchings from Max Kuehne of New York.[21] In spite of the limited space at the gallery, 32 exhibits were circulated in and out of every two weeks. Such a schedule presented an opportunity for regular publicity. By the end of 1936 the format of later exhibitions was established with a tighter schedule of overlapping shows from a number of sources.[22] There was no shortage of exhibits or of media for the 40,000 visitors who came to the gallery to view 2,284 pieces of art in 1936.[23] When the gallery personnel moved to their new location in the next year, they made full use of three galleries, a window display area, and an office by having a series of multiple exhibits.[24] Throughout the following months Federal Exhibits began to appear with regularity, such as Exhibit #272 (Spanish Portfolio) and Exhibit #274 (20 Louisiana Graphics and Watercolors). One unusual exhibit consisted of 18 murals, thirty feet long, painted by Gallery School Manager Ruth Monro Augur. Other exhibits included a WPA traveling show from New York of children's watercolors, a collection of textiles by Ruth Reeves, an old German print show lent by private collectors, and a modern photography show (FAP 264) by New York and California photographers.[25]

The amount of space made available in January 1938 in the new Municipal Auditorium made an even more ambitious program feasible. One of the five galleries housed the permanent collection of the Oklahoma Art League, which included paintings by nationally known Oklahoma artists. In 1938 the exhibits numbered nearly 90. During subsequent years the galleries featured a number of WPA shows from Index of American Design to Farm Securities Administration photographs, to state project easel works and cartoons, and Section of Fine Arts sketches and cartoons; local artist shows in groups and as solos; shows circulated by industry, such as Reynolds and Grumbacher; annual National Lithography shows initiated by the Oklahoma Gallery; and traveling shows compiled by regional artists' societies. Oklahoma gallery visitors were exposed to a visual sampling of Americana from coast to coast and, occasionally, a few European and Oriental threats.[26]

In April of 1940 Heck, now General Superintendent of the
Oklahoma Art Project, submitted in a monthly report of ac-
complishments his comments on the Exhibition Program:

> The purpose of the exhibition program is to expose
> as many different persons as possible to the work
> that is being done by contemporary artists and to
> the work of the past as well, in order that they may
> come to understand the significant expression of
> working artists. Since September, 1938, over one
> hundred shows have been exhibited in the Oklahoma
> City Gallery and in various extensions.... Several
> of the WPA exhibitions have been explanatory of
> techniques and media of the various forms.

> There have been over twenty locally assembled shows
> exhibited since last September. For the most part
> these have been of Oklahoma artists, with the idea
> that the work done by artists of this particular re-
> gion should be of first importance to the people living
> here; possibly because of this interest, most of these
> shows have been quite popular. [27]

In general, exhibits were shown for two- or three-week
periods. Some were held over either because they were pop-
ular or because there was a delay in the arrival of the next
exhibit. They were obtained from the National Exhibition
Section, FAP, Washington, D.C., from Oklahoma and out-of-
state artists, private collections, and from art students and
teachers of the art center and area schools. Each exhibit
was displayed with identifying labels and descriptive informa-
tion, and although a few were self-explanatory (for example,
"The Making of a Print"), most of them were accompanied
by personally conducted tours and lectures. [28]

Oklahoma exhibitions slated for the national circuit were
a group of 34 paintings by Oklahoma Indian artists, a Univer-
sity of Oklahoma Faculty Exhibition of 16 paintings, an Ex-
hibition of Oklahoma Artists, "An Artist Explains" by artist
John O'Neil, and a selection of work from the Negro Extension
Center in Oklahoma City (4 murals, 25 watercolors and sev-
eral art craft pieces). [29]

The Art Center Schools

In its first years the WPA Experimental Art Gallery

offered drawings and painting courses to "underprivileged" children between the ages of 5 and 14. [30] In this instance, Sheets used the term to indicate those who could not afford to pay for private art lessons: they were not in the business of competing with art teachers. Cahill used the term to refer to "those in the congested slum areas of our big cities, and those who suffer from the cultural starvation of districts where purely practical standards prevail." [31] Another group benefiting from the Federal Art Program was hospitalized children, particularly the crippled. That students at an art center should be required to prove destitution in order to receive instruction was brought about in one southern state because art center instruction was competing with private instructors and private art schools, at least according to those protesting. Today we might be inclined to think that forcing art students to pass a means test was about as logical as requiring gallery visitors of the Federal Art Project to pass a similar test. [32]

Of the 1,162 art students attending the Oklahoma Art Center in its first year, 534 were children and 625 adults. After the first year no further mention was made of "underprivileged" when it came to recruiting potential art students in the city newspapers announcing art classes. A program of daily art classes published in 1940 presents a typical offering of options on a regular schedule: hobby painting, lettering, posterwork, sculpture, crafts, figure drawing, perspective, watercolor, ceramics, home decoration, still life composition, landscape, portraiture, fashion drawing, woodblock, children's art and children's crafts. [33]

These options reflect Cahill's distinctions between the art of children and adults:

> In all project teaching there is a clear recognition of the sharp differentiations between the fundaments of child and adult art. In the former, it is largely a matter of instinct having its parallel in the naïve expressions of primitive people who found in painting and drawing their sole method of communicating ideas. In the latter, it is a highly disciplined fusion of technique and emotion, based upon long periods of training and study and dependent in its higher aesthetic manifestations upon the mature human interplay of these elements. However, it has always been true that the genuine artist is very much a child in spirit

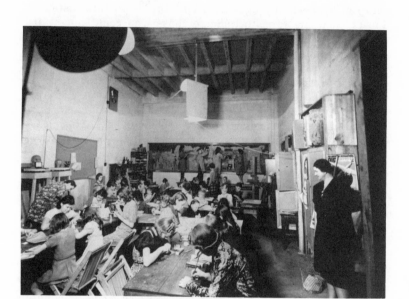

Children's class in early gallery with Nan Sheets on the right.

and always preserves the child's capacity of wonder and surprise. [34]

Whether the children and adults who attended art classes during 1939 knew or cared about such distinctions, their attendance at the Oklahoma Art Center dispelled any notion that they were not eager for art experiences. The total for classes in 1939 was 2,395 children and 4,192 adults in 582 classes. When compared to the 1,100 students in 1936, the combined total 6,500 for 1939 was a marked increase and a certain sign that the center was fulfilling a need of the public. Sheets summarized the center's service:

> It is not the purpose of the Works Progress Administration Federal Art Project to conduct professional art schools in competition with existing schools or private teachers. Many persons who could not possibly afford private instruction have enrolled in the Municipal Auditorium Federal Art Center classes in Oklahoma City. Others who could well afford to pay

for private instruction have come into the classes in
order to determine whether they were sufficiently
interested to enroll in private classes, and whether
they had any latent talent. [35]

Clearly her educational philosophy was integrated into her
public educational service programs.

The Informal Education Program and Public Service

Because informal education and public service were
directed to molding public opinion about art, they can be
viewed as two facets of the same operation--broadening the
base for the appreciation of art in Oklahoma through public
contact.

The informal education program was a series of efforts,
apart from classroom experiences, to improve the quality of
information and affect opinions about art. These consisted
of lectures, tours, news articles, radio programs, and or-
ganized presentations for state and county fairs and for Art
Week. In the days when the neophyte Experimental Art Gal-
lery was a more loosely structured operation, visitors were
treated to weekly lectures, gallery tours, and occasional
demonstrations on media and techniques. By 1940 weekly
illustrated slide lectures were scheduled for Saturday morn-
ings at 11:00 a.m. Known as the "Children's Hour," these
programs were designed to appeal to the young. Millet,
Raphael, Hals, Van Gogh, and Cellini were a few of the
masters selected by art center personnel to expose children
to the giants of art history. Sunday afternoon lectures for
adults hosted by the Association of Oklahoma Artists, the
American Association of University Women, and other communi-
ty groups featured Cezanne, Russian Art, the Influence of
Art on Behavior, and a host of other topics. [36]

Although radio programs were not as regular an event
as the feature stories and gallery talks throughout the years,
they frequently assumed the character of predictability, and
demonstrate a continued effort by Sheets to attract public
attention through every possible means. Sheets even partici-
pated in a series during Art Week, 1940, presenting a na-
tionally broadcast program. [37] In addition to these efforts,
Sheets wrote a regular column for the Daily Oklahoman on

subjects of national interest, such as feature shows at the
Corcoran Gallery and other major museums, notable collections,
and events and criticisms of general appeal. The monthly
News Flashes originating in 1939 as the Gallery's newsletter
was made available to supporters of the Gallery and its ex-
tensions. This mimeographed bulletin, averaging 12 full
pages, was attractively mounted in a silk screened cover in
its later issues, and stocked with informative narrative about
current shows, as well as classes, services and accomplish-
ments of the art center. In one issue we read that:

> The information service at the Center is being utilized
> to such an extent that it takes almost all the time of
> one employee to prepare and mail material to persons
> requesting for [sic] this service. [38]

Among these services were newspaper clipping files, informa-
tion gleaned from magazines about major artists and schools,
and updated vitae on contemporary artists, particularly Okla-
homans. This information was freely shared with those who
requested it. The Center also housed a small library of
books and journals which it recruited from its public through
frequent appeals for donations. Other available information
included a print study collection and an index of art books
to be found in local libraries.

 Artists at times participated in informal demonstrations
of techniques of their work. Some exhibits brought to the
Center, notably "The Making of a Print" and "An Artist Ex-
plains"[39] were self-teaching educational units--visual demon-
strations of specific processes. Fourteen charts in the latter
show illustrated one artist's method of creating a painting
from rough draft to finished work. Project artists also pro-
vided murals for public buildings and programs (Park Board
Murals, Oklahoma City; Chamber of Commerce, Oklahoma City),
a life-sized nativity for the lawn in front of the Municipal
Auditorium, a life-sized crucifixion for a local church,[40] and
a replica of the Statue of Liberty for a local park. The Cen-
ter's poster and silk screen unit designed and produced
thousands of posters, brochures, and pamphlet covers for
any public agency or WPA project so long as the materials
were furnished and sufficient time allowed for meeting dead-
lines.[41]

The Tulsa Art Center and Extension Galleries

Besides the Oklahoma City Art Center, there were over
a dozen extension galleries active in the state and the Tulsa
WPA Art Center which promised to compare favorably with its
coequal in Oklahoma City. The Tulsa WPA Art Center held
its formal opening in October of 1937 with Maurice De Vinna
serving as its director. [42] Maurice De Vinna, Jr., a native
Oklahoman, was Director of the Extension Galleries and As-
sistant WPA State Supervisor under Sheets, as well as Art
Critic of the Tulsa World. Most of his training, primarily
in art criticism and museum administration, was received at
Harvard University under Arthur Pope, Paul J. Sachs, and
Edward Forbes. He held a "Brevet d'Art" from the Univer-
sity of Paris, taught art history classes, lectured, and won
awards in painting and sculpture at the Tulsa Art Association
Annual Exhibition in the early thirties. Like Sheets, he was
eminently qualified for community art center work. The Tulsa
Center, backed by the Tulsa Art Association, enjoyed a great
popularity with the general public, but due to internal prob-
lems, was operative for only a brief period. De Vinna, how-
ever, was kept on as administrator of the extension galleries
after the Tulsa Center ceased to function, working from his
Tulsa Office and later from an office in Oklahoma City under
Nan Sheets. [43]

Over a dozen extension galleries were operative in
Oklahoma. Galleries were established in Altus, Blackwell,
Bristow, Claremore, Clinton, Cushing, Edmond, Enid, Marlow,
Ponca City, Okmulgee, Sapulpa, Shawnee, Skiatook, and
branches in Oklahoma City at the Wright Branch Library,
the Maud J. Brockway Negro Community Center, and Capitol
Hill Junior High School. [44]

Extension galleries were very popular in Oklahoma even
though the requirements for establishing a gallery were strin-
gent. Washington stipulated that a $500 cash contribution be
secured from a local co-sponsor before plans for the space
could be submitted. Further, major interests of the commun-
ity were to be represented in the art association formed as
the active force behind the gallery/school. Only a few com-
munities could meet these requirements. [45]

The supervision of a number of galleries could prove to

be a burden to the state administrator. In October 1937,
FAP Director Heck, working out of the University of Okla-
homa, wrote to Defenbacher about the extension galleries
and about his reluctance to "go too far into the extension
business until I know what the possibilities are."[46] A reply
was received from Parker:

> In order that the program does not get too unwieldy
> for you, I think it best to limit the establishment of
> extension galleries to three, and to limit such centers
> to those where the sponsors will furnish adequate
> space, equipment, and a sizable sponsor's fund to de-
> fray the cost of transporting the exhibits. [47]

In spite of the apparent concern and restraint, eleven ex-
tension galleries were in operation by 1941.

Extension galleries in the smaller communities presented
an exaggerated version of the educational problems of the
larger galleries, particularly Oklahoma City: taste was rather
provincial and unsophisticated by the standards of the East
Coast and the public was unable to cope with the "modernity"
of some of the circulating shows. Co-sponsoring groups of
several new galleries about to be opened in the state had
questioned the alleged and rumored modernity of WPA shows.
They feared that too much of this at the beginning would
hamper the success of their galleries, and requested their
first shows to be rather conservative. Heck understood their
apprehension and approved their request:

> I can see the wisdom of this request, knowing Okla-
> homa. As you know, we are rather out of the main
> currents of American art, and, as Mr. De Vinna
> pointed out, we tend to idolize a certain native son
> named Will Rogers. You are aware of the comments
> he had to make concerning "modern art."[48]

Aware that residents of the smaller communities did not com-
prehend much of the material sent by the Federal Art Project
for exhibition, Heck deployed De Vinna on an experimental
mission. He was sent to the opening exhibit at Claremore
which he studied carefully and prepared supplemental material.
The public response was immediate and rewarding.[49]

De Vinna, however, was disappointed in many of the

WPA exhibits routed from Washington. When they arrived at their destination in Oklahoma they fell far short, in his judgment, of what Washington had written about them. The work was worth showing, De Vinna concedes, but had to be supplemented with other works in order to justify its exhibition.[50]

One of the most popular shows in the WPA circuit was "Paintings from New England" (WPA #487). It was so popular that De Vinna had booked it solid for months to tour every gallery in the state.[51] However, he was to be disappointed, for it was also in demand in a number of other locations around the country, and had to be moved out of the state before local demands could be satisfied.[52]

Not all of the galleries had a substantial history. Many seem almost to have been an overnight event. Sheets made an effort to establish some type of permanency through a variety of efforts. The programs, at least the inaugural ones, were prepared by the Oklahoma City gallery, complete with sponsors, class schedules, philosophy and history of the WPA art programs. Her entry into the extension business commenced after De Vinna had left the program. At this time she assumed the position of mentor in local projects, and added visits to these galleries to her already packed agenda.

The fate of the extension galleries, on the surface, was their total demise when the impending threat of war created a lack of funds and a redirection of art project objectives. Some galleries suffered at the hands of local disunity. In at least one case, the transfer of sponsorship to the state level prompted the gallery director to resign and the program therefore to collapse.[53]

The fate of the Tulsa Gallery was far more complex. Briefly, the supporting group, the Tulsa Art Association, withdrew its support from the government program when it became apparent that another source of art sponsorship would become immediately available in the person of Frank Phillips. From this association the Philbrook Art Association and Museum was born.[54]

The Production Unity

 Although Oklahoma seems not to have had an official
easel project nor a major mural effort nor an Index of Ameri-
can Design unit, several reports refer to the "Production
Unit" and operations which encompass similar activities, in
addition to a major silk screen division which began to de-
velop in late 1938.

 In her summary report for September, 1936, Sheets
wrote about the "Research Division:"

> The Index of Oklahoma Indian Designs being compiled
> by this department is a record that should prove of
> inestimable value to the state. These designs are
> accurately worked out on beaded paper. The beads
> are actually counted and the exact colors reproduced.
> A watercolor of the object is also made and a complete
> description given.... Fifty designs have been com-
> pleted to date.[55]

Subsequent reports give even more detail of the process of
work and sources being consulted.[56] By October 1940, 300
designs were reported to be ready for the library of the Uni-
versity of Oklahoma.[57] In the light of lack of evidence for
further work, the disappearance of this work, and the fact
that Oklahoma did not have an Index of American Design
Unit,[58] these early reports become intriguing historical ad-
juncts. Possibly Sheets was responding to an early intention
to use the Federal Art Galleries as Index Centers.[59] A report
proposing plans for the future of the Federal Art Project
states:

> During the coming year the Federal Art Project plans
> to make all of its Galleries research centers for the
> Index of American Design by having them make studies
> of local American decorative and industrial art from
> the settlement of the particular community to the close
> of the nineteenth century.[60]

Sheets was undoubtedly aware of the effort in the direction
of design compilation. Parker was on a field trip to the
south when he wrote to Ruth Reeves, Superintendent of the
Index, "Work in North Carolina and Tenneessee, Oklahoma,

will have to be carried on through the demonstration art gal-
leries."[61] Reeves responded a few days later, "Also the
gallery idea for creating local interest in their local Ameri-
cana, is fine."[62]

Another project undertaken by the gallery was a series
of murals. Most of these were executed by Augur who was
director of the art school until she was transferred to the
WPA Parks Project; in her new capacity she continued to
create massive murals, completing 16 walls for the Oklahoma
City Zoo.[63] Her final project of ten WPA murals for Will
Rogers Field may also have been a Parks project.[64] On at
least one occasion the gallery sponsored a mural competition
in conjunction with the Parks Department as a demonstration
example for children's mural painting classes at the gallery.[65]

Evidence has also been uncovered to prove that the
Oklahoma City Gallery produced some easel works for alloca-
tions. Stephens reported in 1941, "The Oklahoma WPA Art
Program is, for the first time, producing prints and paintings
for allocations."[66] Several tempera paintings and silk screen
prints have been located and documented in Oklahoma.[67] The
allocation cards, news articles, and other evidence indicate
that most of the "easel artists" were Indians, but that at
least one was non-Indian.[68] No evidence has been found to
date which proves that any of these works were allocated
out of state.

By far the most ambitious production task was posters
and general silk screen production. As early as the Septem-
ber 1936 report we read:

> Attendants and instructors were called in the past
> week to help the poster artist get out a rush order
> of 100 posters for the WPA Theatrical Project. These
> were all made by hand. Posters have also been sent
> to various cities over the state advertising the Okla-
> homa City project.[69]

By the last half of 1938 the art center was producing silk-
screened products. The following year six editions of up to
three colors had been pulled. One of these was a catalogue
of exhibits for June and July 1939, which featured five three-
color inserts. This catalogue of exceptional quality highlighted
the shows in the five galleries. The most unusual was "Beauty

in the Five and Ten" focusing on items of aesthetic merit
which could be purchased for less than $.25. The idea, pro-
claims the catalogue, "is to disabuse the popular belief that
things of beauty are always expensive."[70]

In 1942 and 1943, when at least some of the numbers of
editions were indicated in the scrapbooks, well over 25,000
prints were pulled. Not all of them were posters to support
the war effort, although a great number of them were. Many
of the editions were produced in three-, four-, and five-
color runs. A number of examples are in the scrapbooks,
and the quality of design and registration and color combina-
tions are impressive.

Promotion and Publicity

The inauguration and development of an art center
called for an immense amount of publicity, both personal and
public, and demanded from the directing personnel a dedica-
tion to a cause as yet unfamiliar to the public at large. It

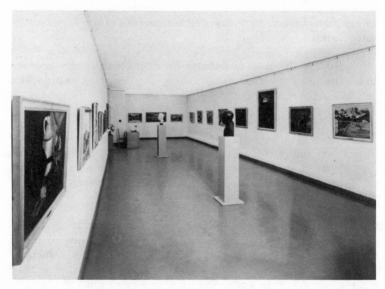

One of the later spacious galleries.

is doubtful whether even Nan Sheets could have aroused sup-
port for the early Experimental Gallery without the backing
of the Chamber of Commerce, who not only supplied the
space, but most importantly signaled their approval of a
community venture in the arts. There was an 'additional
element--a sincere local interest in good art. The idea of
a municipal art museum in Oklahoma City became a vague
dream in the mind of Mrs. John W. Shartel as she visited
the splendid museums in France. Upon her return to Okla-
homa her dream became a conviction. She called together a
group of women and proposed the organization of an Okla-
homa Art League. Its objectives were to foster talent and
art appreciation, and to establish an art museum. This
event laid the promotional groundwork for art activity in
the city. Noteworthy exhibits were slated from time to time,
and paintings were purchased to build a collection for a fu-
ture institution. The Art Renaissance Club joined in the
effort by purchasing works for the same purpose. These
two groups were that added element which helped to promote
the Federal Art Center and they were an important arm of
the Oklahoma Art Association--cosponsors of the Center.[71]

 Sheets was very successful in gaining support from
local newspapers and other publicity sources. Numerous
articles announce the opening, programs, and classes of the
Center. The gallery was required to keep two sets of pub-
licity clippings in uniform binders, one for the National Di-
rector and one for local records.[72] The amount of publicity
generated by the Oklahoma City Center can be measured by
the number of three-ring binders, filled to capacity, accumu-
lated between December 1935 and 1942 when the funds were
withdrawn. A total of 15 books and two similar books of
publicity photos (not including the news photographs) rep-
resent these years.

 Exemplary of the amount of publicity was the effort to
make an event of the opening of the Center when it was
moved in January of 1938 to the Municipal Auditorium. Be-
ginning in December, 23 articles from six different sources
represented in just one of the 1938 books is nearly 30, and
includes some national publications. About half of the pub-
licity items include photographs. Although the national di-
rection attempted to shy away from associating art with
"society," Sheets took advantage of such opportunities to
bring the two together. (When the time came to call upon

support from the community her efforts in this arena were
rewarded by strong backing from local clubs and social
groups.) Society pages often featured local events shot
against the background of the Gallery. A typical example
was a full-page fashion feature set among an exhibition of
"79 Old Masters."[73] Most of the publicity, however, centered
upon the activities of the art school and regular exhibits.
To stir local interest in the classes, typical photo story lay-
outs show teacher and students engaged in studio work and
identify the artists and students by name.[74]

In addition to the regular publicity Sheets was respon-
sible for casual mentions in several regular columns, repro-
ductions of gallery staff's work in the papers, and her own
art column in the Daily Oklahoman. Sheets' feature articles
on current exhibits explained what to look for, and, in effect,
offered a compact, short course in art fundamentals. She and
her publicity staff managed to maintain close ties with the
Art and Society Editors of the city's leading papers. Occa-
sionally, the publicity tactic was to focus attention on an
issue of interest. A two-column editorial in the Daily Okla-
homan caught the eye of its reader with the question, "Are
you a wrathful critic of the Works Progress Administration,
all it does and all it stands for?" This and similar questions
were bombarded upon the reader until Editor Edith Johnson
felt she could make her point:

> Granting that the WPA must answer to the taxpayer
> for a good many follies and sins ... [it] does repre-
> sent something besides air-beating and wave-lashing
> as anybody with an open mind will discover upon
> visiting an exhibition of skills of the unemployed held
> last week and this in the Municipal Auditorium.[75]

Another eye-catcher was an article on visiting artist
Eliot O'Hara photographed beside a famed lithograph on ex-
hibit. Lead-in lines "Tastes of Traveling Companions Vary"
and "Library? Pooh! Gallery? Boo" actually forced the reader
to pursue the article and discover that the Second Annual
Lithography Exhibition would officially open and remain on
exhibit during the month. The two traveling companions
were Congressional Librarian Herbert Putnam (who took a
nap rather than see the exhibit) and nationally-known water-
colorist Eliot O'Hara, Putnam's son-in-law. One was allergic
to art, the other to libraries. O'Hara commented, in response

to the show of 400 lithographs, "This is one of the best exhibits I've seen in my travel across the country."[76]

A series of radio programs was initiated specifically to be of interest to all Oklahomans. The first program was an interview with art center art teachers; another featured an interview with an associate professor of the University of Oklahoma School of Architecture. In a letter to Stephens, Sheets judged the broadcasts to be "another step in our program to bring art to the people of Oklahoma."[77]

Serving as guides and mementos of exhibits at the Center, brochures and catalogues did about as much as anything else to validate the existence of the art center. These and the News Flashes were distributed to the public. In order to recruit a continually growing audience, Sheets obtained lists of new residents of Oklahoma City from the Chamber of Commerce and mailed invitations to exhibits with special notations that tours would be arranged for them upon request.[78] The invitations were produced by the silk screen artists and certainly must have served as very attractive incentive to visit the gallery.

Personnel

The maximum level of employment for the Oklahoma WPA Art Project was recorded at 65 employees--17 professional and technical workers, 24 skilled, 21 intermediate, and 3 supervisory.[79] A listing of wage classifications in Supplement No. 1 to Bulletin 29 described professionals as those who were able to do high-grade work of a creative and/or interpretive nature, skilled as those who were able to do work of a recognizable merit but of a quality not equivalent to the professional, and intermediate as those who have a limited degree of skill or those who are apprentices.[80] Even though lists of personnel from time to time can be reconstructed, it seems impossible to account for all the numbers at this peak of employment. Certainly we may include some of the directors of the Extension Galleries, as suggested by the letter of resignation from the Clinton Gallery Director. In addition to the supervisory (likely Sheets, De Vinna, and Heck on limited per diem), we can enumerate a number of teachers who had subsequently entered professional art careers in one arena or another.[81] Teachers qualified in a number of techniques were

hired to instruct in a variety of media. An employee with
commercial expertise was hired in late 1938, and at that time
the silk screen process was increased dramatically. The
Gallery also had a staff which could perform clerical, secre-
tarial, and public relations duties. One bulletin lists two
elevators, who would also be serving other programs con-
ducted in the Municipal Auditorium, such as the Theatre and
Music Projects.

Without doubt the quintessential employee was Sheets
herself. Jacobson wrote about the survival of the Center
after Federal support was withdrawn:

> It is due entirely to the magnetic personality, ability
> and energy of Nan Sheets that the center survived.
> For a while she was conducting it on a shoestring,
> serving as director, publicity man, secretary, expert
> packer, janitor, and handyman. (But Nan Sheets
> is a personage approaching an institution. If she
> and Eleanor Roosevelt were to alight from the same
> train in a strange town, the reception band would
> follow Mrs. Sheets.)[82]

Sheets' courage and determination apparently also saw
the Center through an earlier crisis. Heck reported in a
letter to Cahill that he had been forced to close down the
Center as of July 1, 1936, due to lack of funds, and that
the staff had refused to close, "paid or not."[83] Sheets main-
tained a strong control over the Gallery throughout its fed-
eral years, its struggles through redirection to a war effort
in the early forties, and its evolution to a major institution
in Oklahoma. She was the constant force who managed to
mediate between the idealism of the National/Regional Directors
and the still undeveloped tastes and informalized symbol of
artistic culture. Her administrative acumen can be appreci-
ated in her admonitions to the Oklahoma Art Center at a
Luncheon held in her honor in 1975. "Any money left to the
Center and not earmarked should be left in endowments and
not used for everyday expenses. Use the interest for that."
She followed her own advice by donating $50,000 the next
year earmarked for the endowment fund.[84]

Funding and Sponsorship

The Federal Government provided money for salaries

for the operating staff and for technical supervision, while businessmen of Oklahoma City contributed the funds with which to pay rent and utilities of the art center. First sponsors of the Center were the Chamber of Commerce and the Art League. Later, the Federal Art Gallery was sponsored by the University of Oklahoma and co-sponsored by the Oklahoma Art Center Association whose members represented 19 local clubs.[85] Anticipating the inevitable withdrawal of federal funds, Parker advised Sheets to garner local support through a membership drive and dues, as early as 1937.[86] It was this association that sold memberships to individuals, clubs, and other groups to raise money with which to carry on the work of the art center and make it the permanent institution that it is today.

Monthly salaries paid by the government to the two Center directors (Sheets in Oklahoma City and De Vinna in Tulsa) amounted to $150 in the beginning, and by 1942 had been raised to $185 and a per diem of $5 for hotel and meals while traveling. The state director of the FAP, Homer Heck, was paid $15 per day, but was limited to a maximum of six days per month. The three state professionals were classified as non-relief personnel. Certified workers received a monthly sum of about $60. The government paid postal fees on WPA exhibits for the Oklahoma Art Center and arranged for out-of-state technical personnel to visit the Center on a special assignment. Over a seven-year period, the government also purchased $1,000 in equipment for the Center.[87]

When federal aid was finally withdrawn, plans were proposed to maintain the art center on the smallest budget possible--approximately $1,400 to operate the Center for five months was proposed under the condition that the city assume the responsibility of keeping the elevator in operation under the auditorium budget. A small budget of $5,000 was proposed to cover the following ten-month period. As for the equipment, the government had turned over the Center such general items as desks, tables, cabinets, office chairs, folding chairs, stereopticon machine, movie projector, screen, tools for workshop and classrooms, and quantity of office supplies.[88]

Relations with Other Agencies

There is very little pre-war evidence of the Oklahoma

Art Center's coordination of activities with the other federal
cultural projects--Music, Theatre, Writers, Historical Records
Survey--or a need for that relationship to operation. There
appears to have been no federal mandate to regulate an inter-
dependency between these programs. Of the recommendations
made at the Conference of Community Art Centers in Chicago,
August 1938, attended by Cahill, Parker, Defenbacher, and
seven state directors, one suggested that the art center di-
rectors invite music and theatre groups, literary societies,
dance groups, garden clubs, hobby groups, men's and
women's clubs, school groups, and others to participate in
the community art center program. But the fullest conscious-
ness must be retained that the primary concern of the FAP is
a visual arts program.[89] Today this kind of program would
sound more like the activities of civic centers or community
centers, which are more broadly based operations than visual
arts programs. Since no reference to the concept of sponsor-
ship appeared in the August 1938 recommendation and no ex-
planation of what was meant by the phrase "to participate in
the community art center program," it is possible that partici-
pation could have been as simple as a dance presentation in
the art center or a group-sponsored visit to an exhibit.

In Oklahoma connections were made with local libraries
to compile an index of art books and periodicals available in
the entire community. Art center research workers had to
use the resources of the State Historical Museum to repro-
duce Indian designs for the Index of Indian Design Project.
The relationship between the art center and area schools was
understandably close--school children visited the art galleries,
art exhibits toured the schools, and occasionally an exhibit
of students' work was held at the Center. For example, an
exhibit of forty murals by sixth-grade students of Oklahoma
City Public Schools was featured in the galleries in October
of 1940. A similar relationship existed between the Center
and colleges and universities in the state. The tie between
the project and educational institutions is especially obvious
in the final distribution of government allocated easel works
which were handled by the art center in the early months of
1943. Hundreds of framed and unframed works were allocated
to the public institutions, a few to the University of Oklahoma,
to Oklahoma City University, and to the art center; but the
lion's share was allocated to the several schools in the Okla-
homa City district.[90] There also seems to have been a close
relationship between the art project and the parks department.

On several occasions there were cooperative projects. For example, a competition sponsored by the project for a mural to be used as a teaching model for a parks project for children, a model of the Statue of Liberty made by the art center teachers for a local park, the loan of a visiting instructor who demonstrated finger painting techniques for parks personnel in a special class for "the park recreation department and the works progress administration" to be passed on to the children in their programs.[91]

The Federal Art Center, the Writers' Project, and the Music Project were all housed in the Municipal Auditorium in the late thirties. Although they were aware of one another's projects, there seemed to be neither time nor inclination to join forces at any level. After the Writer's Project was dropped and most of their papers deposited with the State Historical Museum, some unedited material was found on the Oklahoma Art Center (1,600 words) and on The Arts--probably intended for Oklahoma's State Guide, the last guide to be published in 1941. On at least one occasion when the Writers' Project encroached upon the art field a federal demand was made for the writers to obtain a professional artistic opinion; it was not to the art center that the State Director turned for advice, but to a professor at the University of Oklahoma.[92] Artists were also recruited to illustrate the State Calendars of cultural activities.[93] No evidence has been found that the Art Project assisted the Music Project before the war effort which turned attention to postermaking. In response to Parker's memorandum concerning cooperation between the Federal Art Project and the Federal Writers' Project, FAP State Director Homer Heck informed him that the Art Project made drawings for the Oklahoma Guide Book, and designs and covers for some of the Writers' Project pamphlets, but not to any great extent.[94]

Problem Areas

By far the most annoying problem for the Oklahoma Art Project was the Eighteen-Month Rule. It meant that all project employees who continuously worked for the WPA for eighteen months were to be removed from their positions and not be eligible for re-employment until 30 days had expired. This worked an undue hardship on the arts program. As it was, the search for qualified personnel to fill positions in the

program was a problem. The Eighteen-Month Rule made it a
double problem. When some of the trained personnel were
forced to vacate their positions, Heck reported that it was
oftentimes weeks before he could find anyone suitable to fill
the positions, and in a few cases replacements were complete-
ly impossible. Another problem was the wide disparity of wage
scale between Oklahoma and Tulsa counties and other areas
with less population and lower wage scale. As a result, it
was impractical to distribute personnel from these areas of
surplus labor. A problem also arose when greater demands
were made by other branches of the WPA upon the Center's
silk screen and poster-designing services. According to
Heck, it was rather embarrassing to have rush orders descend
upon them and not be able to fill them. He recommended a
"clearing house" to be set up outside the project for hand-
ling such requests. An unresolved problem was the matter
of securing proper credit for the WPA in newspaper publicity.
Only 50 percent carried WPA credit during the first four
years of the art project. Later, proper credits appeared to
be more generous, but the problem remained to the end par-
ticularly in metropolitan areas. [95]

These were the major problems which Heck officially
reported, but there were also other problems for Nan Sheets
of which he was also aware. Sheets had received from Robert
Andrews the following unsolicited advice about material in the
art center's brochure: "I think it would be desirable not to
play up the use of nudes on covers of any publications," in
reference to a simple line drawing of a nude. [96] "There is
one word I should like to call to your attention," he continued
in the same letter, "and that is the word 'patronage.'"
Andrews felt that a better term for "patronage" by the Fed-
eral Government was "assistance" by the Federal Government,
because American communities as a whole needed financial aid
rather than artists alone. [97]

One of the thorniest problems for Nan Sheets was New
York exhibition designer Miron Sokole who was assigned to
the Oklahoma Art Center to assist in the designing of an out-
standing and unusual exhibition. The theme selected for the
exhibition was the housing problem, but the timing of that
theme in Sheets' view was such that it would arouse unfavor-
able comment in the light of the fiery debate going on in
Oklahoma City concerning the proposed $7,000,000 federal
slum-clearing and housing project. Thomas Parker agreed,

Art Center brochure with "offensive" nude.

"I certainly would not like to see the permanency of the Ok-
lahoma Art Center jeopardized by putting on an exhibition
which, no matter how worthy or how well presented, might
cause unfavorable criticism which would weaken your sponsor-
ship."[98] Upon his arrival, Sokole made few friends when he
outlined a $1,000 plan to modernize portions of the art center,
a request Sheets thought was unrealistic. He seemed to be
very upset by the fact "that all of our shows are not be ex-
ponents of the ultramodern school and apparently can see no
value in works of well-known and competent painters with
other points of view."[99] In his Housing Exhibition Sokole
proposed to recreate a squatter's shack with all its squalor
and to show enlarged photographs of the life of the people in
this "cancer spot," as Sheets put it, and then by photographs
to show how this same problem was handled by the govern-
ment with housing, playgrounds and the like.[100] The ex-
hibition was held, and by February of 1939 Sheets sent photo-
graphs of the show to Defenbacher. She also admitted the
show looked very attractive and agreed that Sokole would be
a good designer if he "wasn't so impossible to work with."[101]
Also assigned on a loan basis to the art center was Virginia
Richman who taught children and adult painting and who, un-
like Sokole, received the approval of Sheets.

 As mentioned earlier, Regional Advisor Defenbacher had
reprimanded Sheets for using the term "museum" in one of
the art center brochures instead of the more ordinary phrase
"community art center." He further requested that she sub-
mit to him a complete outline of the program for the Oklahoma
City Center for the coming year, a request she considered an
impossible one and told him so. She made one concession.
"For your information," she wrote, "I will say that I had
planned on carrying out your suggestions of last summer that
I arrange at least three shows--other than painting and
sculpture--for 1939." Her response to the confusion about
the word "museum" ended the letter:

 While we are from the art centers of the East, and
 probably horribly ignorant, I really do know that the
 traditional art museum is not and could not be the
 objective of any alive group or individual interested
 in a constructive art program. Don't misunderstand
 me and think I am trying to defend the manner in
 which I have carried on the art program here. It
 needs no defense.[102]

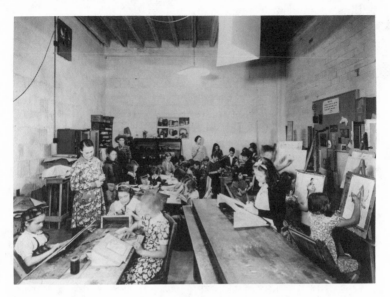

Children's class.

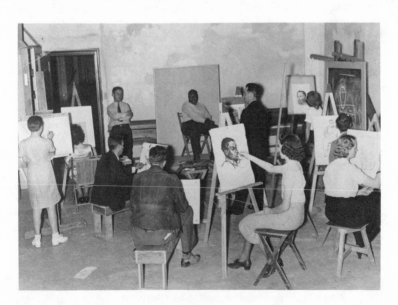

Portrait class.

Later Sheets was indeed obliged to submit a general outline of plans for the coming year.

The Redirection

In 1942 the Federal Art Project was renamed the Graphic Section of the War Services Program and given a redirection of goals, namely to continue certain activities which could contribute directly to the war effort. Before and after redirection, the educational and artistic standing of the Oklahoma Art Center was kept intact--largely due to the University of Oklahoma sponsorship.

On July 19, the Art Program became Phase I of the new War Services Program. This meant that some art centers not located in certified defense areas were not eligible to remain in operation. As a result only three centers were active --The Oklahoma Art Center in Oklahoma City, the Edmond Art Gallery, and the Claremore Art Gallery. It was a severe blow to the ineligible art-loving communities where galleries had been well sponsored and appreciated. New exhibition points were established in Miami, Enid, Hugo, Chickasha, Weatherford, and Camp Gruber near Muskogee. Local sponsors were required to furnish exhibit space and utilities and to pay transportation costs for WPA exhibits. Each unit was manned by a capable volunteer attendant or a certified WPA attendant.

The Oklahoma Art Center managed to fill its five galleries with educational exhibits, many of which were closely geared to the war efforts, and to operate an active workshop for such things as scale model airplanes, including drawings and slides. Scale models of light bombers slated for the Army Air Corps were painted camouflage colors to match the planes on the field, and then used for class instruction. In addition to the smaller models, larger ones with movable controls were built by the WPA artists also for class instruction. The workshop personnel, who were physically handicapped or past the age limit required for either defense work or private employment, turned out hundreds of these special models for identification training at Will Rogers Field and the Air Depot.[103]

The Center's Poster and Silk Screen Division serviced

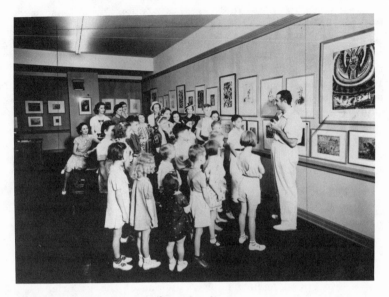

Visiting artist giving informal talk.

military and civilian defense groups as well as other WPA
units with posters, banners, arm bands, insignia, window
signs, maps, backdrops, ribbons, drawings, three-dimensional
designs, bulletin boards, bookmarks, and lettering for photo-
graphic displays. These numbered in the thousands. Agen-
cies who received these services were the Council of Defense,
War Savings Staff--Federal Building, Will Rogers Field, Okla-
homa City Air Depot, Navy Relief Society, Service Men's
Center, Draft Boards, WAAC Recruiting Office, Enid Recruit-
ing Office, U.S. Army Medical Corps, 13th Armored Division,
Mass Transportation Committee, WPA Music Project, U.S.
Health Department, Army, Navy, Red Cross, Boy Scouts,
Park Department, and other WPA projects.[104] Three venereal
disease control posters, designed by the Center were selected
by the Office of the Surgeon General in Washington for na-
tional distribution.[105]

Through the cooperation of the extension division of
the University of Oklahoma, free educational films and war
movies were shown three times each Tuesday at the art center,

at least during 1942. By 1943 when the art center was less
war-oriented, films were still scheduled for entertainment and
general morale. While the Center was open for defense meet-
ings, for the Red Cross and Blue Cross (with one gallery
used to enroll civilians in defense activities), it still offered
art classes. Students in the crafts and life classes were
mostly wives of military men. Also the Center continued to
feature exhibits that would appear to visiting servicemen
and war production workers and help build up their morale.106
One young private who visited an exhibit at the art center
was convinced that art was good for the morale and wrote a
short letter to the Editor of the Oklahoma City Times.

> EDITOR OF THE TIMES:
>
> I paid a visit to the Oklahoma Art Center in the
> Municipal Auditorium the other day and enjoyed the
> exhibit very much.
>
> It has good variety of pictures and I noticed a
> number of servicemen there. Art is definitely good
> for maintaining the morale and is a worthwhile way
> to spend leisure hours. In one of the galleries, I

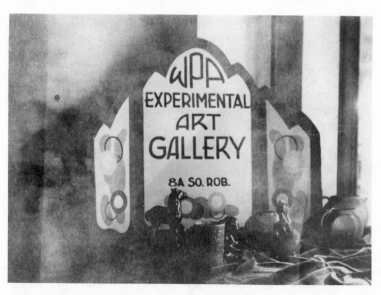

Art Gallery sign with "WPA" clearly shown.

read words to the effect that art is a benefit to the
soul and mind of man.

Something like this: A doctor makes a sick man
well; art can make a well man better.[107]

In a concerted effort to put art in wartime on a higher
plane of respect, Bart Ward, Assistant Director of the Center,
composed a two-page report on the subject and ended with a
brief outline of what artists could do in wartime:

1. Sign up at the local office of Civilian Defense for
 work or for professional work.

2. Register with the State and U.S. Employment Serv-
 ice, the latter for possible retraining.

3. Check with the Section of Camouflage, Operations
 and Training Branch, Office of the Chief Engineer,
 War Department, Washington, D.C.

4. Enter competitions, such as those of Section of
 Fine Arts.

5. Communicate with the Director of the United Service
 Organizations.[108]

As a former art school manager of the Center, Ward
was propelled, like Nan Sheets, by the promise of art educa-
tion and education in general. They both were dedicated to
its literal meaning of being led out of ignorance to a higher
level that would benefit the whole of mankind and uplift man's
spirits. "We still need paintings," Ward once said, "beautiful,
good paintings. The artists of America must paint as they
have never painted before. Artists have in their power a
means for keeping the spirits of men alive."[109]

Today's Oklahoma Art Center[110]

The Oklahoma Art Center is an accredited museum and
the largest in the western two-thirds of Oklahoma. Of the
current facilities which consist of three buildings totaling
67,000 square feet, the primary one is a building designed
as a museum and constructed in 1958 on the State Fairgrounds;

its circular layout encloses a 100-foot diameter sculpture courtyard. This 25,000 square foot edifice houses two major galleries, three support galleries, museum shops, a multipurpose lecture hall seating 130, the vault storage, preparation area, and administrative offices.

In 1976 the downtown extension gallery, Artsplace, was opened by the art center with funds granted by the National Endowment for the Arts over a two-year period. Entirely self-supporting at the present time, it provides services in the visual and performing arts, schedules exhibits or recognized artists (regional, national, and international), and maintains an active sales gallery. The third building called the ArtsAnnex was formerly a science and technology museum and was acquired in 1978 as the art center's educational facility with 40,000 square feet of studio and exhibition space and a 320 fixed-seat auditorium.

For fifty years the art center has amassed a collection of more than 4,000 art objects worth over five million dollars. The collection is strong in twentieth century American Art but also has representative works from the eighteenth and nineteenth centuries--Benjamin West, Charles Wilson Peale and Thomas Moran. In 1968 the Center acquired the entire collection from the Washington, D.C. Gallery of Modern Art with post-World War II works, ranging from paintings of Grace Hartigan, Robert Goodnough, Morris Louis and Richard Diebenkorn to sculpture by such masters as Seymore Lipton and Ruben Nakian. Its graphic collection includes 700 works of such artists as Bellows, Sloan, Hopper, Feininger, and more recent prints of Garo Antreasian, Louise Nevelson, Jim Dine, and Richard Anuszkiewicz. Newer acquisitions have been focused on works of established American artists of this century (Calder, Levine, Hofman, etc.) and younger living American artists (James Harvard, Janet Fish, Jon Carsman, and others).

Embarking on a more ambitious exhibition schedule, the art center has shown major exhibits organized by distinguished scholars in the field. Examples were "Living Masters of Latin America (1980)," "Manscape: 77," "Contemporary Glass in America (1979)." Other exhibitions of national import were "Master Paintings from the Phillips Collection" and "Thyssen-Bornemisza Collection of 19th Century American Landscapes."

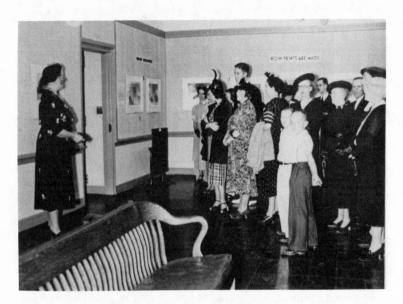

Nan Sheets, "How Paints Are Made."

Ordinarily, two exhibits are shown concurrently in galleries that have 9,000 square feet of flexible spaces, movable walls and excellent lighting. Museum visitors have at their disposal multimedia orientations, self-guided tour cassettes, docent guides, as well as catalogues and gallery guides. Due to present space limitations at the three exhibition areas (art center and branches), only about 8 percent of the permanent collections is available for viewing on a routine basis, but works are rotated whenever possible while special exhibits such as "American Abstractions" from the collections are circulated in eight states and other works are lent to national museums. Portions of the State Art Collections which have been housed and curated by the Center are toured throughout the state and museums in this eight-state region.

The senior staff of the Center is a composite of highly trained, key individuals with from four to twenty years of museum-related experience: Director, Development Officer, Associate Director for Administration, Associate Director for Education and Museum Programs, and assistants. In all,

there are 29 full-time paid museum staff, 24 part-time paid,
and 250 part-time unpaid museum staff (Docents and the Ok-
lahoma Art Center Association). The estimated annual attend-
ance for 1982 was 131,850 museum visitors, who evidently
found that the art center could serve them in a more unique
way than other museums in the city. Within the greater
Oklahoma City district are a museum of science and technology,
the Cowboy Hall of Fame, the State Historical Museum, Enter-
prise Square of Economics, Oklahoma Museum of Art, and the
Firefighters Museum.

Funds to support the art center's annual operation
comes from the Allied Arts Foundation (whose yearly campaign
benefits six Oklahoma City agencies), from the Oklahoma Art
Center Association, from sponsoring businesses of the corpo-
rate community, and from the Beaux Arts Société and the
Friends of the art center. Both latter groups are prominent
in raising funds for acquisitions. Some income is derived,
increasingly in recent years, from the Museum Stores, admis-
sions, and contributions through the major exhibitions. More
and more, emphasis is put on procuring grants and monies
from foundations and corporations to keep the financial struc-
ture stable.

A major but tentative long-range plan visualizes a new
110,000 square foot museum facility to be located in downtown
Oklahoma City, part of an extensive urban renewal program
(Myriad Gardens) designed as a focal point for cultural events.
The building, by architect I. M. Pei, requires an expenditure
of $18,000,000 and another $3,000,000 to the endowment.
Artsplace, the downtown extension gallery would be incorpo-
rated into the new museum. ArtsAnnex will undergo some
slight revision in the method of operating its studios, class-
rooms, and auditorium due to budgetary considerations.

With the demands of more sophisticated audiences and
higher public expectations, the Oklahoma Art Center is obliged
to escalate the quality of its changing exhibition program, to
increase exhibitions from their permanent collections, to or-
ganize more exhibitions for national circulation, and to improve
the care and storage capabilities for the permanent collections.
Whatever the future holds in store for the Oklahoma Art Cen-
ter, Oklahomans can be proud of this institution's half-century
venture in the arts.

Notes

1. Letter, Nan Sheets to Thomas C. Parker, January 1, 1936, Records of the WPA Federal Art Project, Record Group 69, National Archives, Washington, D.C. (Papers from this collection will henceforth be cited by R.G. 69.)

2. Holger Cahill, New Horizons in American Art (New York: The Museum of Modern Art, 1936), p. 21.

3. Time, September 5, 1938, p. 35.

4. Final Report on the WPA Program 1935-43 (Washington, D.C.: U. S. Government Printing Office), p. 60.

5. "They Guard Our WPA Art Projects," Oklahoma City Times, January 16, 1936.

6. Nan Sheets' personal scrapbooks, 4 vols., Collection of Marjorie Durbin, Oklahoma City, Oklahoma.

7. Kathleen Grisham Rogers, "Incidence of the New Deal in Oklahoma," (unpublished Masters' Thesis, University of Oklahoma, Norman, Oklahoma, 1974), p. 42.

8. Homer Heck, "Oklahoma Art Project Report," Western History Collections, Wardell Files, WPA, University of Oklahoma, Norman, Oklahoma, n.d. (Papers from this collection will henceforth be cited as Wardell, WPA.)

9. Letter, Homer Heck to Thomas C. Parker, December 24, 1935, R.G. 69.

10. Letters, Parker to Heck, December 9, 1935; Parker to Sheets December 15, 1935; W. S. Key to Jacob Baker, December 21, 1935; Parker to Heck, November 20, 1935; concerning Jacobson's working out a plan; Sheets to Parker, January 1, 1936, "I have been lining up things for weeks ... ," R.G. 69.

11. Letter, Sheets to Parker, January 1, 1936, R.G. 69.

12. Federal Sponsored Community Art Centers, Art Circular No. 1, WPA Technical Series, Federal Works Agency, Works Progress Administration, Division of Community Service Programs, Washington, D.C., October 8, 1937, pp. 2-5.

13. R. C. Morrison, "Town Art Centers," Holland's, The Magazine of the South, February 1940, p. 13.

14. Numerous contemporary newspaper editorials and letters to the editor in local papers, and articles in the Chamber of Commerce (Oklahoma City) publication reflect a strong interest in a museum. Frequently, proposals suggest a combination of library and permanent art collections.

15. Letter, Daniel S. Defenbacher to Sheets, February 18, 1939.

16. *Chamber of Commerce Magazine* (Oklahoma City), March 19, 1936.

17. Ibid.

18. Letter, Leo Spofford to Florence Kerr, April 4, 1939, R.G. 69.

19. Sheets, "Oklahoma City Gallery Report," September 1936, R.G. 69.

20. Homer Heck, "Report of Accomplishments and Problems, Oklahoma Art Project," April 25, 1940, Wardell, WPA.

21. Oliver Gough Meeks, "The Federal Art Program in Oklahoma," (unpublished Masters' Thesis, University of Oklahoma, Norman, Oklahoma, 1941), p. 146.

22. Ibid.

23. Oklahoma Art Center brochure, n.d.

24. The opening exhibit as scheduled from July 17 to August 8, 1937, featured the following:

> Gallery I--23 oils (FAP)
> Gallery II--13 watercolors (FAP)
> Gallery III--44 color block prints of Tulsa artists, 11 aquatints and 10 pencil drawings of Stillwater artists
> Gallery Pedestals--6 pieces of ceramic sculpture
> Window Display--4 paintings of Oscar B. Jacobson, University of Oklahoma
> Office--1 Jacobson painting
> Display Case--medals and art objects

Daily Oklahoman, March 29, 1936; Meeks, p. 151.

25. Meeks, pp. 146-168; also *Oklahoma Art Center Brochure*, Nan Sheets Collections, Oklahoma Art Center, Oklahoma City, Oklahoma, n.d.

26. Meeks, pp. 149-152.

27. Heck, "Report," 1940.

28. Rogers, p. 45.

29. Letters, Ron Stephens to Florence Kerr, May 5, 1941; Mildred Holzhauer to Dian Berg, May 30, 1936, R.G. 69.

30. *Daily Oklahoman*, January 5, 1936 and March 29, 1936.

31. Holger Cahill, "Essay on Art Education," n.d., Dorothy Miller Papers, R.G. 69.

32. William F. McDonald, *Federal Relief Administration and the Arts* (Columbus: Ohio State University Press, 1969), p. 395.

33. Oklahoma City Advertiser, January 1940.

34. Cahill, "Essay on Art Education."

35. "Policy of School," Oklahoma Art Center brochure.

36. Oklahoma City Advertiser, January 12, 1940.

37. Nan Sheets Collections, Oklahoma Art Center.

38. Sheets, "News Flashes," January-February 1942, Sheets Collections, Oklahoma Art Center.

39. John O'Neil's Masters' Thesis "An Artist Explains" was not a relief project. The traveling exhibit was based on this thesis and compiled by a member of the Art Gallery staff.

40. The Art Center elevator operator served as the model for a body cast for the project.

41. Heck, "Report," 1940.

42. Letter, Heck to Parker, October 13, 1937, R.G. 69.

43. Interview with Maurice De Vinna, Director of the Tulsa WPA Gallery, November 12, 1983.

44. Heck, "Monthly Report," April 1940, Wardell, WPA.

45. Heck, "Oklahoma Art Project Report," February 1942, Wardell, WPA.

46. Letter, Heck to Defenbacher, October 13, 1937, R.G. 69.

47. Letter, Parker to Heck, October 18, 1937, R.G. 69.

48. Letter, Heck to Holzhauer, November 1939, R.G. 69.

49. Letter, Heck to Holzhauer, April 1939, R.G. 69.

50. Interview with De Vinna.

51. Letter, Stephens to Kerr, November, 1940, R.G. 69.

52. Letter, Stephens to Kerr, June 28, 1940; Stephens to Kerr, November 1, 1940; Stephens to Kerr, December 7, 1940.

53. Letter, Juanita Camplin to Fellow Workers at Clinton Extension Gallery, December 14, 1939, R.G. 69.

54. Interview with De Vinna.

55. Sheets, "Report of Oklahoma City WPA Art Gallery, September 1-30, 1936," R.G. 69.

56. Sheets, "Report of Oklahoma City WPA Art Gallery," n.d., but follows September 1936 report, R.G. 69.

57. Heck, "The Oklahoma WPA Art Project," April 1 to October 15, 1940, Wardell, WPA.

58. McDonald, p. 451.

59. Cahill, "Federal Art Project Plans for the Future," (office copy), n.d., Dorothy Miller Papers, R.G. 69.

60. Ibid.

61. Letter, Parker to Ruth Reeves, March 3, 1936,
R.G. 69.

62. Letter, Reeves to Parker, March 16, 1936, R.G.
69.

63. "Woman Paints Murals at Zoo," Daily Oklahoman,
February 5, 1939; "Prehistoric Oklahomans Take Their Place
on Lincoln Park Walls," Oklahoma City Times, June 16, 1939.

64. Daily Oklahoman, October 29, 1942.

65. Oklahoma News (with photo), May 6, 1938.

66. Letter, Stephens to Kerr, May 5, 1941, Wardell,
WPA.

67. Barbara Kerr Scott, New Deal Art: The Oklahoma
Experience (Oklahoma Humanities Committee and Cameron
University, 1983), p. 13.

68. Ira Keppler, WPA Gallery Instructor.

69. Sheets, "Report," September 1936.

70. Sheets, "Beauty in the Five and Ten," exhibit
catalogue, Nan Sheets Collections, Oklahoma Art Center.

71. Sheets, "News Release," April 1943, Nan Sheets
Collections, Oklahoma Art Center.

72. Memorandum, Cahill to State Art Directors, August
10, 1936, R.G. 69.

73. "Sunday Feature," Daily Oklahoman, March 1941.

74. "Art Students Labor Over Their Work, Daily
Oklahoman, March 4, 1937; Nan Sheets Collections, Books 1-
15, Oklahoma Art Center.

75. "The Credit Side of the WPA," Daily Oklahoman,
April 5, 1939.

76. "Art's Where It's Found," Daily Oklahoman, Decem-
ber 4, 1940.

77. Letter, Sheets to Stephens, March 13, 1940,
Sheets Collections, Oklahoma Art Center.

78. Heck, "Monthly Narrative Report, Oklahoma Art
Project," August 1940, Wardell, WPA.

79. Sheets, "Narrative Report of Oklahoma WPA Art
Project," April 1-October 15, 1940, Wardell, WPA.

80. McDonald, p. 194.

81. Derald Swineford, Bart Ward, and Oliver Meeks.

82. Oscar B. Jacobson, "Art and Artists in Oklahoma,"
(unpublished manuscript, n.d.), Western History Collections,
Manuscripts Division, University of Oklahoma, Norman, Okla-
homa.

83. Letter, Heck to Cahill, July 1, 1936, R.G. 69.

84. Sheets, "Brochure," n.d., Sheets Collections, Oklahoma Art Center.

85. Oklahoma City Council of Arts, "minutes," January 27, 1941: The Oklahoma Art League, The Oklahoma City Junior League, The Art Renaissance, the MacDowell Club of Allied Arts, the Philomathea Club, Sponsors Group of the Oklahoma Art Center, Motherhood Culture Club, Keramic Art Club, Cosmopolitan Study Club, Oklahoma Camera Club, National Research Club, Shakespeare Club, 89ers, Kappa Pi Honorary Art Fraternity, Arts and Decorations Club, Association of Oklahoma Artists, Delphian Study Club, Parliamentary Study Club, and Sorosis Club.

86. Letter, Cahill to Sheets, January 26, 1938, R.G. 69. Also "Board is Elected for Oklahoma Art Center," news article, no source, n.d., Sheets Collections, Oklahoma Art Center.

87. Interview with De Vinna.

88. "Too Bad To Lose Such An Asset," Oklahoma City Times, January 13, 1943.

89. "Report on Conference on Community Art Centers," August 27, 1938, R.G. 69.

90. Requests and Receipts for Allocations to Oklahoma, administered by the Oklahoma Art Center, January-April 1941: University of Oklahoma (15), Oklahoma City University (98), State Capitol (6), Oklahoma Art Center (25), Oklahoma City Public Schools (371).

91. "Finger-painting, Fascinating New Art, Introduced Here," Oklahoma Daily, June 11, 1937.

92. Letter, Henry G. Alsberg, Federal Director, Writers' project, to William Cunningham, State Director, Writers' Project, February 19, 1938, Ron Stephens Files, Indian Archives, Oklahoma Historical Society, Oklahoma City, Oklahoma.

93. Sample calendar, Vertical File, Nash Library, University of Science and Arts of Oklahoma, Chickasha, Oklahoma.

94. Letter, Heck to Parker, February 9, 1939, R.G. 69.

95. Heck, "Report of Accomplishments," April 25, 1940.

96. See photograph on page 63.

97. Letter, Robert Armstrong Adams, Assistant to the Director of the FAP, to Sheets, June 29, 1938, R.G. 69.

98. Letter, Parker to Sheets, November 17, 1938, R.G. 69.

99. Letter, Heck to Parker, October 29, 1938, R.G. 69.

100. Letter, Sheets to Parker, October 29, 1938, R.G. 69.

101. Letter, Sheets to Defenbacher, February 16, 1939, R.G. 69.

102. Ibid.

103. Sheets, "Report," October 8, 1942, R.G. 69.

104. Bart Ward, "Report, Oklahoma Art Center, WPA Art Project," n.d., personal papers.

105 "State Art Unit's Poster Chosen for U.S. Drive," Oklahoma City Times, August 14, 1942.

106. Release from Carl Held, State Information Supervisor, WPA, Oklahoma City Times, March 2, 1942.

107. Pvt. H. B. W., "Art Recommended for Low Morale," Letter to the Editor, Oklahoma City Times, April 20, 1943.

108. Ward, "Report."

109. Ibid.

110. The following information was provided by the Oklahoma Art Center from a recent grant proposal.

DESIGN FOR DEMOCRACY: THE PEOPLE'S ART CENTER IN ST. LOUIS

Martin G. Towey

St. Louis first began to appear in the picture of federal art programs when Louis LaBeaume, President of the Board of Control of the St. Louis City Art Museum, joined other museum officials in recommending procedures for implementing the Public Works of Art Project in 1933. St. Louis became headquarters for Region Seven, which included Missouri, Kansas, Nebraska, and Iowa, when the PWAP was decentralized.[1]

By early January 1934 one hundred and fifty artists were employed in Region Seven, with eighteen active in the St. Louis area. According to LaBeaume,

> History is being made. Each artist is free to do whatever he wishes, in whatever medium he prefers. Some are doing drawings of historic buildings, some are painting scenes in the public parks, some are attempting to interpret social problems, such as the conflict of labor and industry, and some are depicting scenes from modern industry.[2]

LaBeaume was a pillar of St Louis society, his family tracing itself to the earliest French settlers of the 1760s. He was a graduate of Washington University School of Architecture in St. Louis and directed a most successful architectural firm bearing his name. During the six months that the PWAP was operative in St. Louis, LaBeaume directed the project out of his firm's office, located in the Buder Building in downtown St. Louis. His personal secretary recalled the weekly visits of artists to the office bringing their art works and leaving with their checks.[3] The works were later distributed to various public institutions, including public schools, courts, libraries, and federal buildings.[4]

Arville Moore, age 2, working with watercolors for the first
time, June 1942 (courtesy of the Archives and Oral History
Center, St. Louis University).

During its existence in St. Louis, the PWAP employed a total of fifty artists, averaging no more than 35 weekly. They produced 248 works in various mediums and were paid a total of approximately $26,000 for their services. Their productions consisted of 149 oils, 56 watercolors, 28 black and white sketches, 8 murals and 7 miscellaneous works. The murals have had the best survival rate. Of the original eight, six are still in excellent condition and available to the general public. These include a large oil on canvas depicting the founding of St. Louis by Robert L. Rigsby at the Carondelet Branch of the City Library.[5] Additional murals were completed at the Cabanne and Crunden branches of the library. The Cabanne mural has vanished without a trace. Besides the work at the branch libraries, murals were painted at the Michael School for Crippled Children by Gisella Loeffler, the John G. Gundlach School and Gallaudet School for the Deaf by Lillian Thoele, and the Benton and J. Gabriel Woerner Schools by H. J. "Dooley" Dionysius.[6]

In May 1934 the Civil Works Administration expired. It had always been a temporary experiment, but its success led to the creation in June, 1935 of the Works Progress Administration, with Hopkins as director. Unlike the CWA, its supporters recognized that complete recovery might be longer in coming than had been previously expected and therefore its programs were of a more permanent nature. In September 1935 the WPA administration announced the creation of Federal Project Number One. Holger Cahill was appointed director of the Federal Art Project, one of the original four divisions of Federal One, the general name for all the arts projects. Although well known in the art world, Cahill came from a poor rural background in Minnesota. In eight years as director of the Newark Museum and later at the New York Museum of Modern Art, he had established an expert reputation in folk and pre-Columbian Art. Cahill's professional experience, his knowledge of American art and artists, and his understanding of the victims of the Depression made him an excellent choice to direct the Federal Art Project. Cahill had a strong conviction that the arts should be available for the enjoyment of the masses and saw the project as an opportunity to achieve this goal. In addition, he wanted to put the largest number of artists to work. While he was required to work within the restrictions of the federal bureaucracy, Cahill did his best to encourage a free atmosphere for his artists. Those interviewed from the St. Louis project all

William Feaman, volunteer art instructor, demonstrates sketch-
ing techniques, June 1942 (courtesy of the Archives and Oral
History Center, St. Louis University).

recall the total freedom of expression and subject choice they enjoyed while employed.[7]

Initially, Federal One would be directed from Washington rather than through state and local representatives of the WPA. This departure from the normal administrative routine created problems between state and federal authorities. This was particularly true with regards to Missouri. The political situation had traditionally cast the city and county of St. Louis against the remainder of the state, even within the Democratic Party. This was especially true during the 1930s and tended to focus on a struggle for control of federal programs operating within the state. Tom Pendergast, the Kansas City political boss and power broker in western Missouri, was said to be personally opposed to the creation of Federal One in Missouri. He believed that the project would be dominated by St. Louis elements and funding would be concentrated there. In addition, the Federal Art Project was coming under mounting criticism for the number of communists allegedly enrolled. During the PWAP experience, the St. Louis Project had a notorious communist, Joe Jones, painting works of sharp social criticism. Jones, a former house painter and self-taught, had received national attention for his work and had departed St. Louis for points east.[8] However, the rural areas of the state still perceived the artistic community in St. Louis as the center for radical socialistic and communistic activity in the state. As a result, Missouri and St. Louis, in particular, failed to establish a Federal One program for some time.

Many of the artists employed by PWAP found work after May 1934 in various relief projects, some as laborers.[9] Noted artist and friend of Joe Jones, William Gropper, passing through St. Louis in July 1937, blamed the political situation for the "shameful plight of the state." Gropper, a New York caricaturist, stated that St. Louis, "is missing something real and vital in art because the city lacks federally sponsored art projects. There are a lot of fine new buildings in St. Louis, but in all of them there are great stretches of bare walls." He went on to say, "When I was in Washington recently there was a lot of comment about Missouri not being represented in the Index of American Design because the state WPA administration doesn't think much of arts and artists.[10]

In early 1938, feeling that the time was right, a group of interested citizens, including Louis LaBeaume, Charles

Leona Morris, volunteer teacher, instructs John Holmes, age 11, in watercolors, June 1942 (courtesy of the Archives and Oral History Center, St. Louis University).

Nagel (director of the City Art Museum), and others contacted Holger Cahill to urge the creation of a WPA Federal Art Project and the appointment of a director. The political situation within the state made it more advantageous to move at this time. Pendergast was in considerable trouble for financial and political irregularities and the St. Louis Democrats were exercising more power, especially with Washington. A state Federal Arts Project was established and James D. McKenzie was appointed state director with James Baare Turnbull his assistant in charge of the St. Louis area. Turnbull was a local artist from the suburb of Webster Groves and maintained a studio in another suburban community of Maplewood.[11] The St. Louis Art Project was created shortly thereafter, directed by Turnbull and a special Advisory Committee consisting of prominent St. Louisans, from the art and business communities. The Committee included Louis LaBeaume; Charles Nagel; Ernest Stix, prominent business leader; Mrs. Fred G. Carpenter; Vera Flinn, Supervisor of Art of the University City Schools; Mrs. Scott McNutt; Eugene Polk; Carl

Mose; L. J. Case, all well known in the business community;
James B. Musick and Perry Rathbone of the Art Museum
staff; Donald Williams and Donald Finley, also representing
the business community; and Elizabeth Green. Mis Green
was the daughter of a prominent St. Louis eye specialist
and was active in civic affairs. She donated many hours to
the City Art Museum, the Missouri Historical Society and was
a member of the Board of Directors of the People's Art Center
throughout its entire existence.

This Advisory Committee was responsible for securing
sponsorship for various art projects throughout the St. Louis
area and recruiting and screening artists to perform the
task.[12] The first task of the St. Louis Art Project was the
cataloging of objects for inclusion in the Index of American
Design. Working through the St. Louis Art Museum, a num-
ber of artists were employed in this task. To initiate this
project, an exhibit of items already entered on the Index
was held at Stix, Baer and Fuller Company, a leading depart-
ment store in the downtown area. This exhibit of some 400
items included reproductions of furniture, ceramics, glassware,
metal work, textiles, costumes and accessories, work carvings
and toys and puppets.[13]

The oil painting collections of the City Art Museum and
the Missouri Historical Society were repaired and reconditioned
by a troop of artists. This particular part of the project
was less than totally successful. Many of the individuals in-
volved had little or no experience in art restoration, and as
a result more harm than good was done in many instances.
At the Missouri Historical Society, where the staff was largely
volunteer and lacking in expertise themselves, strong cleaning
solvents and harsh erasures were used with considerable dam-
age done to the collection.[14]

Responding to William Gropper's suggestion, a great
deal of energy was expended on the production of murals for
the new and already existing buildings. The city of St. Louis
became a major sponsor of the project, hiring a number of
artists for the production of murals in municipal buildings.
Frank Nuderscher and his assistant, Ben Landesman, directed
a corps of ten artists at city medical facilities, under the
sponsorship of Ralph Thompson, City Hospital Commissioner.
Nuderscher was a recognized Missouri artist, well known for
his paintings of Ozark scenery and industrial scenes in St.
Louis.[15] An elaborate mural was completed by Nuderscher

and Landesman in the children's ward of the City Hospital.
The work, entitled "Flower Children," covered a semicircular
wall with a dancing procession of "wild flower children."[16]

Two other artists painted biblical scenes on the walls
of the hospital chapel. At Koch Hospital, two artists decorated
the entrance and auditorium walls with geometric designs.
Two scenic artists created new stage sets for the auditorium
of the City Hospital murals were created depicting cartoon
characters.[17]

Another corps of artists was put to work at City Hall
under the direction of Charles A. Welsch, building commis-
sioner. The three major entrances to the building were dec-
orated with murals depicting various aspects of the city's
history. The landing of Laclede, founder of the city; the
original city hall; the Indian mounds of the original inhabit-
ants of the area; King St. Louis IX; and Lindbergh's Spirit
of St. Louis were among the subjects.[18]

Arlen Vincent and Leola Rose, both 8 years, sketch at the
art center. Poster to the rear of the children has identifi-
cation of "People's Art Service Center," June 1942 (courtesy
of the Archives and Oral History Center, St. Louis University).

The Advisory Committee of the St. Louis Art Project began to consider the possibility of establishing a community art center for the underprivileged in response to WPA/FAP guidelines. According to the guidelines, the Federal Art Project would furnish personnel, provided the local community supplied the location and materials. Vera Flinn, Art Supervisor for the suburban University City School System, presented a proposal for a community art center for Negroes to the Advisory Committee on October 7, 1940. It was Flinn's contention that because of the segregated public and private school situation in the metropolitan area, Negro children were being deprived of any exposure to the fine arts. She was also concerned that the already existing FAP projects within the area had failed to meet the needs of the Negro artists, since none were currently employed in the various projects around the area. Following extensive discussion, a suggestion was made by Carl Mose that a committee be appointed to confer with John T. Clark, executive director of the St. Louis Urban League and a leader of the black community concerning the desire of the black community in the establishment of such a center. The committee appointed consisted of Elizabeth Green, Vera Flinn, and James B. Musick. Shortly thereafter, the committee met Clark and the Art Appreciation Committee of the Urban League. The leadership of the League endorsed the plan enthusiastically and pledged the League, "to do all in their power to stir up interest and support for the proposed center.[19]

An organizational meeting was planned for April 1, 1941, at the Metropolitan A.M.E. Zion Church with the pastor, Reverend W. A. Cooper, presiding. Letters had been sent to interested parties, both blacks and whites, during the early months of 1941 explaining the proposed center and encouraging attendance at the meeting. In response, some 30 individuals, about equally divided racially, attended the meeting. Reverend Cooper opened the meeting by explaining that the proposed center would respond to the particular needs of the Negro community in the fine arts and opened the meeting for comments and suggestions. Mrs. George Gellhorn stated a concern about the segregated nature of the project. She had a deep interest in the "forward progress of St. Louis" and regarded this center as an opportunity to attack the historic segregation of the city. She therefore proposed that the center be open to all, "regardless of race, color or creed." Compromising, the group reached a consensus that "a center

should be established with the special needs of the Negro
population in mind but in which all who desired to take ad-
vantage of its offerings would be welcome."[20] This was a
rather startling proposal at the time, considering that all
public and private schools, public transportation, and enter-
tainment and other public facilities were segregated in Mis-
souri.

A number of other significant decisions were made at
this organization meeting. James D. McKenzie, the Federal
Art Project state director, and his new St. Louis assistant,
Paul Stoddard, attended and stressed the necessity for ade-
quate funding. McKenzie stated that the Federal Art Project
would supply a director, instructional services within certain
limitations, and clerical and custodial services. The community
would be responsible for providing facilities, including utilities,
and materials. He estimated that this would amount to approx-
imately $2,500 annually.[21]

An executive committee was elected, including the
Reverend W. A. Cooper, chair; Elizabeth Green, vice-chair;
Jennie Roland, secretary and Henry S. Williams, treasurer.
A second committee on facilities was selected which included
John T. Clark, chair; Henry V. Putzel and Charles Nagel,
members. These three individuals were charged with the task
of finding an adequate home for the center. A name, "The
People's Art Center," was also selected for the new center.
Finally, it was proposed that the national director, Holger
Cahill, be invited to initiate the fund-raising drive.[22]

Cahill accepted the invitation and met the Executive Com-
mittee on the afternoon of May 5, 1941. He encouraged them
to continue in their efforts to open the center and gave some
practical advice concerning funding. That evening he ad-
dressed a large and enthusiastic mixed racial gathering of
about 300 at the Metropolitan A.M.E. Zion Church. He spoke
of the accomplishments of the Federal Art Project and of the
Art Centers in particular, urging those in attendance to sup-
port such a center for St. Louis. At the conclusion of the
meeting a collection of cash and pledges added substantially
to the fund drive.[23]

Throughout the summer and fall of 1941, the fund drive
continued, but with limited success. John T. Clark's committee
on the selection of a site had greater success. The committee

was approached by the Reverend W. W. S. Hohenschild, Rec-
tor of the Episcopal Church of the Holy Communion. He of-
fered to rent the vacant rectory at 2811 Washington Avenue
for a nominal fee to the committee for an indefinite time.
Hohenschild had labored for many years in the Negro ghetto
of the city and was a strong believer in the benefits the cen-
ter had to offer.[24]

During the fall of 1941 work progressed on the renova-
tion of the Washington Avenue facility. With workers and
furnishings supplied by the WPA the first floor was converted
into a gallery and the second and third floors into classrooms.[25]
With the facilities ready, the Committee decided to move ahead
with the opening of the center, even though the necessary
funds had not been raised. It was felt that an operating
center might attract more funds than merely a proposed one.
The visit of E. Simms Campbell, native St. Louisan and art
editor of Esquire, would serve as an appropriate occasion for
the opening of the Center.[26]

The People's Art Center was officially opened with an
exhibit of Campbell's sketches on Sunday, April 17, 1942.
In an editorial marking the occasion, the Post Dispatch praised
the event as a triumph "for those who are working to improve
race relations and to help members of this minority group find
the best way to use their talents."[27]

The center opened with a most ambitious program. But
even before the formal opening, classes for children were being
held daily between 4:00 and 6:00 P.M. Evening classes, held
three times each week, met between 8:00 and 10:00 P.M. for
adults. A number of servicemen from nearby Jefferson Bar-
racks, and from the Negro USO facility next door to the cen-
ter, attended the evening classes.[28]

Donald Williams was named director by the Federal Art
Project, which also supplied a secretary and custodian.
Local artists volunteered as faculty through the encourage-
ment of E. Oscar Thalinger of the City Art Museum. Thalin-
ger also served as chairman of the curriculum committee and
director of the adult program. Elizabeth Greiderer-Leon di-
rected the children's program.

In the first instructional sequence, 47 youngsters from
neighborhood public schools enrolled in an introductory art

program. A total of 34 adults took advantage of the courses and facilities offered by the center. The children's program drew high praise from community and school officials, and the center received positive reviews in local newspapers, and a laudatory article in the Magazine of Art.[29]

The first summer of operation for the center witnessed a tremendous increase in the number of children enrolled in courses. Two hundred forty-seven attended morning and afternoon sessions. And for the first time in the history of St. Louis education, these classes were integrated. The majority of the children were blacks from the surrounding neighborhood, but a few white children came to the center from the outlying suburbs. Throughout the summer the children visited locations within the city such as the Missouri Botanical Garden, the various parks, the City Zoo, the riverfront and the City Art Museum. For most of these children it was their first journey out of the ghetto and into a world hitherto unknown to them. These trips, in small groups,

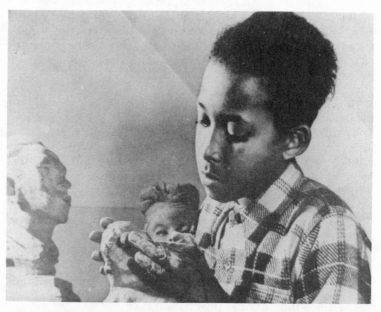

Unidentified youth sculpting at the new quarters of the center, 3657 Grandel Square, November, 1952 (courtesy of the Archives and Oral History Center, St. Louis University).

furnished the experiences and stimulation for their paintings
and drawings, such as "Trolly," "Bridge in Cambridge,"
"Two Ducks on a Pond," and "Aquarium."[30]

 The curriculum for the fall 1942 semester was even more
ambitious. Williams, Stoddard, and Thalinger outlined the
program which included extensive day and evening classes.
A wide range of offerings included oil painting, anatomy,
ceramics, print making, drawing, sculpture, portraiture,
watercolor, wood inlay, photography, modern dance, jewelry,
enameling, weaving, dress designing and batik, creative de-
sign, commercial art, mechanical drawing, interior design,
art appreciation and introduction to theatre.[31] The Bulletin
of PAC (as the center was commonly called) for the fall 1942
semester answered questions about itself. "Is the art center
limited to one race?" "No. The center, as a government
sponsored activity, must be open to all without regard to
race, color or creed." The Bulletin also solicited membership
in the Center Association to help defray the annual operating
cost. According to the same publication, 278 children were
enrolled with an average weekly attendance of 240, and 47
adults were enrolled, with an average weekly attendance of
25. Children were furnished materials, but adults were re-
quired to pay for their supplies. All classes were offered
free of charge.[32]

 During fall 1942, the gallery of the PAC held a con-
tinuous series of art shows which included local and national
exhibitions. The gallery program included lectures, guided
tours of the exhibits and various entertainments. All these
were provided without charge and drew sizeable audiences.
A large number of servicemen attended these gallery activi-
ties since the Negro USO was next door to PAC. It was at
this time, and for the remainder of World War II that the
center used the name "People's Art Service Center."[33]

 Although the center's board was interracial and the
faculty of volunteer artists balanced between Negro and white,
a concern developed during the fall semester that almost all
of the adult participants were white. There was concern
among board members that the center was failing in its attempt
to attract black adults. This situation was dealt with in the
spring, 1943 semester through a revised schedule and the
center then retained its interracial program character through-
out its existence.[34]

The People's Art Center lost its WPA/FAP affiliation and financial support in January 1943. This meant the removal of all staff including Donald Williams, the director. The equipment supplied by the WPA was donated to the center and remained. Elizabeth Green was appointed acting director while reorganization took place. The regulations ending federal sponsorship required that all works of art produced under government auspices be donated to government agencies. As a result, art produced or accumulated during the center's first year was donated either to the City of St. Louis Art Museum or to the United States Army command at Fort Leonard Wood, Missouri. Records at the art museum indicate the 255 works were received from the center. These consisted primarily of oils and watercolors.[35]

The next episode in the life of the center began in March 1943, when the unit was organized under state statute. A board of directors was elected which included Charles Nagel as president, C. Spencer Tocus, first vice-president; Henry V. Putzel, second vice-president; Elizabeth Green, secretary; Henry S. Williams, treasurer; and E. Oscar Thalinger, chairman of the curriculum committee. Other board members included Mr. and Mrs. John T. Clark, Dr. and Mrs. James E. Cook, Dr. Ruth Harris, Agnes Baer, L. Guy Blackmer, Anna Hensley, Frank M. Jones, Anna Lee Scott, and Jennie Wahlert. Pauline Dickerson was hired as a full-time director.[36]

Funding created the most serious problem for the newly independent center. An annual fund-raising drive was initiated which appealed to both the white and black communities. In addition, considerable financial support came from an annual art sales of works donated by local artists. During the first year the art sales netted over $1,600.[37] Financial problems were eased somewhat in early 1945 when the center was accepted as a member agency of the Community Chest of Greater St. Louis, the forerunner of the United Way. The Annual Report for 1945 indicated an operating budget of $6,696.23, with $3,806.52 coming from the Community Chest and the remainder raised through various methods. The annual fund-raising appeal netted $1,685, with a total of 281 businesses and individuals contributing. Registration for the spring 1945 semester included 499 children--469 black and 30 white; while there were 256 children registered for the summer session--234 black and 22 white. During the same period 382 adults were registered but a racial breakdown was not given.

During the month of July 1945, 113 individuals visited the
gallery. Also during the summer session the center continued
its policy of field trips for the children to various locations of
interest in the area. [38]

The center was required to seek new quarters in 1945
due to the sale of the original building at 2811 Washington.
A special committee was formed with Henry V. Putzel as chair-
man, supported by a $2,000 grant from Irma Rombauer, to se-
cure a permanent location for the center. A victorian mansion
at 3657 Grandel Square, in the central city, was purchased
for $8,000. An additional $10,000 was required for renova-
tion. A major fund drive was initiated under the direction
of Henry V. Putzel and L. Guy Blackmer. Support came
from a broad spectrum of the population. The Art Apprecia-
tion Committee of the Urban League donated $1,000 in honor
of the Negro pilot and hero, Captain Wendell Pruitt. Alpha
Phi Alpha Sorority, Sigma Gamma Rho Sorority and Alpha Phi
Alpha Fraternity collectively donated another $1,000. The
vast majority of contributions came from individuals in small
amounts. The new quarters were occupied and in use for the
fall 1946 semester. [39]

The increased space and improved facilities made it pos-
sible to increase the center's offerings. The former carriage
house was converted into an excellent sculpture studio.
Courses offered for children included drawing, painting, clay
modeling, puppet making, metal and leather tooling, block
printing, woodworking, and sewing. Adult classes included
drawing, painting in both oil and watercolor, photography,
weaving, clay modeling, ceramics, wood and metal working,
creative writing, dramatics and group singing. All classes
continued to be taught by volunteer artists, many from the
faculty of the Washington University School of Fine Arts and
the staff of the City Art Museum. [40] For the tenth anniver-
sary of the center, the Board of Directors arranged on an
outside evaluation of the center's contributions and the quality
of its current programs. Betty Chamberlin of the New York
Museum of Modern Art was recruited to make the evaluation.
Her findings traced the progress of the center from a small
program in the spring of 1942 to a major center for the arts
serving the entire metropolitan community. During 1951-52,
the center served 1,385 children and 702 adults. Children
came from all 29 black city public schools and from 95 white
public and private schools located in St. Louis and St. Louis

County. The gallery was used during that year to acquaint
the St. Louis public with the work of some of the best Negro
artists: E. Simms Campbell, Allan Rohan Crite, Aaron Doug-
lass, and James Parks. In addition, exhibits of the works of
the children and teachers were also held. An interracial
chorus under the direction of Kenneth Billups performed
regularly. The Chamberlin report recommended that the
number of offerings be reduced and that the remaining classes
be taught by full-time, paid faculty. While adopting this
recommendation did increase the budget, it also increased the
quality of the program. Also, a full-time, paid program direc-
tor was hired to supervise the faculty and plan the course
offerings each semester. [41]

Holger Cahill was asked to return for the tenth anni-
versary celebration in 1952. In his address, he summed up
the progress during those ten years:

> My acquaintance with the People's Art Center ...
> remains with me not only as a pleasant recollection
> but even more as a hope and a promise that our great
> America, born in the vision of freedom and harmony
> among men, will find and is finding a sure path
> through the troubling forest of race relations. [42]

Throughout the decade the People's Art Center continued
to enroll an average of 2,000 children and 1,000 adults annual-
ly. The ratio of blacks to whites remained approximately two
to one throughout the period. [43]

On September 1, 1960, the support for the center by
the United Way of Greater St. Louis was discontinued. The
exact reasons for the suspension of support were never speci-
fied but many felt that the increasing racial tensions in the
nation may have been a contributory factor. The center had
always been an unpopular member of the United Way, being
criticized as an unnecessary facility when so many more press-
ing human needs demanded support. [44]

The center then sold its property on Grandel Square
because of financial exigencies, and the fact that the neighbor-
hood was in a state of decline. New, but reduced, quarters
at a community center were donated by the city, and the
People's Art Center continued in operation at this facility until
its last classes were conducted in 1965. Lack of funds and

community support finally ended its career just short of its 25th anniversary.[45]

During its years of activity, the People's Art Center introduced thousands of children and adults to the wonders of the fine arts. Into the center came teacher and student, adult and youngster, male and female, black and white, Catholic, Protestant and Jew. From its modest beginning in 1942 as a part of the Missouri WPA Federal Art Project, through the efforts of volunteers, it expanded to serve the artistic and cultural needs of the community. Fannie Cook, author and board member, best expressed its major contribution:

> Within the doors of the center color is not pig-
> mentation which makes a man unfit to eat at our lunch
> counters; it is something which makes interesting
> models, thoughtful teachers, selfless board members,
> and happy, vigorous pupils.[46]

Notes

1. Post Dispatch (St. Louis), December 27, 1933, pp. 1-6.
2. Ibid., p. 6.
3. Interview with Miss Martha Dill, June 12, 1980.
4. Post Dispatch, September 12, 1934, p. 3.
5. Interview with Robert L. Rigsby, CWA artist, July 16, 1976, Archives and Oral History Center, St. Louis University.
6. Interview with H. J. "Dooley" Dionysius, CWA artist, July 13, 1976, Archives and Oral History Center, St. Louis University, also Post Dispatch, January 28, 1934, p. 1 and September 12, 1934, p. 3.
7. Op. cit., interviews, Rigsby and Dionysius, Joe Genna, CWA artist, July 14, 1976; Kenneth E. Wischmeyer, CWA artist, May 3, 1982, Archives and Oral History Center, St. Louis University.
8. "It Does Happen Here: Left Wing Artists Guggenheim Winners," Art Digest, April 15, 1937; "Joe Jones of Missouri, A Success Story," Art Digest, January 15, 1936; "Jones Now Militant," Art Digest, November 15, 1937; "Local Color and Stark Realism," Art News, October 30, 1937.
9. Star Times (St. Louis), July 2, 1937, p. 1.
10. Ibid.

11. Star Times, January 23, 1938, p. 6.
12. Post Dispatch, March 7, 1938, p. 12.
13. Ibid.
14. Interview with Karen M. Goering, Curator of Art, Missouri Historical Society, February 24, 1981, Archives and Oral History Center, St. Louis University.
15. Globe Democrat (St. Louis), March 11, 1938, p. 1.
16. Star Times, April 13, 1938, p. 13.
17. Ibid.
18. Ibid.
19. Minutes of Meeting, October 7, 1940, Advisory Committee of the St. Louis Art Project (in the files of the Art Department, St. Louis Public Library).
20. Minutes of Meeting, April 1, 1941, Advisory Committee.
21. Ibid.
22. Ibid.
23. Minutes of Meeting, May 5, 1941, Advisory Committee.
24. People's Art Center, Annual Report (St. Louis: People's Art Center, 1942).
25. Ibid.
26. Ibid.
27. Post Dispatch, April 16, 1942, p. 1.
28. People's Art Center, Annual Report.
29. Jack Blach, "Democracy at Work: The People's Art Service Center in St. Louis," Magazine of Art, XXXVI, (February 1948), pp. 66-68; and Post Dispatch, June 7, 1942, Magazine Section, pp. 5-7.
30. People's Art Center, Annual Report; also Inventory of Works Progress Administration Art (in the files of the City of St. Louis Art Museum).
31. People's Art Center, Bulletin (St. Louis: People's Art Center, Fall 1942).
32. Ibid.
33. People's Art Center, Annual Report (St. Louis: People's Art Center, 1943).
34. Ibid.
35. Inventory of Works Progress Administration Art (in the files of the City of St. Louis Art Museum).
36. People's Art Center, Annual Report.
37. Ibid.
38. People's Art Center, Annual Report (St. Louis; People's Art Center, 1945).

39. People's Art Center, Annual Report (St. Louis: People's Art Center, 1946).

40. People's Art Center, Bulletin (St. Louis: People's Art Center, Fall, 1946).

41. Betty Chamberlin, Evaluation of the People's Art Center (in the People's Art Center, Annual Report, 1952).

42. Holger Cahill, "Address," given at the tenth anniversary dinner of the People's Art Center, February 4, 1952 (contained in the Annual Report, 1952).

43. People's Art Center, Annual Report (St. Louis: People's Art Center, 1950 through 1960).

44. People's Art Center, Annual Report (St. Louis: People's Art Center, 1960).

45. Post Dispatch, May 18, 1965, p. 3.

46. People's Art Center, Annual Report (St. Louis: People's Art Center, 1946).

THE SPOKANE ART CENTER

Sue Ann Kendall

The history of the Spokane Art Center in Washington State,
one of the many WPA community centers that sprouted across
the country between 1936 and 1942, followed a pattern common
to many small arts institutions--an initial burst of enthusiasm
spurred on by dedication to a common cause; a post-honeymoon
phase during which euphoria turned into the realization that
keeping an art center going was harder than getting it started;
and finally, a decision to close the institution due to lack of
support, in this case brought on more by the buildup of World
War II than by any apathy.

The genesis of the Spokane Art Center was like that of
art centers established by the Works Progress Administration
in many other states--the community earned its right to have
a center by providing an advisory committee of prominent
citizens who would later establish a board, by raising a
stipulated amount of cash both initially and yearly, and by
finding a suitable location to house classes and exhibitions.
The WPA then hired the staff, provided necessary adminis-
trative functions, and contributed a yearly stipend--in this
case $12,000, or approximately four-fifths of the operating
budget.

Spokane's initial fund-raising drive, set in motion in
March of 1938 by Daniel S. Defenbacher, regional advisor of
the WPA, generated unbounded enthusiasm. The necessary
$2,500 was raised in under two months; by June 21, 1938,
just three months after it began, the drive had brought in
about $1,000 extra, or a net total of $3,480.54.[1]

More important than the final figure was the fact that
most of the money had been acquired in the form of small

donations--pennies, nickels, and dimes. A penny drive was conducted in the schools, for instance, and small contributions of one dollar or under were solicited from medium-income families. Such civic groups as the American Legion, the Boy Scout Mothers' Troops, the DAR, the PTA, and the Rotary and Kiwanis Clubs all responded with gusto. For the first time in its history, for example, the Kiwanis Club sent letters to its members asking for contributions.[2] As it was stipulated that no major endowments would be accepted, the largest single contribution, given by the Junior League, was $200.[3]

The community's own enthusiasm and self-congratulation, reported in feature stories in the Spokesman Review, were echoed by state director R. Bruce Inverarity in a letter to Holger Cahill as early as May 16, 1938: "The whole town has risen to the occasion and everybody is talking art center and subscribing. The school teachers alone gave $500...."[4]

The overwhelming response had not been anticipated. According to Defenbacher, who was responsible for choosing the site for Washington State's center, the selection was largely fortuitous. He had set up a successful center in Butte, Montana, a mining town, and claims that he just "headed west," adding, "Inverarity and I talked about Pullman (a town about eighty miles south of Spokane), but said, hey, let's take a crack at Spokane. We did, and it worked."[5]

Indeed it did--a pioneer town of 120,000 people, with little if any credits in its cultural hat, Spokane proved its mettle and became the home for the nation's fiftieth WPA art center.[6]

That the center thrived may have been due in part to the fact that there was no art museum to conflict with its mission. A healthy rivalry with Pullman may also have spurred the founders on initially--a sales pitch they used during the fund-raising drive read: "This is the most important cultural opportunity that has been offered to us since 1890 when we lost the State College to Pullman for the lack of a few thousand dollars."[7]

The successful fund-raising drive was followed in the summer of 1938 by the hiring of a director and by the renovation of a three-story building at 106 North Monroe Street in

downtown Spokane, a building formerly used by the Spokes-
man Review for its printing press operation.[8]

The selection of the right kind of director for this city
that was still rough around the edges was considered critical.
Inverarity, the state administrator, wrote to Cahill that it
should be "a he-man with a bass voice, as there is still a
bit of the pioneer liking of manliness in Spokane, and we
need a two-fisted sort of a fellow to go in there if that gal-
lery is going to run and turn out to be successfully inde-
pendent...."[9] A little later he reiterated his demand for a
he-man type (a woman was obviously out of the question):
"Being a western town in spirit if not in looks, anything
that smacks of the effeminate they cannot understand."[10]

Defenbacher, with Holger Cahill's approval, selected
artist Carl Morris as the center's first director. Tall, hand-
some, and rugged, though refined enough to charm the social
elite of the community, Morris filled the bill--he was immediate-
ly liked by both his superiors in the project and by the
board members in the community.[11]

Morris himself recalls that when he arrived in Spokane
there was nothing but a building and a board, neither of
which he had chosen. Despite his lack of administrative ex-
perience--he had been a teacher at the Art Institute of Chi-
cago--he dove into the tasks at hand, one moment pounding
nails in the new building, the next requesting contributions
from a board member over lunch.

In his first three months, he had to get the building
renovated, a task which required working with the volunteers
on the board, who brought with them personality clashes and
power struggles common to such groups.[12] He was also con-
fronted with city building ordinances which required more
money and time to satisfy than anyone had anticipated--un-
expectedly, fire escapes and fans had to be installed, for
instance. As a result, the opening of the center, originally
scheduled for August 1, was postponed several times and
ultimately had to wait until October 29, 1938.[13]

Despite the inevitable delays and frustrations, a small-
town barn-raising atmosphere permeated the whole renovation
process: On July 31, the Spokesman Review reported, "Adults
and young people gather in the new building at all hours of

the day to help with the construction of drawing benches,
drawing horses, easels, work tables, classroom benches
and chairs. Those more expert are helping with lettering.
Women are helping with curtains and burlap on the walls."
The article then went on to solicit everything from type-
writers and filing cabinets to waste baskets and dust rags.[14]

Morris fueled the enthusiasm of the community by brain-
storming and coming up with new ideas for the center, from
scholarships for children to kilns for a pottery program.[15]
He seemed to share Inverarity's determination to make Spo-
kane's center "better than anything that you (Cahill) now
have on the circuit."[16]

By fall he had set up a curriculum and requested the
type of people he wanted on his staff. Artists were sought
from around Washington State, but complications arose be-
cause its quota of artists, established by the WPA, was al-
ready filled. Besides, Defenbacher wanted to bring "fresh
blood" into the state rather than to raise the quota on the
project.[17]

Ultimately, four "loan" artists from the New York Proj-
ect were hired. Arriving in Spokane in the last half of
October, barely in time for the opening day of classes, they
began teaching immediately to approximately six hundred
students, an enrollment figure never dreamed of by the found-
ers.

The boundless zeal which set the center in motion car-
ried through its first six months of operation. The commun-
ity as well as the state and regional WPA administrators clear-
ly viewed the center as a permanent addition to the community.
As early as June 2, 1938, Defenbacher had written (to Ca-
hill): "I think you can impress upon whoever [sic] you choose
(as director) that if he makes a good of it he has a practically
lifetime job because the whole town is now behind this move-
ment and already are delving into their budgets for next
year's contribution to be made to the center."[18]

And when Morris wrote to the Washington, D.C. office
for information on developing plans for a civic auditorium in
Spokane, it is clear that he envisioned the art center having
a permanent place in it: "A civic auditorium in Spokane is a

distinct possibility.... This would, of course, be a great
advantage to our (the center's) future security."[19]

It was in this spirit that Morris and eventually his
staff tackled their jobs. They believed in their mission,
which was to make art a vital part of people's everyday
lives, or as summarized once by Morris in a long feature
story on the front page of the Spokesman Review's art sec-
tion, "to bring the enjoyment of creating and the pleasure
of seeing and recognizing fine creative work to people who
have never known these things before."[20]

The community responded in kind, eagerly signing up
for the free classes in painting, drawing, and sculpture.
While exact figures are not available for each month of the
first year, the average number of enrolled students seems to
have hovered around 500. Morris recalls especially the impact
the center had on public school art teachers, whose own art
association had been among the strongest advocates of the
center's initial fund-raising drive and who now sacrificed
their own personal time to get the training they had never
been given in college. He also recalls how it gave purpose
to the lives of many artistically inclined people whose talents
had never before been validated.[21] Jan Thompson, for in-
stance, then a high school student and budding artist, re-
calls how the staff influenced her: "All these fabulous people
came.... I decided at that point not to go to college....
They changed my whole way of looking at life."[22]

Though the largest single group of students was chil-
dren, there were all types and ages of people, other than
artists who took advantage of the free classes--newspaper
cartoonists, free-lance commercial artists, interior designers,
house painters and plasterers. Stories about them were re-
lated in the Spokesman Review and in the center's own pub-
licity brochures: a dentist who went from casting dental in-
lays to modeling plaster statues, for example, and a ten-year-
old girl who spent her weeks caring for an invalid mother but
who, on Saturdays, found not only a creative outlet at the
center but also a chance to associate with other children.[23]

The center offered an ambitious schedule of exhibitions
in addition to its classes in all kinds of art. Some were or-
ganized by the national office of the WPA, others by the local
staff. Rotated regularly, usually every three weeks, they

offered a wide variety of subjects for contemplation--contem-
porary oil paintings, photography, design ideas and archi-
tecture. Occasionally symposia were held in conjunction with
shows, usually on topics which were of particular relevance
to the community--art in agriculture, farm tools, wood prod-
ucts, church design (held during the construction of a large
new church in Spokane).[24]

The center continued to prosper during all of 1939
and 1940. Morris and his staff came to view their organiza-
tion as much more than a place where one learned how to ma-
nipulate paint or clay; they saw it as a cultural mecca for the
community, one which could promote an awareness of all the
arts. Many civic clubs and societies met in their building,
for instance. At one point the center purchased a Radio
Victrola and asked people to bring in records that could be
circulated like books in a library. In Art Horizons, a publica-
tion the center launched in October of 1939, they announced
new books published on art, television concerts by the NBC
Symphony Orchestra, and late-night radio shows featuring
classical music.

The publication itself, which evidently appeared every
three to four weeks, from October 1939 through most if not
all of 1941, was a significant contribution to the cultural life
of the community, offering essays on the meaning of art and
on trends in contemporary art as well as announcements re-
garding activities held at the center and elsewhere in the
community. Even its own hand silk-screened cover, each
one individually designed to reflect whatever exhibition was
on view at the time, was intended to educate the public eye.[25]

Despite the center's prosperity--in addition to the stu-
dents, some 1,300 to 2,500 people visited the center monthly[26]
--certain significant and, in some cases, long-term problems
began to emerge as early as the spring of 1939. From then
until January of 1940 when he resigned his directorship, Mor-
ris had to confront the uncertainties of a basically itinerant
staff, the consternation of a conservative community over the
ideas and life-styles of that staff, the shift of WPA programs
from federal to state sponsorship, and most serious of all,
an ever-expanding statewide WPA program which diffused the
attention of the state administrators.

First, he had to assuage a restless staff of artists who

wanted more time for their own creative work.[27] Next, he
had to face the reality of having "loan" artists, who were by
definition impermanent, originally assigned to Spokane for
three months only, with a limit of one three-month extension.
Personal indecision among them and government regulations
resulted in a long period of ambiguity during which Morris
did not know how long any or all of them would be staying.
Ultimately, by April of 1939, two had decided to stay and be-
come certified in Washington State, and two had returned to
New York. The vacancies were ultimately filled by artists
from within the state.[28]

Another problem arose because of differences between
the indigenous, conservative community and the imported,
liberal staff who enjoyed controversial issues, avant-garde
art, and in some cases a nontraditional life-style. Morris
preferred that the center teach ideas rather than craft, for
instance, and he and his staff made a conscious effort to
avoid a "how to" approach. It is clear that some of the
center's publicity, which reflected this teaching policy, was
disconcerting to the community. The first issue of Art
Horizons, for instance, openly stated, "... we like to think
that a good hearty difference of opinion on certain matters
shows strength and growth. In fact, we already find our-
selves growing regretful and nostalgic over those angry (and
anonymous) phone protests about the (earlier, modernist)
brochure covers."

Another incident which even caught the attention of the
national administrators, occurred on the occasion of an exhi-
bition titled "Modern Design in Everyday Life." Morris was
chided in a letter from Cahill for the "injudicious selection of
words" used in a brochure caption showing the "old" and the
"new" in furniture design. The "old" was labeled "tasteless
and decadent." Cahill stressed that the majority of people
reading the brochure in a city like Spokane would themselves
own furniture of this kind.[29]

Morris's response epitomizes his and his staff's feelings
about controversial issues: "We must admit a certain feeling
of jealousy over the riot created in Phoenix (a reference to
public reaction to the same exhibition). The general apathy
created by this particular phase of the show here in Spokane
is comparative [sic] to a lonely midnight visit to a grave-
yard."[30]

While the notion of design may not have disturbed the community, the life-style of some of the staff, including Morris himself, did: His sharing of living quarters with Hilda Deutsch, who would later become his wife, created quite a stir. [31]

A more significant issue was marked in September 1939 by the transition of WPA sponsorship from federal to state hands. Although the change-over seems to have had more immediate impact on the administration in Seattle than on the center--the former was closed from August 31 to about October 6--in hindsight it can be seen as signaling the beginning of the center's end, for without federal support the community would ultimately be unable to keep it alive.

Under state control, the University of Washington in Seattle agreed to assume sponsorship. Thenceforth, the state administrators directed their energies toward statewide programs, some of which had been envisioned from the beginning. Inverarity in particular had always had grand and ambitious ideas. As early as July 15, 1938, he had written to Cahill, "As soon as the [Spokane] Center is opened, I am going ahead with the development of extension galleries"--mini-centers which would be on the national circuit of WPA traveling exhibitions and perhaps offer occasional workshops. [32]

Morris too had been interested in cooperating on a statewide basis. Early on he had worked out special arrangements with WSU's art gallery in Pullman. Tentative plans were underway to have the gallery renovated under the Spokane Center's supervision even before the latter had opened. [33] And Washington State University was included on the WPA exhibition circuit soon thereafter.

In December of 1938 Inverarity proposed yet another possibility: integrating the center with the whole public school system of the state. By June of 1938, he had developed a plan: The state project would organize portions of the WPA exhibitions into traveling portfolios. To receive them, the schools would pay a minimum cosponsorship fee to cover transportation. [34]

Meanwhile, Inverarity was also working towards the realization of a full network of extension galleries. By early 1939, he felt he had enough support in Yakima to open one

there. When he told Cahill that the town was ready to go,
however, Cahill put the kibosh on the plan because there was
no way to staff it. [35]

But Inverarity was not to be subdued. By September
of that year a center for Seattle was in the offing. And by
January of 1940 a statewide program for extension galleries
was actually in place, with a six-page explanatory brochure to
back it up. Morris was transferred to Seattle to act as as-
sistant supervisor in charge of community exhibition galleries.
Despite Cahill's admonition not to remove two people from
Spokane simultaneously, Hilda Deutsch was soon to follow as
exhibition designer and builder. The continuity of the teach-
ing program in Spokane was disrupted once again.

Tension between Cahill, who was cautious about expan-
sions, and Inverarity, who was more zealous in his approach,
had been mounting for months. While Cahill was in favor of
extension galleries--there were others in Florida, North
Carolina, and Wyoming--he wanted one central gallery, in
this case Spokane, to service the others. [36] Inverarity, on
the other hand, wanted each gallery to be independent.
Whether the latter's plan had the support of others is hard
to determine, as he had never really worked with an advisory
committee--as early as June 1939 he had written that he
couldn't keep anyone on one and that such a group would
only interfere anyway. [37]

Whatever the case, the straw that broke the unspoken
tension was a letter Inverarity wrote to Cahill denouncing
the kind of exhibitions provided by the WPA and proposing
that the state project put together its own shows with an
emphasis on meaning rather than on craft and process.

Cahill's response was angry and not a little sarcastic:
After defending the WPA-designed exhibitions, he wrote:
"I like the enthusiasm and youthfulness displayed in your
plan, but I see no reason why it need overturn the community
art center organization...." He chided Inverarity for assum-
ing that he had come up with something truly unique and
closed his letter with the following admonition: "It seems to
me that one good art center like Spokane in the hand is bet-
ter than ten exhibition galleries in your hat." [38]

Undaunted, Inverarity set up a community center for

Lewis County in Chehalis without sending information about it
to Cahill. He in turn received strict orders to get approval
from Washington, D.C. for such projects before going ahead
with them.[39] The next and perhaps last idea initiated by
Inverarity was for an arts and crafts project for which he
hoped to get the cosponsorship of Mt. Rainier National Park.
Negotiations with the National Parks Service were conducted
both in the state and in Washington, D.C., but apparently
the project never materialized.[40]

Meanwhile, Kenneth Downer, one of the art instructors
in Spokane, had replaced Morris as its director. By this
time, the board members realized that they were confronting
their moment of truth: Fund-raising was more and more
difficult, classes were diminishing in size, and the buildup
of World War II was preoccupying the public more than any
opportunities for art.

When James FitzGerald was hired to replace Downer in
the summer of 1941, a separate business manager was also
hired. According to Mrs. Jane Baldwin, a founding member
of the board, the sponsors had come to realize that "managing
finances and public relations on the one hand, and being the
art director on the other, required two different kinds of
person. In order for the center to succeed, a business man-
ager was essential."[41]

The founders were still optimistic about the center's
future, however, and they undertook extensive redecorating
that same summer. In an attempt to become more inclusive
geographically, they changed their name to the Inland Empire
Art Association (Inland Empire was a somewhat vague geo-
graphic designation but seemed to include Idaho, parts of
Montana, Oregon and Washington).

They were also beginning to feel that their programs
were too narrow in scope to elicit the necessary financial
backing. They proposed broadening the range of oppor-
tunities offered at the center. An unsigned typewritten
sheet dated July 8, 1941, drawn up by some of the board
members, was titled "Suggestions for Promoting Interest in
the Spokane Art Center." It began:

> The City of Spokane will contribute to the cause of
> the Art Center in proportion to the benefit received

therefrom and to the exhibitions which have a varied
appeal. Present exhibitions appeal only to those
interested in the fine arts and have a limited clientele.
More diversified exhibitions will bring new inter-
ests....

Seventeen enumerated suggestions followed, including Boy
Scout and Girl Scout projects, a show of airplanes made by
boys from five-and-dime blueprints, an exhibit of inventions
submitted by local citizens, shows of crocheted and knitted
work and a hobby week. [42]

By 1942 it was clear that federal support would be with-
drawn completely. Furthermore, statistics revealed that only
8 percent of those citizens who had contributed in 1938 also
gave in 1941. Little documentation exists from this period
on events and classes, but there is a host of typed, in-house
proposals with such titles as "Disadvantages of Present Fi-
nancing Methods," "Suggested Methods of Raising Money for
the Spokane Art Center," and "Sales Techniques," a sheet
prepared for fund-raisers with specific methods for getting
pledges. Clearly, the alarm had been sounded and the board
had awakened to the nitty-gritty financial responsibilities of
running the center independently.

By October 1942, just four years after the center had
opened, the assumption that it would become a permanent
institution had turned into a struggle for day-to-day survival.
It was decided that the group's annual report shoud attempt
to "establish firmly in the minds of all that the Spokane Art
Center is a permanent civic institution created, operated and
owned by the people of the City of Spokane." It should
create "a feeling of permanency and purpose" by suggesting
plans for a permanent collection of contemporary local art, a
color slide collection of the old masters, an annual watercolor
show, a larger library, a permanent home, endowments, and
accreditation for the school. [43]

Despite the dedication of its board members, the Spokane
Art Center--the one that had set a national attendance record
in the first few months of its existence--was forced to close
its doors. While its demise could be attributed in part to the
overly rapid growth of the statewide programs and to a lack
of local, long-range planning, it was mostly the inevitable
result of its own dependence on a government whose attention

had shifted from a depression to a war. On November 29, 1942, Jane Baldwin was quoted in the Spokesman Review: "The war and the great demand for public financial support for war activities caused the board of the art association to close the center for the duration."[44]

The equipment, however, was to be taken over by the YWCA for its new craft program. Baldwin noted in the same article, "After the war is over we shall look toward the day when we can have our own Spokane art museum."

The war ended, but the Spokane center never reopened as a museum. Washington State University, in conjunction with Spokane's park department, opened another art center in 1952 for extension classes, and a new museum building was constructed in the sixties by the Cowles family, owners and publishers of the Spokesman Review. But in neither case was there a direct link to the original WPA Center.

Nonetheless, it has been said that the center had a significant impact on the community because it was the first and only institution ever to offer to the general public a full schedule of both exhibitions and classes--no other institution before or since has combined the roles of an art school and a museum. More important but more difficult to measure is the intangible influence it exerted over the years on the founding of those other institutions, paving the way for them by having instilled once and for all in the minds of the people of Spokane the idea of an art center in their city.[45]

* * *

The author extends appreciation to Dr. Martha Kingsbury of the University of Washington for her early assistance in this project.

Notes

1. Papers and financial records of the Spokane Art Center, Works Progress Administration: Spokane Art Center, Eastern Washington State Historical Society, Spokane, Washington. All papers, financial records, and publications of the center, in the collection of the Eastern Washington State Historical Society will hereafter be referred to as WPA Spokane Art Center papers.

 2. Letter from R. Bruce Inverarity to Holger Cahill,
June 2, 1938, central correspondence files of the Works Prog-
ress Administration/Federal Art Project (hereafter referred to
as WPA/FAP papers), Archives of American Art (hereafter
referred to as AAA), microfilm roll DC-109. Unless otherwise
indicated, all letters in this chapter are on AAA microfilm
roll DC-109 and will be cited WPA/FAP papers. All AAA
papers cited here were filmed from originals in Record Group
69, Records of the WPA, National Archives.
 3. Dan Putnam, "Spokane Art Center Uncovers Hidden
Talent," Spokesman Review, March 26, 1939.
 4. WPA/FAP papers, AAA.
 5. Telephone interview with Daniel S. Defenbacher,
July 3, 1984.
 6. "Spokane Will Get Art Center," Spokesman Review,
June 2, 1938, p. 6. The only organizations of a similar
nature that had existed in Spokane prior to the Center were
an art association and an art students' league. The former
was a social organization and was open only to members, many
of whom were teachers; the latter had offered a few classes
(June Baldwin, "The Spokane Art Center--Notes on its His-
tory," an unpublished, four-page statement, 1952, WPA Spo-
kane Art Center papers).
 7. Updated, unsigned statement from the board, WPA
Spokane Art Center papers.
 8. Personal interview with Carl Morris in Portland,
Oregon, February 2, 1984; hereafter cited as Carl Morris
interview.
 9. Letter from Inverarity to Cahill, May 16, 1938,
WPA/FAP papers.
 10. Letter from Inverarity to Cahill, June 2, 1938,
WPA/FAP papers.

 11. Letters from Inverarity to Cahill, July 7, 1938;
from Harold Whitehouse (President of the Spokane Art Center
Board) to Defenbacher, October 12, 1938; from Cahill to Mor-
ris, December 17, 1938; WPA/FAP papers.
 12. Carl Morris interview.
 13. There is conflicting information surrounding the
opening date of the center. A letter from Inverarity to Ca-
hill on October 8, 1938, mentions an opening on September
29 (WPA/FAP papers); statements written by the board in
1942 also give September 29 as the opening date (WPA Spo-
kane Art Center papers). Other sources mention late October.
Carl Morris, for instance, gave October 29 as the opening

date in an article he wrote in 1939, published in Francis V.
O'Connor, editor, Art For the Millions (Boston: New York
Graphic Society, 1976), pp. 218-220. It may be that an
opening party was given on September 29; classes, however,
did not begin until the end of October.

14. "Speed Up Plans at Art Center," Spokesman Review,
July 31, 1938, p. 8.

15. Letter from Inverarity to Thomas Parker, assistant
to Cahill, July 28, 1938; letter from Inverarity to Cahill, July
15, 1938; and letter from Morris to Cahill, July 19, 1938,
WPA/FAP papers.

16. Letter from Inverarity to Cahill, July 15, 1938,
WPA/FAP papers.

17. Letter from Defenbacher to Cahill, September 15,
1938, WPA/FAP papers.

18. Letter from Defenbacher to Cahill, June 2, 1938,
WPA/FAP papers.

19. Letter from Morris to Holzhauer, September 15,
1938, WPA/FAP papers.

20. Putnam, Spokesman Review.

21. Carl Morris interview.

22. Personal, transcribed interview with Jan Thompson,
Northwest Oral History Project, Archives of American Art,
Washington, D.C., p. 1. Jan Thompson became a lifelong
friend and confidante of several northwest artists, most
notably Morris Graves.

23. Undated pamphlet on the Spokane Art Center,
written sometime during Carl Morris's directorship (hence,
prior to January 1940), WPA Spokane Art Center papers.

24. Carl Morris interview.

25. The whole series of Art Horizons are in the WPA
Spokane Art Center papers.

26. Figures are compiled from copies of Art Horizons.

27. Letters from Inverarity to Thomas Parker, his
assistant, October 27 and 28, 1938, WPA/FAP papers.

28. Letters were exchanged between Inverarity and
Cahill regarding the loan artists from February through April
1939, WPA/FAP papers.

29. Letter from Cahill to Morris, February 6, 1939,
WPA/FAP papers.

30. Letter from Morris to Cahill, February 9, 1939,
WPA/FAP papers.

31. Telephone interview with Mrs. Janes Baldwin, one
of the founders and longtime board members of the center,
July 2, 1984.

32. Letter from Inverarity to Cahill, July 15, 1938, WPA/FAP papers.

33. Letter from Morris to Holzhauer, October 19, 1938, WPA/FAP papers.

34. Letter from Inverarity to Parker, December 20, 1938, WPA/FAP papers.

35. Letter from Cahill to Inverarity, February 15, 1938, WPA/FAP papers.

36. Letter from Cahill to Inverarity, December 16, 1938, WPA/FAP papers.

37. Letter from Parker to Inverarity, June 12, 1939. The original advisory committee had consisted of Richard Fuller, director and benefactor of the Seattle Art Museum; Nellie Cornish of the Cornish School; and Halley Savery of the Henry Gallery at the University of Washington.

38. Letter from Inverarity to Cahill, December 19, 1939, WPA/FAP papers.

39. Letter from Thomas Parker to Carl W. Smith, then acting state administrator, February 20, 1940, WPA/FAP papers.

40. Letter from Inverarity to Cahill, April 25, 1940, WPA/FAP papers.

41. Jane Baldwin, "The Spokane Art Center--Notes on its History."

42. WPA Spokane Art Center papers.

43. The in-house statements are in the WPA Spokane Art Center papers.

44. "Y. W. Takes Over City Art Center: Project Closes for Duration; Classes Continue," Spokesman Review, November 29, 1942.

45. Jane Baldwin interview; Carl Morris interview.

Sources

Baldwin, Jane. Telephone interview, July 2, 1984.

Defenbacher, Daniel S. Telephone interview, July 3, 1984.

Morris, Carl. Personal interview, February 2, 1984.

O'Connor, Francis, ed. Art For the Millions. Boston: New York Graphic Society, 1976.

Putnam, Dan. "Spokane Art Center Uncovers Hidden Talent."
 Spokesman Review, March 26, 1939.

"Speed Up Plans at Art Center." Spokesman Review, July 31,
 1938.

"Spokane Will Get Art Center." Spokesman Review, June 2,
 1938, p. 6.

Thompson, Jan. Personal interview, Northwest Oral History
 Project, September 6, 1983. Washington, D.C.: Archives
 of American Art.

Works Progress Administration/Federal Art Project, Record
 Group 69. Microfilm roll DC-109. Washington, D.C.:
 Archives of American Art.

Works Progress Administration: Spokane Art Center, papers.
 Spokane: Eastern Washington State Historical Society.

"Y. W. Takes Over City Art Center: Project Closes for
 Duration: Classes Continue." Spokesman Review, Novem-
 ber 29, 1942, p. 1.

A WPA ART CENTER IN PHOENIX: 1937-1940

Daniel A. Hall

The most important of all the federally sponsored art projects of the depression period was the Federal Art Project of the Works Progress Administration. The purpose of the project, which began in August 1935, was to provide employment for persons with training and experience in art who had been certified by the WPA as eligible to participate in the work program.[1] Activities included the production of works of art, including easel painting, mural painting, sculpture, and graphic design; art education, which involved the establishment of community art centers; and art research, which was centered primarily on the Index of American Design.[2] In Arizona the project was primarily involved in the establishment and development of the Phoenix Federal Art Center.

Planning and Preparation: 1936-37

In September 1936, Mark Voris of Tucson was appointed State Supervisor of the Federal Art Project. Voris, who had moved to Arizona from Franklin, Indiana, in 1924, was assigned the task of establishing an art center in Arizona either in Tucson or Phoenix, with smaller extension units around the state. The major unit was to have a sponsoring organization, while smaller units were to be established in connection with schools, colleges, and other civic agencies.[3]

Mark Voris believed that the effect of the art center would be more far reaching and permanent if it was located in Tucson. The Tucson Fine Arts Association, however, wanted only WPA exhibits, and Phoenix had more to offer in the way of qualified personnel to operate the center.[4] Phoenix may also have had a greater need for the educational activities

114

of the proposed art center since it had the greater population. Phoenix had a population of about 58,000 and Tucson about 35,000.

Voris tried but could not find a director with the necessary qualifications. The problem of finding a director was then given to Daniel Defenbacher, Assistant Regional Advisor of the Federal Art Project.[5] The person selected was Philip C. Curtis.

In November 1936, an entire week was set aside for art activities of many different kinds throughout the country. In Phoenix, National Art Week began on Sunday, November 8, with a preview showing of the works of the Artists Guild and the Charcoal Club, two local artists' groups. At the close of this week of activities on Saturday evening, a public auction was held, at which canvases by artists from Phoenix and the Valley were sold to establish a fund for a permanent art gallery.[6] Whether this money would be spent for a private gallery or a WPA art center was probably not then known. Certainly the idea of establishing an art center in Phoenix was not new; the Phoenix Fine Arts Association had been established in 1925 "to foster and promote art interests of the community, to establish and maintain a suitable art gallery, to acquire works of art and to provide exhibitions and lectures in furtherance of the general purpose of the association."[7] And from 1925 to 1936 the Phoenix Fine Arts Association was primarily involved in 1) planning programs and lectures by artists and art historians; 2) searching for gallery space; 3) exhibiting the art work of members of the organization and other artists; and 4) raising funds for the purchase of art works to be included in a Phoenix Municipal Collection of Art.[8] It is not entirely clear, however, just what role the association played in the early planning stages of the Phoenix Federal Art Center, for the association seems to have been inactive throughout 1936; it came to life again in January 1937 in response to the renewed interest in establishing an art center in Phoenix.[9]

The sponsoring group for the art center was probably not identical to the Phoenix Fine Arts Association, but in such a small community as Phoenix was at that time there was almost certainly a good deal of overlap in membership. Voris probably assembled the art center sponsors in the fall of 1936 while the Phoenix Fine Arts Association was dormant, but it

is not certain just who the members of this group were. Un-
doubtedly some of the members of this originally sponsoring
group later served on the Board of Directors of the Phoenix
Federal Art Center.

Once it had been decided that the art center would be
located in Phoenix, the problem of finding a building arose.
The local sponsors' group was to be held responsible for pro-
viding the building and, quite understandably, they wished
to keep their expenses as low as possible. By February 1937,
the Social Service Building at 710 East Adams Street had been
selected as the best alternative. With a definite location es-
tablished, it was possible to begin a search for funds. [10]
The Federal Art Project was to provide salaries for a complete
operating staff. This was to include a full-time director, a
teaching staff, gallery attendants, office help, a carpenter,
and a janitor. In turn, the community was expected to provide
gallery space, heat, and light. [11] The fund-raising drive
was conducted by the Civic Art Committee headed by Mrs.
Foster Rockwell. [12]

Holger Cahill, National Director of the Federal Art Proj-
ect, visited Arizona on March 11 to confer with the local com-
mittee. Cahill stressed the need for Arizona to support its
own indigenous artists and to focus on art activities rather
than exhibits or galleries. [13] Cahill must have wondered how
an art center could possibly take root in such a provincial
and culturally isolated area, for when he spoke with Philip
Curtis with the directorship in mind, he warned him that he
would be working with a conservative group of Phoenicians who
would have an inadequate knowledge of art and who would
know nothing whatsoever about how to get an art center
started. He advised the new director to find some prominent
person in Phoenix who would have the persistence and the
know-how to follow through with the original idea. [14] Just
who that prominent Phoenician might be was not then known.
Curtis liked the idea of a community art center and was full
of enthusiasm; however, being a rather young man, he could
not have fully appreciated what he was letting himself in for
when he accepted the position of Director of the Phoenix Fed-
eral Art Center.

Curtis was a native of Michigan and had studied at
Albion College and the University of Michigan. He gave up
a career in law for a career in art. [15] Between 1932 and

1935, Curtis studied art at Yale, after which he became an assistant supervisor of mural painting for the Federal Art Project in New York City.[16]

Curtis arrived in Arizona in May 1937 and, working with Voris, supervised the remodeling of the Social Service Building, changing it into a functional art center.[17] Renovations were based on designs originally developed by Daniel Defenbacher; as work progressed, however, many changes were made, including changes in the color scheme.[18]

The art center was equipped with indirect lighting, with furniture built by WPA craftsmen, and draperies and bench covers handwoven under the direction of teachers of the National Youth Administration. The designs for the fabrics were based on ancient Indian patterns found in prehistoric ruins in the state.[19]

The First Year: 1937-1938

The opening of the Phoenix Federal Art Center was scheduled for midsummer, a most unlikely time of year, considering that many of the residents of Phoenix leave the Valley during the summer in order to escape the extreme desert heat. Nevertheless, over 500 persons attended the opening ceremony on the evening of July 15, 1937. Joseph Danysh, Regional Director of the Federal Art Project, was present and made a brief gallery presentation.[20] The paintings on display were selected by Holger Cahill and were by contemporary American artists, including Arnold Blanch, Joseph DeMartini, Ferdinand La Pinto, Jack Levine, Lawrence Lebduska, Julian Levi, and Warren Wheelock.[21]

A member of Curtis's staff, Lew Davis, was placed in charge of art instruction.[22] The original teaching staff of the art center included John Leeper, Creston Baumgartner, and Florence Blakeslee.[23] Shortly after the opening of the art center, R. Phillips Sanderson joined the staff to teach classes in sculpture and modeling.[24] The gallery supervisor was Burdell Tenney.[25] The art center program included free classes for every age group. In order to avoid competition with artists who were making their living by teaching art privately, enrollment had to be limited to students who were

financially unable to pay for private instruction and to under-
privileged groups. [26]

The educational program of the art center was outlined
in September 1937 by Philip Curtis and Lew Davis. They in-
tended to initiate what they called a creative workshop,
which was designed to make students conscious of their own
creative powers. The program was to be directed to the lay-
person rather than to the aspiring professional artist. Stu-
dents were to be guided to see form, color, and design artis-
tically, and to become aware of the universality of art. [27]
Just what Curtis meant by the "universality of art" was soon
made clear. For the fall of 1937, Curtis planned a comparative
showing of modern art at the center. Two interior designs
were to be set up in the gallery; one room was to represent
the late nineteenth century and the other was to feature the
contemporary period. As many items of everyday use as pos-
sible were to be contrasted, the purpose being to show how
design is related to daily life. Curtis thought it was time
for Phoenicians to become aware of modern art and modern
design, but he was also concerned that they might not be
prepared to accept a really advanced exhibition; Joseph
Danysh had warned him about this. The comparative show
was therefore intended to prepare Phoenicians for the more
daring displays that were to follow. [28] During his first year
as Director of the Phoenix Federal Art Center, Philip Curtis
was confronted with a dispute that he could well have managed
without. The central figure in the controversy was Lew Davis,
who, as has already been mentioned, had been placed in
charge of art instruction at the center.

Lew Davis was a native of Jerome, Arizona, and had
studied at the National Academy of Design in New York under
Leon Kroll. He returned to Arizona in 1936 while employed
by the Treasury Relief Art Project. [29] On March 1, 1937,
Davis was transferred to the Federal Art Project, and he con-
tinued to be employed by this agency of the government even
while working at the art center. [30]

The quarrel was between Davis and several members of
the Board of Directors of the center. Curtis, as the Director
of the center, was inevitably drawn into the squabble. Curtis
had met with his Board shortly after arriving in Phoenix, but
during the summer months, several of the members were ap-
parently away on vacation. Plans had to be made, of course,

and Curtis went ahead on his own. When Curtis met with his
Board again in the fall, a number of objections were raised
about the policies of the art center and the Federal Art Proj-
ect generally. The protesting members of the Board were
opposed to the center's policy of providing free classes for
poor and underprivileged children.[31] They seem to have
been disturbed by the observable fact that many of the chil-
dren were coming into the center (usually on Saturday morn-
ing) were not as clean and neatly dressed as would have
been the children of more affluent families.[32] Lew Davis was
aware of the views that were being expressed and did not take
kindly to them. At some time during the fall he may have
argued with two or more members of the Board, or at least
in some way managed to antagonize them. As a result, the
protesting members of the Board came to feel that Davis was
not the person that they wished to have in charge of classes
at the art center.[33] Actually, there never was any question
that the classes at the center would be primarily for the
underprivileged because of the Federal Art Project stipulation
that art center classes were not to compete with artists who
were supporting themselves by teaching art privately.

The discontented sponsors were also unhappy about
the exhibition program of the center. The names of the
artists represented in the program were unfamiliar and the
styles of art were new and perhaps shocking to some.[34] The
dissenting Board members must have realized that it would be
impossible to change the policies of the Federal Art Project
in regard to classes at the center, or, from their point of
view, greatly "improve" the quality of exhibition program;
they then argued that the art center should become indepen-
dent from the Federal Art Project, that the center should be
privately supported.[35] There was, however, little chance of
this actually occurring due to the limited support for the
center at that time. Curtis was primarily concerned that an
effort might be made by members of the Board of Directors
that would cause Lew Davis to lose his job. Had this happened,
the Arizona Art Project would have lost a vital resource since
Davis was probably the most important painter living in Ari-
zona during the New Deal Era.

It is unlikely that Davis could have survived very long
as administrator in charge of classes for it would have been
impossible for him to get along with the most vocal members
of the Board of Directors of the center. The problem was

partially resolved when Davis was reassigned to a position on the Arizona Art Project where he would be available for consultation but where he would be considerably less visible.[36]

Several members of the art center Board were also members of the Phoenix Fine Arts Association, including those not opposed to the policies of the Federal Art Project, but the members of the fine arts group were not necessarily all of one mind. In the thinking of Curtis, Davis, and others, however, the views of the more quarrelsome members of the art center Board were associated with the views of the overall membership of the Phoenix Fine Arts Association. Perhaps so. The fine arts group had a conservative reputation with a debatable record in matters of artistic taste and judgment.

Philip Curtis, Lew Davis, and others were considered outsiders among the more conservative members of the Phoenix Fine Arts Association. As no other art organization in Phoenix appealed to progressive, liberal-minded young artists at that time, a new group was established. An organization calling itself the Arizona Painters and Sculptors was formed on June 5, 1937, "to protect and advance the economic and cultural interests of state artists and art."[37] Chairman of the group was Lew Davis, Mark Voris was vice-chairman, and Mathilde Schaefer was secretary-treasurer. Arizona Painters and Sculptors was affiliated with the Federal Arts Committee, which was sponsoring legislation (the Coffee-Pepper Bill) to establish a permanent Federal Bureau of Fine Arts as an extension of the Federal Art Project of the Works Progress Administration and other federal programs for the arts.[38]

At the Phoenix Federal Art Center on February 12, 1938, an invitational preview exhibition was planned and sponsored by the Arizona Painters and Sculptors.[39] Lew Davis, as representative of the group, went to Taliesin West and asked Frank Lloyd Wright to appear at the preview exhibition and speak on behalf of the Coffee-Pepper Bill. Much of the content of Wright's speech has been forgotten, but it seems to have had a great deal to do with the artist and his relationship to society. We do know that Wright intrepidly suggested on this occasion that artists should stop paying their bills, since society owed them a living,[40] and that the best thing an artist could possibly do would be to become indebted to a banker, for the banker would not allow the artist to die until every cent of the debt was paid back.[41]

At the art center some very positive and constructive activities were taking place. On one occasion Burdell Tenney had arranged for an exhibition of rare violins, with an opening on January 23, 1938. An afternoon tea was held with the Phoenix Musicians' Club members as hosts. The program featured instrumental and vocal music and a guest speaker, Benjamin F. King, who explained and demonstrated violin construction. [42]

After the opening of the exhibit, something curious happened. The most valuable of the violins was to be on display only during the opening; it was then to be removed from the center by its owner. Burdell Tenney, who was himself a violinist, did not want the display case to be left empty, so he placed his own student grade violin in place of the more valuable instrument. That night a burglar broke into the center and stole Tenney's violin, undoubtedly thinking it was far more valuable than it actually was. [43]

Not long after the violin exhibit an important administrative change took place at the art center. On April 1, 1938, Philip Curtis was reassigned as State Director of the Federal Art Project, succeeding Mark Voris, who then became Supervisor of Creative Art. It does not appear that anyone replaced Curtis as Director of the art center. Therefore, beginning in April, Curtis was serving in two capacities with no increase in pay. [44]

The center's second annual fund-raising drive began on Monday morning, May 9, 1938. Mrs. E. Ray Cowden (now Mrs. Peggy Reed) directed the drive. Mrs. Cowden worked with the Board of Directors of the art center including Dr. Trevor Browne who was President. [45] On the evenings of May 31 and June 1, 1938, Beaux Arts Parties were held at the Phoenix Federal Art Center. For the first of these, invitations were extended to all attorneys of the Valley and their spouses. For the second, invitations were sent to all physicians, surgeons, and dentists of the Valley and their spouses. [46] Several artists of the Valley contributed art works to be given away as prizes. [47]

The Beaux Arts Party efforts were clearly intended to reach affluent and influential citizens in support of the center.

The Second Year: 1938-1939

 Emphasis on fund raising did not lessen the concern for
education at the center. In the fall of 1938, Eugene Upton of
Wickenburg joined the teaching staff of the Phoenix Federal
Art Center, where he taught classes in life drawing and paint-
ing. Creston Baumgartner taught classes in block printing. [48]
During the second winter season of the art center, however,
the major emphasis shifted to art instruction for children.
Curtis had come to feel that the most vital group of sponsors
were people who had children and that the program of the
art center became understandable to parents through the ef-
forts extended to their children.

 Curtis built a small gallery just for children in order to
display art objects that would be of special interest to them.
He also established a radio program for children, directed by
Kathleen Wilson, with talks on the lives and art work of artists
of all periods. Saturday morning was children's day at the
center, beginning with a meeting of the Junior Artists Club
in the children's gallery. The club meeting was followed by
painting and modeling in the creative workshop.

 The center also sponsored a circuit of experimental
exhibits that traveled to various schools in Phoenix and
Maricopa County. Curtis felt that local public school art
activities were lacking in vitality and, without seeming to
interfere with school programs, he wished to influence them
toward a more progressive outlook. [49] These exhibits, like
Wilson's radio program, were intended to be of benefit to
children who might never have visited the art center.

 In late 1938, Sarah Sklar was loaned by the New York
City project to the Phoenix Federal Art Center to assist
Kathleen Wilson in teaching children's art classes. Such
loans were made by the Federal Art Project for varying
lengths of time; in this case the loan was for three months.

 The other artists who were loaned at this time were
August Goertz, who was to conduct an easel or mural work-
shop; Sol Horn, who was to produce a photographic documen-
tation of the Federal Art Project in Arizona including the art
center; and Boris Gorelick, who was to assist in designing
exhibitions. [50] In the opinion of Curtis, these four artists
made a significant contribution to the work of the Arizona

Project and the Phoenix Federal Art Center. During the
short time they were in Arizona, the Arizona Project seemed
more a part of the national program, rather than primarily
a local undertaking.

Curtis's principal concern and responsibility during the
time he was director of the Phoenix Federal Art Center was
the daily operation and maintenance of the center. However,
Curtis never lost sight of his long-range objective: the
construction of a permanent art center and museum. Further-
more, Curtis was one of the first persons to take an active
interest in establishing a civic center in Phoenix.

In 1939, it was generally known in art circles that land
would soon be made available for a civic center by the chil-
dren of the late Adolphus Clay Bartlett, and Curtis went
ahead with the preliminary planning. His original idea was
to expand the scope of the existing art center to include a
little theater, a public meeting hall, a museum, a living gal-
lery, and a workshop. There was also some discussion of
the possibility of including a public library.[51]

While living in Arizona, Curtis met Frank Lloyd Wright
and was impressed with his achievements in architectural de-
sign. Curtis believed that if Phoenix was to have a civic
center, Wright should design it. Curtis talked to Walter
Bimson about this, and Bimson was so impressed with the
idea that he consulted Wright about it. For some time it
looked as if Frank Lloyd Wright would definitely be selected
through Bimson's influence as President of the Valley National
Bank, the largest in Arizona. Ultimately, however, the con-
tract was given instead to Alden B. Dow of Michigan, who
had been an apprentice of Wright's. Curtis believes that his
major accomplishment during the period 1937 to 1940 was that
he was able to interest Walter Bimson in the idea of building
a civic center in Phoenix, for Bimson played a leading role
in the building of the present Phoenix Art Museum, one of
three structures in the civic center complex designed by
Dow.[52] When Curtis and others were attempting to plan for
a permanent art center, however, they must have been con-
stantly perplexed by the question: How can one map out and
secure the future when the present is so unsettled? The future
of the nation's economy, after years of depression, was still
uncertain and even the WPA itself was changing.

The Third Year: 1939-40

In 1939, the Works Progress Administration, together
with several other agencies, was consolidated into a new
agency called the Federal Works Administration. The title
"Works Progress Administration" was at this time changed to
"Work Projects Administration."[53] In September 1939, the
Federal Art Project in Arizona was renamed the Arizona Art
Project, and the Phoenix Federal Art Center became the
Phoenix Art Center. There was, however, no apparent break
in the continuity of the two programs. At the Phoenix Art
Center, Dr. Trevor Browne continued as head of the Board
of Sponsors. John Leeper taught classes in painting and
drawing; Jane Morrissey taught fashion design; and Philip
Curtis, the Director, was at this time teaching clay model-
ing.[54] Hugo Radke taught the mechanics of casting sculp-
ture.[55]

It is not known in what month elections were held for
members of the Board of Sponsors, but by December 1939
Mrs. Frank Otis Blake (Beth) became Chairman, succeeding
Dr. Trevor Browne, who had had this office for about two
years. On December 30, Beth Blake announced a new policy
of one-man and group exhibitions at the Phoenix Art Center
of the work of Arizona artists. The artists assumed the re-
sponsibility of receiving the public and handling the sale of
their work, and they were charged 20 percent of the sales
for use of the gallery, the money going to the center's ex-
hibition fund.[56] This policy looked good on paper, but it
did not aid the exhibition fund to any great degree because
of the infrequency of sales.

On May 1, 1940, Philip Curtis resigned from his posi-
tion as State Supervisor of the Arizona Art Project and for
about one month the project was without a supervisor.[57]
Miss Hope Brown served on the project temporarily, pending
the appointment of a successor to Curtis.[58] On May 27,
1940, Thomas R. Wardell became superintendent of the proj-
ect.[59] Wardell had studied industrial design at the Carnegie
Institute of Technology. As superintendent of the Arizona
Art Project, Wardell worked under the supervision of Mrs.
Agnes Hunt Park, who was state director of the Professional
and Service Division of the Work Projects Administration.[60]

On June 1, 1940, Mrs. Frank Otis Blake was appointed

assistant superintendent of the Arizona Art Project.[61] It was at this time that Mrs. Blake became an employee of the federal government, and she drew heavily upon her previous voluntary experiences. She assumed the direction of the Phoenix Art Center and was assigned many other project duties.[62] Her qualifications included a degree from the University of California and study with noted artists.[63]

The Final Months of Federal Involvement: 1940

During the summer months of 1940, classes were offered in jewelry, leather work, sculpture, advertising art, and painting. The class in advertising art was conducted by Robert King and included window design, lettering, block printing, and advertising layouts. These classes were offered again in the fall, together with an additional course, directed by Edward Burke, in home decoration and design.[64]

A Beaux Arts Ball was a feature attraction at the Shrine Auditorium on November 8, 1940. The ball's theme was "Let Your Subconscious Be Your Guide."[65] Dancers wore costumes in the fund-raising venture.[66] The ball enjoyed sponsorship of various art support groups, including the Phoenix Fine Arts Association Board, the Phoenix Art Center Board, the Little Theater Board, the Artists' Build Board, and the Art Students League.[67] On the day after the ball, it was announced that the Executive Board members of the Phoenix Art Center Association had voted to withdraw from its alliance with the Work Project Administration in the operation of the center. The center was to function as a community enterprise, financed through membership subscriptions, and by a percentage of tuition charge from students.[68] Fred W. Whittlesey was at that time President of the Phoenix Art Center Association; Beth Blake was slated to continue as Director of the Center.[69]

Reflections

One might well ask just what was the importance of the WPA center? The Phoenix Federal Art Center was small in floor space and could hardly have been adequate to meet the need that existed in Phoenix in 1937. Perhaps the most immediate and practical benefit of the art center program is

that a number of persons with widely varying backgrounds in art were employed to work at the center at a time when economic conditions were most unfavorable for the arts, thus providing both individual, professional, and public cultural assistance. The free instruction for children and adults and a successful exhibition program clearly provided inspiration to many young artists. Indeed, through its classes and its exhibition program, the art center helped to generate wide community interest in art and other cultural activities, and it is clear that this cultural impetus was not lost when New Deal patronage ended.

What influence the Phoenix Federal Art Center had on the later building of the Phoenix Art Museum has not yet been established. It should be remembered, however, that in 1937 few people in Phoenix had any idea what a working art center or a working art museum could be. People generally thought of a museum as a place for the display of inanimate materials. It was the role of the Federal Art Center to demonstrate, at an operational level, the working art center. The active cultural campaigning of Philip Curtis and others certainly helped make the art center concept a reality in Phoenix.

When the history of the Phoenix Art Museum is finally written, the role of federal support will remain important and the relatively brief life of the Phoenix Federal Art Center served cultural notice that more would be accomplished in future years.

Notes

1. U.S., Works Progress Administration, "Federal Art Project Manual," October, 1935, p. 1. (mimeographed).
2. William F. McDonald, Federal Relief Administration and the Arts (Columbus: Ohio State University Press, 1969), p. 422.
3. Letter, D. S. Defenbacher to Mark Voris, September 22, 1936, National Archives, r.g. 69, WPA files, Arizona 651-315.
4. Letter, Mark Voris to Jane Rider, Ocotober 15, 1936, National Archives, r.g. 69, FAP files, Arizona 1936.
5. Letter, Mark Voris to D. S. Defenbacher, November 7, 1936, National Archives, r.g. 69, FAP files, Arizona 1936.

6. "Art Week Activities to Open with Preview Showing Today," Arizona Republic, November 8, 1936, Section III, p. 1, cols. 7-8.

7. Jean Harrison (Mrs. L. D.), "Phoenix Fine Art Association: History," 1957, unpublished manuscript in the files of the Phoenix Art Museum.

8. Jean Harrison.

9. "Art Groups Hold Display in Museum," Arizona Republic, January 10, 1937, Section III, p. 1, col. 1, and p. 2, col. 4.

10. Letter, D. S. Defenbacher to Mrs. Foster Rockwell, February 10, 1937, National Archives, r.g. 69, FAP files, Arizona 1937.

11. Letter, Mark Voris to Dr. Trevor Browne, November 6, 1936, National Archives, r.g. 69, FAP files, Arizona 1936.

12. Letter, Mark Voris to D. S. Defenbacher, February 27, 1937, National Archives, r.g. 69, FAP files, Arizona 1937.

13. "Beauty of Arizona Art Is Stressed by Director of National Project," Arizona Republic, March 12, 1937, p. 2, cols. 1-3.

14. Personal interview with Philip Curtis, June 26, 1984.

15. Elton Thomas High, "Philip Campbell Curtis (1907-): A Study of His Life and Painting" (unpublished master's thesis, Arizona State University, 1969), pp. 8-26.

16. Philip C. Curtis (Flagstaff: Northland Press, 1970), p. 69.

17. "Fine Arts Group Plans Activity," Arizona Republic, May 16, 1937.

18. Letter, Philip Curtis to D. S. Defenbacher, May 27, 1937, National Archives, r.g. 69, FAP files, Arizona 1937.

19. "Art Exhibit Opening Set," Arizona Republic, July 11, 1937, p. 6, col. 1.

20. Letter, Jane Rider to Holger Cahill, July 16, 1937, National Archives, r.g. 69, WPA files, 651-315, Arizona 1937.

21. From the catalog of the opening exhibition of the Phoenix Federal Art Center, July 15, 1937.

22. "Phoenix Federal Art Center Prepares to Open Quarters," Arizona Republic, June 6, 1937, p. 9, cols. 2-3.

23. "Federal Art Center Calls Many Visitors During Week," Arizona Republic, July 25, 1937, p. 3, cols. 2-3.

24. "Class Opened by Sculptor," Arizona Republic, July 27, 1937, p. 7, col. 6.

25. "Federal Art Center Calls Many."

26. Letter, Thomas Parker to Mark Voris, July 29, 1937, National Archives, r.g. 69, WPA files, 651-315, Arizona 1937.

27. "Broadening of Art Concept Is Phoenix Center Project," Arizona Republic, September 19, 1937, p. 5, col. 2-4.

28. Letter, Philip Curtis to Holger Cahill, September 24, 1937, National Archives, r.g. 69, WPA files, 651-315, Arizona 1937.

29. Lew Davis, "Commentary," The Art of Lew Davis: A 40-Year Retrospective (Flagstaff: Northland Press, 1970), pp. 9-11.

30. Letter, Thomas Parker to Mark Voris, February 27, 1937, National Archives, r.g. 69, FAP files, Arizona 1937.

31. Personal interview with Lew Davis, December 13, 1970.

32. Personal interview with Philip Curtis, July 28, 1984.

33. Letter, Philip Curtis to Thomas Parker, December 9, 1937, National Archives, r.g. 69, WPA files, 651-315, Arizona 1937.

34. Letter, Philip Curtis to Mildred Holzhauer, December 28 or 29, 1937, National Archives, r.g. 69, WPA files, 651-315, Arizona 1938.

35. Letter, Curtis to Parker, December 9, 1937.

36. Letter, Philip Curtis to Holger Cahill, November 24, 1937, National Archives, r.g. 69, WPA files, 651-315, Arizona 1937.

37. "Arizona Artists Form New Group," Arizona Republic, February 11, 1938, Section II, p. 1, col. 8.

38. John M. Coffee, "The Permanent Federal Bureau of Fine Arts," Appendix to the Congressional Record, Vol. 83, pt. 9 (Washington: Government Printing Office, 1938), pp. 818-821.

39. "Art Preview Set Tomorrow," Arizona Republic, February 11, 1938, Sec. II, p. 1, col. 8.

40. Personal interview with Lew Davis, December 13, 1970.

41. Personal interview with Creston Baumgartner, January 1971.

42. "Rare Violins to Be Seen at Tea Today," Arizona Republic, January 23, 1938, Section 3, p. 1, col. 1, and p. 2, col. 7.

43. Personal interview with Burdell Tenney, January 31, 1972.

44. Letter, Mrs. Ellen S. Woodward to W. J. Jamieson, May 2, 1938, National Archives, r.g. 69, WPA files, 651-315, Arizona 1938.

45. "Federal Art Center Opens Second Annual Drive Today," Arizona Republic, May 9, 1938, p. 3, cols. 5-6.

46. "Beaux Arts Parties Set," Arizona Republic, May 29, 1938, Section III, p. 1, col. 1.

47. "Exhibits Feature Beaux Arts Fete," Arizona Republic, May 31, 1938, p. 6, col. 6.

48. "Life Classes Set at Center," Arizona Republic, September 25, 1938, Section III, p. 3, col. 4.

49. Letter, Philip Curtis to Thomas Parker, October 15, 1938, National Archives, r.g. 69, WPA files, 651-315, Arizona 1938.

50. Letter, W. J. Jamieson to Mrs. Ellen S. Woodward, October 5, 1938.

51. Letter, Philip Curtis to Thomas Parker, April 26, 1939, National Archives, r.g. 69, WPA files, 140 Cr-Lz, 1939-40.

52. Personal interviews with Philip Curtis, August 6, 1971 and June 26, 1984.

53. U. S. Congress, United States Statutes at Large, Vol. 53, Part 2 (Washington, D.C.: Government Printing Office, 1939), p. 1428.

54. "Art Classes Are Arranged," Arizona Republic, September 22, 1939, p. 4, col. 8.

55. "Art Center Is Popular," Arizona Republic, November 19, 1939, Section X, p. 7, col. 8.

56. "Policy Changed by Art Center," Arizona Republic, December 31, 1939, p. 3, col. 2.

57. Letter, Agnes Hunt Park to H. E. Smith, June 7, 1940, National Archives, r.g. 69, WPA files, Arizona 651-315.

58. Letter, June J. Owens to Mrs. Florence Kerr, June 15, 1940, National Archives, r.g. 69, WPA files, Arizona 651-315.

59. Transcript of employment, Thomas Wardell, enclosed with a letter, J. W. Fath to the writer, November 23, 1971.

60. Personal interview with Thomas Wardell, December 29, 1971.

61. Transcript of employment, Beth Blake, enclosed with a letter, J. W. Fath to the writer, November 23, 1971.

62. Work descriptions for Thomas Wardell and Beth Blake from the files of Mrs. Frank Otis Blake.

63. Gertrude Bryan Leeper and Maude Morris House (eds.), Who's Who in Arizona (Phoenix: The Arizona Survey

Publishing Co., 1938), p. 56.

64. "Art Interest Gains Locally," Arizona Republic, September 15, 1940, p. 9, col. 1.

65. "Beaux Arts Ball Planned," Arizona Republic, October 13, 1940, Section III, p. 4, col. 1.

66. "Plans for Beaux Arts Ball Friday Are Near Completion," Arizona Republic, November 3, 1940, Section III, p. 4, cols. 7-8.

67. "Beaux Arts Ball Plans Progress," Arizona Republic, October 27, 1940, Section III, p. 2, col. 1.

68. "Art Center, WPA Tie-up Is Ended," Arizona Republic, November 10, 1940, Section III, p. 8, col. 7.

69. "Season Opens at Art Center," Arizona Republic, November 17, 1940, Section IX, p. 4, col. 3.

CHICAGO'S SOUTH SIDE COMMUNITY ART CENTER:
A PERSONAL RECOLLECTION

Margaret Goss Burroughs

In traditional African life and culture, there is a very special person. This person is generally an elder of the tribe. This elder records through mind and memory the history and achievements of the tribe, and is called a "griot" (pronounced gree-ote). It is the duty of the griot to preserve and to pass down the achievements, exploits and legends of the tribe from father to son, from mother to daughter, from one generation to the next. The griot-ship is passed down in the family.

It seems that since I was the youngest member to sign the original Charter and one of the few alive today, that I merit the pleasant task of being the South Side Community Art Center griot. At this writing there are only three people alive whose name appears on the Charter. Mine is one of them. So many of the founders have gone to their great rewards. I am pleased for the opportunity to share my memories and experiences and to record them for history's sake.

Prior to the advent of the art center, we black artists of Chicago had no place to get together, to exchange ideas, or to exhibit our works. There were absolutely no opportunities for us to show in the downtown galleries (these galleries did not recognize art by blacks as legitimate). Only a very few of those who could afford it were able to attend classes at the Art Institute of Chicago, or the private art schools.

Before the organization of the art center, some of us (I was still a teenager) had our first out-of-school art classes

131

under George E. Neal. At the time, we all belonged to an
art club called the "Arts and Crafts Guild." William McGill,
a sign painter, was the President and we met every Sunday
afternoon at each other's homes. Our exhibit gallery was
whatever space was available. We showed at the "Y," in a
church basement, and anywhere we could. Thus, when the
Federal Art Project came forth with the idea for an art center
in the South Side community we were all quite interested. It
was about in 1938 that we first heard that the WPA Arts Proj-
ect was interested in setting up a number of art centers in a
target group of cities. We were delighted to hear our city
was to be included.

The initial organizer for the art center was Peter Pol-
lack, a Jewish gentleman. Our first contact had been with
Mr. Pollack when he ran a small art gallery on North Michigan
Avenue. It was in this gallery that the black artists were
given their first opportunity to exhibit downtown. In 1938
Peter Pollack was on the staff of the Illinois Federal Art Proj-
ect, then headed by George Thorpe. Mr. Thorpe and Mr.
Pollack called together a small group of "leading" black citi-
zens, including a few young artists like myself, to talk about
this proposed art center.

Our first meetings were held at the South Side Settle-
ment House at 32nd Street and Wabash Avenue. Mrs. Ada S.
McKinley, a fine woman, was the director. She was the black
counterpart of Jane Addams. Indeed, I understand they were
quite close friends and marched together in the streets of
Chicago trying to quell racial antagonisms during the 1919
riots. Golden B. Darby, a public-spirited businessman, was
Chairman of the Board of the South Side Settlement House
and had recently inspired that institution to conduct a contest
for the young black artists of the community. His insurance
firm provided cash awards and certificates. A number of us
submitted entries. I, along with Charles White, Bernard
Goss, Charles Sebree, George Neal, Joseph Kersey, and others,
was accepted. This was my first occasion to exhibit and I
was quite proud of my blue ribbon and certificate. Shortly
thereafter, when approached by Mr. Pollack, Mr. Darby ac-
cepted the post of Chairman of the Art Center Sponsoring
Committee and encouraged the idea. Then, a few meetings
later, a South Side Community Art Center Association was
organized and chartered.

Mrs. Katherine Marie Moore, wife of Herman E. Moore, Federal Judge of the Virgin Islands, was elected the first President of the Community Art Center Association. From 1938 to 1940, meetings were held at various places, including the Urban League, which was then located at 46th and Indiana Avenue. The group also utilized a funeral parlor at 55th Street between Michigan and Wabash Avenues. At one meeting, the late Irene McCoy Gaines, a prominent club woman, stated, "I believe this art center will be the most important single factor for the improvement of the culture of the people of the South Side." She was indeed prophetic, for the institution proved to be just that in ensuing years.

On October 25, 1939, at a committee meeting at the Settlement House, George Thorpe, Director of the Illinois State Art Project, explained that if the community could find a facility for the center, the Federal Art Project would do the renovations. It would also provide the funds for paying the salaries of the staff, teachers, and maintenance crews. It would be our responsibility to raise funds for the utilities.

Edgar E. Mitchem, an insurance man, then assumed the post of Chairman of the Finance Committee. Henry Avery, an artist, was named Chairman of the Site Committee, and Ethel Mae Nolan, a public school art teacher, was chairman of a committee to locate temporary headquarters. Many community persons were eager to participate. The task of fundraising had been launched the same year with a campaign for "A Mile of Dimes." I well remember that. I was 21 years old and I stood on the corner of 39th and South Parkway (now Martin Luther King Drive) collecitng dimes in a can. I believe I collected almost $100 in dimes.

Later, a membership campaign was mounted under Dr. Ralph Schull, a prominent dermatologist. Assisting him were Simon Gordon, a sculptor (who incidentally taught Marion Perkins); Thelma Kirkpatrick (née Wheaton), who is still active with today's DuSable Museum; William Harrison; Mrs. A. M. Mercer; Anna W. Wilkins; and Verna Vaughn. A highlight of our fund-raising was the presentation of the First Annual Artists and Models Ball (1938) at the Savoy Ballroom, next to the Regal Theatre at 47th and South Parkway. Frances Mosely Matlock was the first producer of this glamorous affair. It presented models whose unique costumes were originals designed by the artists of the community. Mrs. Katherine

Marie Moore served as Chairman and Mrs. Pauline Kigh Reed
as Vice Chairman. The ball and other benefit events were
held and soon our fund-raising efforts proved successful
enough to provide the down payment for our art center home
at 3831 South Michigan Avenue.

The near South Side neighborhood along Michigan Avenue
was lined with gorgeous Victorian-style old Gold Coast man-
sions. They were once occupied by Chicago's old line families.
The neighborhood underwent transition and a number of these
mansions were placed on the market for a song and a dance.
They were sold as is, complete with furnishings. One such
was the Charles Comiskey (baseball magnate) family home.
Negotiations were quickly entered into and the Art Center
Association purchased the property complete with a two-
storied coach house for about $8,000. With the building
finally ours, there was then the excitement of seeing the ex-
pert craftsmen from the Federal Art Project redesigning the
old home into offices, galleries, classrooms, and assembly
hall. They did an excellent job of modernization while the
fine features of the original structure were still retained.

The year 1940 was a busy one for the entire community.
Along with the organizing for the new Community Art Center,
we were also involved with participation in the observance
of the 75th anniversary of the Emancipation Proclamation.
A state commission had been appointed by the governor to
organize and oversee these programs and exhibits. The ex-
position filled the large halls of the Chicago Coliseum (now
razed) at 14th Street and Wabash Avenue. Besides exhibits
from sundry national organizations and businesses, Alonzo
Aden, of the Howard University Art Gallery, was engaged to
curate an exhibition of Afro-American art. This was in my
area of interest and here, for the first time, I saw the works
of many famous black artists, including Augusta Savage, Rich-
mond Barthe, Archibald Motley, and William E. Scott.

Rosalie Dorsey, Katherine Davis, and I were among the
young ladies who were hired to work as "Docents" in the art
gallery. Many of the other people who were on the Art Center
Organizing Committee were involved with the 75th anniversary
programs. In fact, the 75th anniversary program, especially
with its emphasis on the Negro artist, helped to prepare our
community psychologically to welcome and to support the idea
of an art center.

Though it was not formally dedicated until the summer
of 1941, the art center began to hold classes and exhibits in
1940. In 1941, the 4th Annual Artists and Models Ball Bene-
fit was held at the Savoy and produced by a teacher and
dance fancier, Rosalie Dorsey Davis. Miss Davis was assisted
by the well-known dancer (and painter) Frank Neal. The
theme was "Pan-Americana." Excitement mounted in the
artists and the entire community as we moved toward the dedi-
cation of May 8, 1941. Annabelle Carey Prescott, an assistant
school principal and sister to Archibald Carey, a prominent
minister and lawyer, chaired the Dedication Committee. A
special exhibition of sculptures by Augusta Savage, luminary
of the Harlem Renaissance period, was shown in the gallery.
In that year, the following persons were officers of the Art
Center Association: Pauline Kigh Reed (social worker),
President; Pauline J. Lawrence (businesswoman), First Vice
President; Ethel Hilliard (teacher), Second Vice President;
Walter A. Abernathy (businessman), Treasurer; Margaret
Goss Burroughs (teacher and artist), Recording Secretary;
Laura Stark (artist), Assistant Secretary and Frankie Raye
Singleton (businesswoman), Financial Secretary. Other
directors included Beatrice Glenn, Daniel Catton Rich, Dr.
Alain Locke, Robert A. Cole, Judge George Quillici, Elise
Evans Harris, Jeanette T. Jones, Katherine Dickerson, Rose
Tancil, William Y. Browne, Jessica Anderson, Lida Tavernier,
and Thelma Kirkpatrick Wheaton. The chairman of the board
was Patrick B. Prescott.

Because the Federal Arts Projects had been ushered in
by Roosevelt's New Deal to give assistance and employment to
artists and to support projects, the First Lady, Mrs. Eleanor
Roosevelt, was selected as the ideal person to be invited to
dedicate the South Side Center, one of several that were
opened simultaneously across the country. Another special
guest was Dr. Alain Locke, Professor of Philosophy, Art and
Humanities at Howard University. Dr. Locke was the author
of some pioneering works on black art and culture. He had
discovered and encouraged quite a number of the young black
artists. On arrival in Chicago Mrs. Roosevelt was whisked
from Midway Airport to the spit-shiny, renovated art center
building at 38th and Michigan Avenue, where the ribbon was
cut and she was taken on an official tour by the officers.
Michigan Avenue from 37th Place to 39th Street was cordoned
off from the traffic by police barricades. Crowds of people
who could not get inside spilled down the art center steps

and into the streets in an effort to catch a glimpse of the
great lady. The Dedication Banquet, to which several hun-
dred persons held tickets, was presented at the Savoy Ball-
room at 47th and South Parkway (King Drive). After the
tour and the ribbon-cutting, ticketed guests retired to the
Ballroom. A police-led motorcade escorted Mrs. Roosevelt
and the special guests to the ballroom. At the banquet,
Mrs. Roosevelt and Dr. Alain Locke presented the major
addresses.

 An interesting anecdote about the dedication concerns
J. Livert Kelly, a well-known gentleman-about-town whose
activities were not considered socially acceptable by some
people. However, Mr. Kelly had the undisputable honor of
being the first "life" member of the South Side Community
Art Center. He had unhesitatingly plunked down the first
$100! Certainly one would assume that the first life member
would be one of the first persons to receive an invitation to
the Dedication Banquet. He should have received a seat at
the speakers' table. However, that was not in the thinking
of the society ladies who were in charge of the arrangements.
These ladies feared that the presence of this "uncouth" and
sometimes questionable character might be offensive to the
First Lady. Therefore, a decision was made not to invite
Mr. Kelly. According to the grapevine, when Mr. Kelly
heard of how he was being snubbed, he sent out a message
that since he was the first life member, he would be coming
to the banquet, invitation or not, and that he just might
break up the whole party, First Lady or no. Somehow or
other, by some miraculous "coincidence," two hours before
Mrs. Roosevelt arrived in town, Mr. Kelly was picked up
"for questioning" by the police. He was held incommunicado
until all the ceremonies were over and Mrs. Roosevelt was
safely on her way back to Washington. Only then was Mr.
Kelly released!

 Mr. Kelly was not the only one shut out of the dedica-
tion ceremonies. We artists were just about shut out as well.
However, because of the fact that we (the artists) also
threatened to disrupt the proceedings, David Ross was granted
five minutes to deliver the following statement which I had
prepared on behalf of the artists. The speech was delivered
on behalf of the center's artists on the occasion of Eleanor
Roosevelt's dedication on May 8, 1941.

This addition to our community of the South Side Art Center, built by many sincere and hard working persons, means much to the local artist. This is what it means from the artist's point of view.

Five years ago, we had practically no place in our community where we could exhibit our paintings and practically no audience. We had to lasso people, cowboy fashion, in order to get them to see our work. We used to meet from studio to studio, to draw and paint and talk about art and our problems as artists. People thought then that paintings were just to look at and never considered buying any to grace the walls of their homes. From our small group came forth one, George E. Neal. George was a pioneer in the development of just such an institution as we have here today. He envisioned an art center when he opened up his studio at 33rd and Michigan Avenue to us neophytes. He took us on sketching tours and to visit downtown art galleries and the Art Institute. George E. Neal, who died young at the age of 34, was the person who, more than any other, we felt was responsible for the sustained interest and development in art which is manifested today in many of the young Chicago artists. He died just when he was on the brink of gaining national recognition as an artist. He certainly should be remembered for his contribution.

George Neal, myself, and other artists rolled up our sleeves and renovated his coach house into a working studio and school. People from the neighborhood came often to model or to watch the sketch classes. Every other month or so we would have a showing of our work in the summertime. Few people came in the winters because there was only one coal stove which wasn't too effective.

The end of the "art center" such as it was, came with a fire which almost completely destroyed the studio and 40 paintings of three of the artists who were having their first show. Thus it was that the golden opportunity for the development of the young Negro artist, hard up for food, materials and schooling, came with the Federal Arts Projects. Here was our chance to stop shining shoes all week and painting only on Sundays. This gave us a means of learning as well as earning our living as artists.

We were not then and are not now complimented by
the people who had the romantic idea that we artists
like to live in garrets, wear odd clothes and go round
with emaciated faces, painting for fun and living until
the day we died and hoping that our paintings would
be discovered in some dusty attic 50 years later, and
then we would be famous. As persons who were
creatively endowed, we had to express our creativity
and our humanity. We believed that the purpose of
art was to record the times. As young black artists,
we looked around and recorded in our various media
what we saw. It was not from our imagination that
we painted slums and ghettos, or sad, hollow-eyed
black men, women and children. These were the
people we saw around us. We were part of them.
They were us. Thus, the coming of this community
art center has opened up new hope and vistas to all
of us.

As teachers, some of us were able to unearth, en-
courage and develop dormant talents of many. As
artists ourselves, creatively, we were able to experi-
ment and work in many techniques and processes which
were denied to us before because we would not afford
to pay to go to art schools or because we were dis-
criminated against as Negroes. We feel that with this
art center, a worthwhile contribution is being made to
all the peoples of the community. This art center
is an opportunity for self-expression and development
for all people. We truly feel that art belongs to all
of the people and should be enjoyed by all.

Now, in this critical wartime period, we have our own
plan for defense; a plan in defense of culture. The
opportunities which we have now, in the coming of
the art center, we did not have before. We realize
as you all do, their great benefits to our community.
This quickens our determination to see to it that this
art center, the first cultural institution of its kind on
the South Side, and one of the few in the country
shall stand and flourish.

This art center presents the means for the distribu-
tion of culture. It is thriving and in full bud now
and we feel that it would be pathetic and tragic
should any obstacle loom forward to hamper or destroy

it. We, the artists pledge to continue to work un-
tiringly with the admirable and socially-minded Spon-
sors Committee to see that the South Side Art Center
continues to grow and serve the needs of our com-
munity. To this end, we pledge ourselves!

Looking back over the years, I think we lived up to
our pledge. Later in the program, Mrs. Roosevelt was pre-
sented with a beautiful painting of a Negro girl by a fine WPA
artist, Charles Davis. Mrs. Roosevelt, Dr. Locke, and other
dignitaries gave their speeches and at last the excitement of
the dedication was over. Mrs. Roosevelt was safely back in
Washington and Mr. Kelly was back on the streets again.
A warm glow was left over everyone concerned with the af-
fair. Mrs. Roosevelt wrote a column called, "My Day,"
which was syndicated nationwide and carried in one of our
local papers. The week after the dedication she wrote the
following:

> At 3:15 we went to the South Side Community Art
> Center to dedicate their building. Chicago has long
> been a center of Negro art. Many Negro artists have
> had a hard time getting their training as many artists
> do, even when they have achieved a certain amount
> of recognition. The art center is situated in the old
> home of Charles Comiskey, who was once a great
> baseball magnate. It had become a rooming house
> before the South Side Art Center bought it a year
> ago. With the aid of federal money it has been con-
> verted to its present purposes. There are classes
> in drawing, oil and watercolor painting, poster letter-
> ing and composition. Gradually the teaching of some
> of the crafts and other skills will be added. It was
> all a most delightful experience and I am happy to
> have been able to spend this time in Chicago and to
> assist at these ceremonies.

The art center calendar during that dedication year
was full and rich. Activities included several stellar exhibi-
tions, lectures, and numerous art classes. A tea was given
by the NAACP to honor Daisy Lampkin, one of its national
officers; a Folk Party was given by the National Negro Con-
gress as a fund-raiser to support its civil rights work. A
reception was held to honor K. Marie Moore, First President
of the Art Center Association. In its first year of full

operations, the art center's records stated that there were
25 exhibitions seen by 28,000 visitors. Twelve thousand
children and adults participated in the various art classes.
That was quite an auspicious start.[1]

The art center's 1942 schedule was just as full and
active. It was fully carrying out the purposes for which it
was founded. Exhibits included the sculptures of Richmond
Barthe of Harlem Renaissance fame. This exhibit was co-
sponsored by Sigma Gamma Rho Sorority, a local group of
women. A traveling exhibition of the works of Chicago black
artists was sent to the Howard University Art Gallery. Other
exhibitions included ceramics and wood sculptures from the
New Mexico Art Project. Dr. Ruth Allen Fouche, teacher
and musicologist, was assisted by Katherine Davis and Mar-
garet Goss Burroughs in presenting a series of monthly musi-
cals. These included Leon Kirkpatrick, the concert pianist.
Art center patrons at the time included Robert Maynard
Hutchins, President of the University of Chicago; Dr. Urich
Middeldorf, University of Chicago professor; and Elizabeth
Wells Robertson, head of the Art Department of the Chicago
Public Schools. Other activities included a poetry class
taught by Inez Cunningham Stark Boulton. From this class
emerged such luminaries as Gwendolyn Brooks, present poet
laureate of the state of Illinois and Pulitzer prize winner;
Davis Roberts, now a television actor; John Carlis, an artist;
William Couch, a university professor; Henry Blakley, a poet;
Margaret Danner, poet; and other artists.

It was rumored that the WPA federal funding might be
withdrawn and the association became concerned about raising
sustaining funds for the art center. Thus, on April 18,
1943, the Chicago Defender published an editorial in support
of the art center's appeal for funds. The editorial reported
that 50,278 persons had been served by the art center in
1942. The editorial reiterated that "the art center must be
saved!"

One of the main activities which enabled the art center
to survive this withdrawal of WPA support was the Annual
Artists and Models Balls which raised needed funds. These
spectaculars allowed Frances Taylor Mosely (Matlock), Rosalie
Dorsey (Davis), Etta Moten Barnett, Katherine and Posey
Flowers, Katherine Towles, Frank Neal, and many others to
demonstrate their production talents. In 1942, Kathryn

Dickerson chaired the ball. Helen Page Taylor and Marva
Trotter Louis, the wife of heavyweight champion Joe Louis,
were co-producers. In this particular presentation, Margaret
Goss (Burroughs) directed a number called "Cavalcade of the
United Nations." A columnist of the Chicago Defender noted,
"The show was original, daring, esthetic and artistic." Par-
ticipants included artist Frank Neal, Winifred Ingram, George
White, Robert Hardin, and Julia Gustafson. Frank Neal
moved from Chicago to New York where he danced on Broad-
way in "Finian's Rainbow" and other productions. In 1943
the ball (given in the last year of federal support) was again
held at the famous Savoy Ballroom. Pauline Kigh Reed and
Jessica Anderson were co-chairs. Talented teacher and
actress Bruentta Mouzon was the producer. Her theme,
"Below the Border," was complete with Latin-American songs,
dances, and costumes. It was this ball which first brought
Carmencita Romero to prominence, a dancer and dance teacher
who is still on the scene today. Later she danced with the
Katherine Dunham group and she now teaches dancing in
Madrid.

At one of those balls, Elizabeth Catlett won the grand
prize. Her costume was made from my studio window drapes.
At another ball, a dancer named Lester Goodman painted him-
self all over in gold and shook up the whole audience. Those
who saw Valerie will never forget her. She was half black
and half German from Vienna, and six feet tall. She was a
featured dancer. Those were really the days and the nights!

Now, this is not to say that everything was smooth
sailing during those years. There were numerous problems
and disputes, especially between the artists and the center's
largely black bourgeois Board of Directors. The art center
was our life. All of our spare time was spent there. We
taught the classes and hung the exhibits. We washed the
walls and scrubbed the floors. We painted the walls and we
did whatever was necessary to keep the art center going.
During the three years of the center's existence, we were
often mistreated and kicked out of the art center by this elite
board. Somehow or other the board looked upon us artists
in a deprecatory fashion. It was unthinkable that we should
be on or dominate the board. We had no money, no influence,
and no prestige. How could artists properly direct the affairs
of such an affluent, cultural center such as they (the Board)
envisioned? So, but for a few exceptions we were ignored or

shut out, either as a result of our trusting naiveté of our
bourgeois co-workers or by outright betrayal by some of our
fellow artists who had been corrupted by the establishment.
This elite board was with the center when it was riding high,
but when the going got rough and the tinsel and glamor were
gone, leaving only hard work and the prospect of hard work
to keep the center afloat, the majority of those fine bour-
geois blacks found any excuse to put the art center down.

A principal excuse given ten years later in the McCarthy
period of the 1950s was that the organization had been infil-
trated by Communists. But as I remember now, from the
very beginning, there were always battle lines drawn between
the artists and this bourgeoisie. Witness the fact that they
tried to shut us out of participation in the dedication. They,
the culture vultures, were always up front when there were
pictures to be taken. But when the funds finally died up
and we were faced with the nitty-gritty of raising money for
repairs and operations, they became disenchanted and flitted
off to other interests.

But the artists remained to pull the chestnuts out of the
fire. This disparity, this conflict between the Board and the
artists in the running of the center, still exists to some degree
today, after over 40 years. For this reason I believe the
center has not grown or developed as it could and has reeled
year after year from one financial crisis after another. How-
ever, it has managed to survive. It survived, I believe be-
cause the property was purchased by the association. A non-
profit organization, it held the center property in public trust
for the people of the community.

As we progressed further into 1943, it became more
and more evident that the art center would no longer receive
WPA funds to pay for its salaries or operations. Reactionary
congressmen wiped out all of the social and culture programs.
Efforts were made to build a membership which would contrib-
ute annually to the center's support. Pauline Kigh Reed or-
ganized a committee of 100 women to help to raise funds.
Artists and board members alike cooperated together in a
series of fund-raising events, with the Annual Ball remaining
a major one. On May 23, the Chicago Tribune featured
activities and accomplishments of the art center in an article
in which it prompted the art center's campaign for $5,000.
It noted that the center was opened in June 1940 and was

dedicated by Mrs. Roosevelt in May 1941, and further that its
staff salaries funded by the Federal Arts Project ended in
February 1943. The response of the community to that article
must have been good. That was 1943. This is 1986. And
the art center never once closed its doors!

The South Side Community Art Center still stands as a
beacon of culture. Through the years, in good times and
bad, it has acted as the catalyst which gave great inspiration
and impetus to our development as artists. The art center's
activities totally involved all of us. It hasn't been easy.
In the past the South Side Community Art Center has strug-
gled but it has managed to make do. The names are legion
of those who are indebted to this WPA art center, but the
list would certainly name Gordon Rogers Parks, Charles
White, Eldzier Cortor, Gwendolyn Brooks, Margaret Danner,
Gerald Cogbill, Charles Sebree, Marion Perkins, Simon Gordon,
and many, many others, including myself. The experiences
at the art center affected and encouraged all of our careers.
And we were grateful. I personally am deeply indebted to
the art center. My knowledge and expertise in organizing
and working with people was honed in the over 30 years
that I labored with the South Side Community Art Center.
At the time of its founding, I was the youngest member of
the board (age 21). I was an artist. I was the "Jane
Higgins" and the "Go-For." I kept my eyes wide open and
learned much from such cultural leaders as K. Marie Moore,
Pauline Kigh Reed, and Katherine Dickerson. I served for
many years in the post of Recording Secretary, then the
President, and finally as the Chairman of the Board. This
was in 1952. Much of what I learned at the South Side Com-
munity Art Center motivated me and a few others who were
oriented toward history and heritage to believe that there
was room in Chicago for yet another cultural institution
whose main emphasis would be on black pride and heritage.
Thus, the birth of the DuSable Museum of African-American
History in 1961. The South Side Community Art Center is
still inspiring and encouraging, exhibiting and training young
black artists and doing the job for which it was founded back
in 1941.

Note

1. It should be recorded that in the year of the art

center's dedication that the following persons served as officers: Board Chairman, Patrick Prescott; President, Pauline Kigh Reed; First Vice President, Pauline Jackson Lawrence; Second Vice President, Gonzells Motts; Financial Secretary, Frankie Raye Singleton; Recording Secretary, Margaret Goss Burroughs; Treasurer, Walter Abernathy. Other members of the Board included Kathryn Dickerson, Rena Tancil, William Y. Browne, Jessica Anderson, Lida Tavernier, Thelma Wheaton, Jeannette T. Jones, Beatrice Glenn, Daniel Catton Rich, Alain Locke, Robert Cole, Judge George Quillici, and Elise Evans Harris. Peter Pollack was the first Director and David Ross, Assistant Director.

THE UTAH STATE ART CENTER

Dan E. Burke

Utah has always been proud of its strong support for the arts. As early as 1899, three years after statehood, legislation was passed which established the Utah Art Institute, the nation's first state arts council. This important step in providing state support for the arts established a precedent for cultural program assistance in Utah during the New Deal Era.

When the Federal Works Progress Administration was forced to assist with the unemployment crisis, Utah was willing and anxious to join in partnership with the WPA in order to employ painters, writers and musicians. One of the most important projects which developed out of this partnership was the establishment of the Utah State Art Center in July 1938. A lease was signed to use the Elks Club Building at 59 South State Street in Salt Lake City, and for the next four years, this building served as a center for projects in the visual arts, music and writing. Remodeling changed the ground floor, consisting of a restaurant, a bar and bowling alleys, into a large gallery for exhibitions. Other rooms were renovated to provide offices for various federal projects, studios for artists, and classrooms for the public. The ballroom on the third floor was used for concerts, recitals, rehearsals and lectures.

In return for local cooperation and financial support, the federal government allocated $12,500 per year for operation of the art center. The state provided $2,500 and a membership campaign raised $500. Gail Martin, Chairman of the Utah State Institute of Fine Arts, commented upon signing the lease:

> This will be Utah's attempt to take art off the shelf
> of dilettantism and make it a possession of all people.
> Federal art centers throughout the United States have
> done more to democratize the arts than any other
> movement ever instituted. By the central location
> of the Utah Center, exhibits and activities will be-
> come accessible to all the people at a minimum of in-
> convenience. [Salt Lake Tribune, July 9, 1938.]

After building acquisition and renovation, the next step
was to appoint a committee to propose potential arts program-
ming for the art center. The program committee, headed by
Louis C. Zucker, presented its prescriptive report in Febru-
ary 1939 at the Second Annual Conference of the Utah Insti-
tute of Fine Arts.

> So far as financial means will allow, art should circu-
> late wherever people live who are sufficiently inter-
> ested. Only so will art ever integrate vitally with
> the life of the people; only so can the esthetic cul-
> ture of the whole people be levelled up to a reference
> for the good. And certainly the number is decreas-
> ing of those who believe that art is only for the few,
> the elite. The experience of recent years in this
> country has shown that the faculty to appreciate true
> art, even the faculty to practice the principles of it,
> is quite general.

Recommendations by the committee included the organiza-
tion of a statewide arts program by setting up community art
centers across the state and using the Utah Art Center as the
operating agency. This proposal provided communities outside
of Salt Lake City with a variety of arts programming including
exhibitions, lectures on the arts, classes in art and crafts,
and programs in music.

The community went further in explaining the proposal
and brought recommendations into a Utah context.

> The art exhibit may be the work of Utah artists who
> are independent of the Federal Art Project ... or
> collections of Federal Art Project work or other
> traveling exhibits arranged for and sent out by the
> Federal Art Project in Washington.... The lecturers
> will be members of the art center staff or people on

the Federal Writers Project or others well known for
their attainments. The teachers of the classes in
arts and crafts will be carefully chosen by the direc-
tors of the Federal Art Project in this region. The
concerts, instrumental and vocal, will be performances
by the Utah State Sinfonietta or by a section of it
and by other artists who will be available.

Professional staff of the three Federal Art Projects
would be available as consultants in assisting communities in
developing arts programming. The committee also provided an
example of a constitution to facilitate the organization of art
center branches. This constitution was prepared to be flexi-
ble enough to adapt to local conditions and preferences.
There was great enthusiasm in response to the committee's
recommendations and results manifested themselves shortly
thereafter with the establishment of art centers in Provo,
August 27, 1939; Helper, December 29, 1939; and Price,
April 15, 1940.

Elzy J. Bird, Director of the Art Project in Utah, noted
the origins of the Helper and Price art centers. Helper, a
small mining and railroad town about 120 miles southeast of
Salt Lake City, expressed interest in forming an art center.
Bird was invited to speak to the Helper City Council and dis-
cuss the community's responsibilities. He was familiar with
an auditorium/gymnasium which Helper had recently completed,
and suggested that by remodeling the first floor the building
would make an ideal art center. After he explained that the
operating expenses and transportation charges on exhibitions
would amount to $25 per month and that $225 would take care
of construction costs, the acting mayor asked, "Is there any
reason why the City of Helper cannot afford this sum for the
expenditure toward culture for the ensuing year?" A motion
was made in favor of the proposal and the council room re-
sounded with "ayes." Consequently, Bird claimed the record
for the "fastest-sold" art center in the history of the WPA
Art Program.

Bird gives an account of the opening of the art center
at Helper when he traveled to Helper to arrange the first ex-
hibition:

I don't know yet whether the town will appreciate
what we have done for them (or to them), as just

before the opening, some guy, testing his strength,
punched a hole through the top of a pedestal with
his fist. Somebody else ruined a screen by seeing
if the alcohol in a bottle of whiskey would take the
stain off.

But if the success of the Helper Art Center was in
question, Bird dispelled any doubt when he noted that Helper,
with a population of 2,700, proudly boasted an attendance of
3,017 for the first three weeks of the art center's opening
exhibition.

Citizens of Price, a small town located near Helper,
were so impressed with Helper's commitment to the arts and
felt that "the competition next door has beat them to the
draw on a great movement of culture." Price inhabitants,
not willing to be outdone by their neighbor, invited Bird to
speak to their city commission. Bird explained to the com-
mission that they could develop an art center for $150 to
cover remodeling costs of a local building and $25 a month
for exhibition expenses. The proposal was voted on and
readily accepted. Bird received letters from the directors
of the Helper, Price, and Provo branches, and attendance
figures and programs for 1940 were described. Lawrence
Payne, Director of the Helper Art Center, indicated that
nineteen Utah and national exhibitions had been presented
with a total attendance of 28,720 adults and children. He
commented that "the Helper Community Art Gallery has been
an important factor in bringing to the people of Carbon County
the realization that art plays a vital role in their education
and well-being." Jack Smith, Director of the Price branch,
reported that fourteen exhibits had been shown during 1940
with a total attendance of 21,406. F. Delmar Nelson, Director
of the Provo Gallery, listed 22 exhibits with a total attendance
of 25,730. Other activities included art classes, lectures and
demonstrations. Nelson wrote about other activities and con-
cluded that "service of the gallery to Provo community is ex-
tensive," and that "comments by publicly-interested persons
such as the Mayor, librarian, art teachers, artists, students,
judges, lawyers, and residents of Provo show a very favor-
able attitude as to the good the gallery is doing for the com-
munity."

Salt Lake City Direction

The Utah Art Center in Salt Lake City served as a hub for the outlying art centers, and adopted six administrative objectives:

1. To offer opportunity for both art participation and understanding to every member of our community.

2. To hold exhibitions by talented Utah artists and sculptors.

3. To bring to Utah displays of outstanding merit, both historical and contemporary in character.

4. To sponsor musical events of particular value, and to encourage the development of talented Utah musicians.

5. To foster progress in the field of the speech arts.

6. To assist in the maintenance of a broad cultural program whose effect will be felt in every section of the state.

In an attempt to meet these objectives, the art center, under the direction of Donald B. Goodall, developed several programs in the visual arts, music and writing.

The visual arts program extended opportunities for practicing and understanding two- and three-dimensional art forms through art classes and exhibits. The art classes were an immediate success and during the first two years over 1,100 adults and children had enrolled for free instruction. Adult classes included graphic and plastic arts, sculpture, metal crafts, leather crafts, design and color, art appreciation, oil and watercolor, life drawing, and textile design. Children's classes included graphic and plastic arts, painting, children's design and crafts, modeling, drawing, woodcarving, marionette and puppet-making, and children's theater. Salt Lake City mothers took advantage of the popular "Check Your Child Class" by leaving their children at the center for painting and craft classes.

One of the greatest benefits of the educational program

was the employment of Utah artists as instructors. Each in-
structor's annual salary averaged only $1,200, but the op-
portunity of teaching classes provided them with a job and
dignity at a time when unemployment was at an all-time high.
Instructors who taught at the art center included Maurice
Brooks, Richard M. Cannon, Leona Eitel, E. Monroe Husbands,
Millard F. Malin, Ernestine McDonald, Barbara Moore, William
J. Parkinson, Stanley Perkins, Chris Rasmussen, Henry N.
Rasmussen, Alma Riding, Paul Smith, Inex Vaky, Thurlow Van
Campen and Kenneth Whipple.

Exhibitions

Art center exhibitions were characterized by their vari-
ety. Two outstanding historical exhibits were presented.
One displayed early Utah arts and crafts and the other pre-
sented religious art. Four exhibits were devoted to "Better
Housing and Town Planning." Gail Martin commented on ex-
hibition activity:

> Of the 54 exhibitions, 20% were modern in character.
> The remainder from Utah colleges and universities
> were educational exhibitions, or were composed of
> conservative paintings and sculpture. Due to the
> change in system of exhibition presentation made
> possible through the Federal Art Program, WPA, a
> wide variety of exhibitions is brought to Salt Lake
> from other parts of the country. The cost of these
> displays has been extremely small during the first
> year of the center's operation. This cost averaged
> five mills a day for each unit displayed during 1939.

Art center attendance at exhibitions was 96,126 in 1939,
and in 1940 and 1941, it was 101,457 and 86,627 respectively.
Although attendance figures at exhibitions indicated the pub-
lic's overall support, some exhibits did not escape criticism.
One example suffices: Alice Merrill Horne in the April 1940
edition of Art Strands wrote:

> I went to what they call the art center, and there I
> saw "Woman in Labor," which I think should instead
> be called "The Lay of the Last Minstrel" though the
> arm and leg and abdomen appear somewhat like a pot-
> bellied man though the scarlet drape (which somehow

wasn't intended to drape) is a nice color near like
chanticleer's head. Also I beheld a dozen suggestive
nudes with no drapes (when even the barbarians use
a breech clout) and they are taching art to our young
while they smoke!!--the "Vandals!!"

If showing nudes was a controversial issue during this
period, an even more heated issue evolved from the modern-
versus-tradition controversy. This issue eventually elicited
a statement prepared by nine Utah artists and arts adminis-
trators. Representing members of a modern movement in the
field of the graphic and plastic arts in Utah, they recorded
the following:

> The modern artist does not attempt to reproduce the
> photographic or surface appearance of things, but,
> 1. Uses individually conceived forms, the products
> of his experience, to express his aesthetic ideas and
> emotions, in terms of the particular medium employed.
> 2. Employs the design elements contained in plastic
> form, including relationships of line, tone, space,
> planes, texture, color and subject matter. 3. Uses
> emotional and intellectual freedom in organizing the
> subject into unified form. 4. The modern artist
> goes beyond composition, as a generally accepted
> term, since composition implies only the arrangement
> of objects within three-dimensional space to achieve
> a surface balance. The modern, however, uses de-
> sign elements in organized interrelationships within a
> defined three-dimensional field. 5. The modern
> artist respects the validity of the picture field. This
> picture field is composed of front, back and side
> planes, determined by the artists.

There was, then, a strong impetus to bring "modern"
art to the people. How successful this movement was in
changing people's opinions in Utah is difficult to evaluate.
It is certain, however, that the chance to view both modern
and traditional styles was broadening for the citizens of Utah.

In addition to the visual arts, the Utah Art Center
sponsored other cultural options for a participating public.
Music, writing, and theatre offices were housed at the same
location. Lovers of music had long worked for a permanent
symphony orchestra for the metropolitan area, and the

formation of the WPA Orchestra in 1935 was a milestone for
music in Utah. By 1940, the ensemble had given 1,012 con-
certs to 348,000 listeners. Over 53,000 people attended 131
concerts in 1940 alone, the same year that the WPA Orchestra
was reorganized and became Utah State Symphony Orchestra.
Through the industry and direction of Reginald Beales (a
member of the Utah Music Project) and of the art center staff,
the first concert took place in May 1940. Hans Heniot, a
brilliant young composer-pianist from Chicago, was brought
to Salt Lake to conduct the musicians in a performance so
successful that nearly 1,000 people in the audience voted for
the permanent establishment of the orchestra. Fred E. Smith,
President of the Utah State Symphony Orchestra Association,
immediately began to plan a series of concerts for the 1940-41
season. By August, a membership campaign was launched,
resulting in nearly $10,000 to engage guest artists. Alexander
Kipnis, basso of the Metropolitan Opera, Henri Temianka,
Polish violinist, and Webster Aitken, an American pianist,
were booked for the season. The beginning of the present-
day Utah Symphony can be traced to that first concert in May.

 The Utah Writers Project, headed by Dale L. Morgan,
employed certifiable Utah writers to research and write about
the state. The program culminated with the publication of
Utah--A Guide to the State.

 A Speech Arts (Theatre) Department was formed at the
art center in February 1940, and during the first six months,
218 classes were held for children and adults, with attendance
over 2,000. Twenty-four radio programs, four plays, two
puppet shows and a children's theatrical production came out
of the department.

The War Effort

 In July 1942, the WPA Art Program became part of the
War Services Program. Accordingly, the Utah State Art
Center was renamed the War Services Center and the change
in name formalized a direction already underway. Discussions
in January by the Advisory Board had suggested instruction
in camouflage, exhibits of war salvage materials, and land-
scape and utilitarian gardening in wartime environment.
Instruction in camouflage later resulted in cooperative effort
between the art center, the State Board of Vocational

Education, and the U.S. Army Corps of Engineers in a proj-
ect to prepare blackout and camouflage plans for Utah.

Posters developed by stencil processes detailed black-
out procedures; announced paper, rubber and metal salvage
campaigns; and provided graphic information that ranged
from espionage to disaster warnings.

Activities for the War Services Center fell under two
separate categories: 1) the recreational and moral building
activities, and 2) the educational and informal activities.
Although widely different in purpose, the two divisions often
overlapped and were able to be of assistance to one another.
For example, the Art and Writers Programs created and dis-
tributed posters advertising symphony concerts. Members of
the Music Program assisted the writers in assembling their
war-clipping file. Although now historically distant, a center
brochure from the War Services Era brings to immediate life
a wide scope of activities. It is not only a strong commentary
on the diversity of ways in which the Utah Art Center
"served," but also an expanded and related catalog that grew
from the center's first activities in 1938. It is worth quoting
in its entirety:

I. Recreation
 A. Regular Wednesday evening dances.
 1. 125 to 150 servicemen entertained.
 2. Hostesses selected from hostess organizations.
 3. Music furnished by the WPA Dance Band.
 4. Each serving hostess contributes to the cost
 of refreshments, i.e. punch and cookies.
 5. Variety entertainment provided during inter-
 mission.
 B. War Service Mothers
 1. Sponsor enjoyable dances once a month.
 2. Conduct special meetings of interest to service-
 men twice a month at the War Services Center.
 C. Colored USO
 1. Has use of auditorium for dances occasionally
 on Saturday nights.

II.
 A. Music Appreciation Hour
 1. Tuesdays at 8:30 P.M.
 2. New Magnavox (combination radio and phono-
 graph) entertainment.

3. Popular classic and semi-classic library of records donated by the American Federated Music Clubs.
4. Definite theme developed each evening with cooperative and interesting discussion about various compositions played led by the director.

B. Soldier Practice House
1. Thursday at 7:30 P.M.
2. Servicemen are invited to bring their own instruments and enjoy playing classical and semi-classical music to their hearts content.

C. Through the generous contributions of Utah citizens, the War Services Center provides 150 to 200 servicemen with seats for the delightful performances of the Utah State Symphony Orchestra at Kingsbury Hall.
1. Servicemen are invited to rehearsals of symphony orchestra, and a chance to meet the world renown conductors such as Beecham, Coates, Echaniz, and others.
2. WPA String Group plays for hospitals, religious services at camps, and social and cultural programs.
3. Swing band plays for regular Wednesday night dances.

III. Art
A. Artists from the War Services Center have painted an interesting series of pictures depicting the colorful history of Fort Douglas which are to be hung in the Fort Douglas Officers' Club.
B. Murals are being painted for Camp Kearns, Utah.
C. Attractive art exhibits are on display continually in all the galleries at the War Services Center.
D. Servicemen are utilizing the many art facilities offered at the center to paint and draw in their spare time.
E. Remington Arms Plant workers meet once a month to conduct a class in advanced photography, where darkroom facilities are made available.
1. Darkroom facilities are provided gratis at all times to servicemen.
F. Soldiers' art classes are conducted under the sponsorship of Salt Lake art clubs.

 G. Screen processed posters and other types of advertising are available to the armed services and other war agencies.

IV. Writers
- A. Bulletins, pamphlets and leaflets are written, mimeographed and distributed for the armed forces, Utah State Council of Civilian Defense, and other war agencies. A Servicemen's Guide (10,000) copies is being published weekly.
- B. Radio scripts are written for the armed forces, and war agencies.
- C. A complete war news clipping file is maintained for the use of the information centers and interested parties.
- D. Clerical assistance is given to armed forces, war agencies.
- E. War Information Centers are kept supplied with the latest war information received from all government agencies, war and Navy departments, etc.
- F. A war information pamphlet file is maintained for the use of the war agencies and others interested.
- G. Workers are supplied to the War Information Centers to answer questions, keep files up to date, and do general library work.

V. Historical Records
- A. Map inventory is being taken of all official maps in the state.

This long list of activities attests to Utah's commitment to the value of art in its citizens' lives at a time when war was threatening the nation. The state's commitment to the arts rings strong and true in a report by the Utah State Institute of Fine Arts in 1940:

> There are those, who will say that in these days of impending warfare, all of this people's energies, resources and treasure should be concentrated upon the need to arm for the protection of democracy. But is not democracy a way of life? We cannot go out to defend a way of life and at the same time abandon that way of life. Hence, art, music, and culture, too, must be defended and fostered in preparation for the time when mankind will arise to a new and higher plane of existence.

Days of doubt and gloom must be lightened by the
ministration of art. Men cannot fight heroically
without having something to fight for. If democratic
society cannot maintain those institutions of art and
culture, which alone differentiate man from beast,
then it does not deserve to live. For these reasons,
officers and members of the Utah State Institute of
Fine Arts, believe that the State has a definite
responsibility toward its activities.

This passionate plea to support the arts during a period
of great turmoil and stress did not go unheeded. When the
art center began in 1938, it received approximately $1,100
in donations. Just two years later, private groups, counties
and municipalities had contributed over $20,000. In 1942 the
Utah Legislature appropriated $5,000 to support the War
Services Center, while Salt Lake County contributed $2,500.
As a direct result of that local sponsorship, federal funds
coming to Utah through the WPA provided $152,746 annually
for the employment of 120 people in the art, music and writ-
ing projects. After the withdrawal of federal assistance in
1943, it was clear the art center and its branches had proven
itself after four years of existence. The first stone had been
laid down in the foundation of a vital cultural movement--a
movement which is still felt more than 40 years later. Today,
Utah proudly boasts of its nationally recognized symphony,
ballet, opera, and two modern dance companies. The Shake-
spearean Festival, Pioneer Memorial Theatre and the Salt Lake
Acting Company are only three of the many theatre productions
operating in the state. Since 1943 several art museums and
art centers have developed in the state. Many of these arts
organizations proudly trace their roots to the exciting activ-
ities of the Utah State Art Center and the influence it had on
arts programming throughout the state.

Sources

Advisory Board Committee, Utah State Institute of Fine Arts,
 January 13, 1942.

Bird, Elzy J. "The Federal Art Project As It Applied to Salt
 Lake City and Utah, n.d. (unpublished report).

Board Meeting, Utah State Institute of Fine Arts, December
 14, 1942.

Curtz, Arley. "The Depression, WPA, and Growth of the
 Utah Institute of Fine Arts, 1975 (unpublished report).

Horne, Alice Merrill. Art Strands, The Deseret News Press,
 April 1940.

Letters to Elzy J. Bird: Lawrence Payne, December 30, 1940;
 Jack Smith, December 30, 1940; and F. Delmar Nelson,
 December 30, 1940.

O'Connor, Francis V., ed. Art for the Millions. Greenwich,
 Conn.: New York Graphics Society, New York, 1973.

Salt Lake Tribute, July 9, 1938.

Second Annual Conference, Utah State Institute of Fine Arts,
 February 11, 1939.

Twenty-first Biennial Report, Utah State Institute of Fine
 Arts, 1940.

NORTH CAROLINA'S COMMUNITY ART CENTERS

Ola Maie Foushee

Through a remarkable coincidence Raleigh, North Carolina, became the first headquarters for the Federal Art Project: Holger Cahill was appointed National Director of the Federal Art Project, and a group of art-conscious citizens of Raleigh became his first applicants for aid in expanding the development of art in that area.

Cahill had just finished several months in the South collecting colonial art objects from attics and junk shops to be used in the restoration program at Williamsburg, Virginia. With his southern travels fresh in his mind, he decided that "a southern city asking for aid" would be ideal for FAP's first experiment, as well as for its headquarters. Thus, Raleigh became the first city in the United States to receive federal assistance for an art center and, consequently, to become a model for other centers throughout North Carolina and the United States.[1] This development saved the North Carolina State Art Society from obscurity and breathed new life into its plans for a State Art Museum. (By September 1936, the Advisory Board of the Raleigh Center sought more permanent status and took strong steps to campaign for funds, and this was accomplished with the help of the professional staff of the center.)[2]

Daniel S. Defenbacher, then of Chapel Hill, North Carolina, was appointed State Supervisor of FAP by May E. Campbell, State Director of Professional and Service Projects of the WPA. Defenbacher had gained prominence through an exhibition of his watercolor paintings in a show sponsored by the Southern Art projects--a Carnegie Foundation project.[3] When Defenbacher left North Carolina in 1938 to go to Washington, D.C., as Regional Advisor, Gene Erwin of Durham,

North Carolina, became State Supervisor; he was subsequent-
ly followed by Katherine Morris of Raleigh in 1940.

At the time of Defenbacher's appointment, there were
only two artists registered for WPA employment, but about
forty qualified or certifiable artists were thought to be reg-
istered in other classifications. To be employed, artists were
required to have been on the relief rolls prior to November 1,
1935. According to William C. Fields, a later director, North
Carolina artists apparently were in less need of support than
were many artists in other states, as WPA had not sponsored
an individual artist in this state. [4]

With FAP headquarters situated near a triangle of uni-
versities (the University of North Carolina at Chapel Hill,
Duke University at Durham, and North Carolina State Uni-
versity at Raleigh), it was able to lure highly qualified people
to assure a high quality of art instruction. Dr. Elizabeth
Gilmore, instructor in Fine Arts at Duke University, was
appointed District Art Supervisor of FAP in North Carolina,
"to assist the WPA office in approving the technical quality
of all art projects and to act as chairman of the State Ad-
visory Committee." Serving on the esteemed committee were
Mrs. Katherine Pendleton Arrington, Warrenton; Mrs. John
Sprunt Hill, Durham; Dr. C. C. Crittenden, Secretary of the
State Historical Commission, Raleigh; Dr. William Kenneth
Boyd, Duke University; Mrs. Corrine McNair, Curator of
Person Hall Art Gallery, University of North Carolina at
Chapel Hill; Juanita MacDougald, Raleigh; and Louis Voorhees,
artist, High Point. [5]

At a conference with May E. Campbell and Gene Erwin,
Defenbacher extolled the WPA's impact on North Carolina's
artistic climate:

> Before the WPA art project, there was no art museum
> in North Carolina with a paid staff, there were no
> art dealers handling original paintings and practically
> no contact with the public for native artists. Now,
> over 7,000 children and adults monthly come into
> contact with recognized art work through the WPA
> Federal Art Project. [6]

May E. Campbell commented in a similar vein that:

> ... prior to the art project, any number of artists in
> North Carolina had no means of following their train-
> ing and earning a livelihood.... A good artist might
> have had to take in washing to make a living....
> Today, however, there are 34 employed on the art
> project, all of them North Carolinians.[7]

Federal Art Project assistance enabled nine Tarheel
artists to be represented by twelve works of art in a preview
exhibition in the Virginia Museum of Fine Arts in Richmond,
Virginia, in December of 1938, as a screening process for
the World's Fair Exhibition in New York City. From the
many hundreds of paintings previewed in Richmond to rep-
resent the southern states at the World's Fair, artists Claude
Howell, Henry MacMillan, Richard Lofton, and Nathan Ornoff
had work accepted for the Exhibition.[8]

Holger Cahill's appearances in the state did much to
stimulate interest in the idea of the art center. He traveled
about the state speaking to civic, art and social groups, and
his zeal for federal patronage was abundantly clear in an
address at Wilmington in December 1938:

> Government patronage of the arts produced the glory
> that remains of Greece, though it was criticized then
> just as President Roosevelt's WPA program for artists
> is criticized now.... The WPA project does more than
> provide a livelihood for artists.... More than 95,000
> works of art have been created and allocated to
> schools, libraries and other tax-supported institu-
> tions.... The program tends to make art "the prop-
> erty of all rather than the hobby of a few." It
> checks "cultural erosion," the flocking of artists to
> big cities, leaving communities bare. It has helped
> to rediscover America's cultural past, and has brought
> together art interests and resources in communities.[9]

Holger Cahill's enthusiasm, together with close national
attention to North Carolina's cultural program possibilities,
inspired the establishment of art centers in nine North Caro-
lina towns and cities: Raleigh, Winston-Salem, Asheville,
Concord, Greensboro, Sanford, Greenville, Kingston, and
Wilmington. Each center had its own director and personnel,
and the general plan consisted of three main units--gallery,
school, and extension work. Each program provided art

exhibitions, gallery, lectures, and arts and crafts instruction for children and adults, with special emphasis on the creative work of children. Downtown areas were usually selected for the centers, with the definite idea of making them a permanent addition to the cultural life of the city.

Response to Cahill's leadership was tremendously grati-fying. By December 1938 (a period of only three years), more than 4,000,000 visitors had attended art centers in North Carolina. One enthusiastic newspaper reporter recalled that humorist Irvin Cobb, who once said that North Carolina was the butt of the forty-eight states of the Union, had lived to see North Carolina grow away from this opprobrium. "Re-cently," she said, "the state has taken a long step forward in starting the first Federal-sponsored art center in the state capital, Raleigh."[10]

She also recalled that Sanford, the smallest town in the state to have a center, and with a population of only 5,000, had more than 200 people register for instruction on opening day.

Inspired by a speech given by Greensboro's director, Frederick J. Whiteman, the Sanford center was established on an experimental basis, with one instructor. The unex-pected enrollment, however, necessitated the engagement of others. William C. Fields, a new graduate of the University of North Carolina's Art Department, was director of the San-ford Center until his appointment to assistant state director.

The Raleigh Center, under the directorship of James McLean for its first four years, and then of William C. Fields as his successor, maintained two sub-galleries: one at Need-ham Broughton High School and one at the Crosby-Garfield School for Negroes. Art classes were conducted at both places, as well as at the Hugh Morson High School, until 1939. At that time the State Art Society and the Raleigh WPA art center merged and under joint sponsorship estab-lished an uptown art gallery on the second floor of the Su-preme Court building. Katherine Morris, the State Super-visor at the time, maintained offices in the old Academy Building.[11] On January 6, 1940, the Raleigh News and Observer reported that "about 400 Raleigh school children take WPA art courses."

Encouraged by the inordinate success of the new
organization arrangement, the State Art Society renewed its
requests to the General Assembly and to federal sources for
funds to establish a State Art Museum in Raleigh--the capital
city of North Carolina. But it was not until April 6, 1956,
that this dream was finally a reality. On that evening Gov-
ernor Luther Hodges cut the opening ribbon to the world-
renowned North Carolina Museum of Art.[12]

The Wilmington Art Center began in a downtown build-
ing formerly occupied by an undertaking establishment,
which at the time was humorously reported as "undergoing
a cheerful change" as WPA carpenters and painters renovated
it for an art gallery and museum. It was formally opened
on the evening of October 31, 1938. Irving Guyer, of the
Exhibition and Graphic Arts Division of the Federal Art Proj-
ect, spent three months in Wilmington, assisting with exhibi-
tions and the establishment of the center. Successful in
securing brilliant and nationally known exhibitions, the Wilm-
ington Center opened with an exhibition comprised of Ameri-
can watercolor paintings lent by Boston's Museum of Fine
Arts, New York's Museum of Modern Art, watercolorist Eliot
O'Hara, and the Metropolitan Museum of Art. Attendance
was high, including many visitors from nearby military in-
stallations.[13]

The Greensboro experience reveals the pattern of
center development that Defenbacher usually followed in or-
ganizing local support and reflects the reasons for his suc-
cesses in Greensboro and other centers. At a conference
of Regional and State Directors of the Federal Art Project in
1936, he provides an early account of his Greensboro efforts:

> I went into Greensboro and talked with three people
> on the idea of the project. With the help of one of
> those three people who could contribute substantially
> to the project, and keeping out all those of the
> Chamber of Commerce because it reaches out to the
> greatest number of donors ... the question was
> raised there, Well, what are we going to offer the
> people for their subscriptions, and we simply said
> nothing. It was an investment in a very small ex-
> periment.... I went to see the president of the
> Jefferson Life Insurance Company and got him to
> donate the first floor, corner location, in the Jefferson

Standard Building, which is right in the center of
town.

I stood in a meeting of about 15 of the wealthiest
North Carolina men at Greensboro. Most of them
were textile men and the first thing they shot at me
was who is going to spend our money, and I had it
out with them then that there would be no project
unless I spent it. It was a simple thing to do be-
cause those men realized that no business can be
operated with more than just one head, so they
placed their faith in me and went ahead with the
project.

We then had a meeting of the sponsoring committee
again and all the people were invited who were
sponsors, who had contributed and at this meeting
we selected a chairman of an advisory board.... We
decided to get the superintendent of public schools
... a rather good choice ... because much of the
work ... will be done with the schools and with
school children. Then we appointed an advisory
board composed of the presidents of all the major
civic organizations.[14]

With $1,500 pledged by citizens, the Greensboro Art
Center began its activities in July of 1936. By 1938 its staff
included Director Whiteman, a supervisor of teaching, sev-
eral instructors, a gallery attaché, gallery technicians, re-
search workers, a secretary, a carpenter, and a janitor.
By December 1938, the Charlotte Observer could report on
wide community participation:

From the opening of the Greensboro Art Center, its
new quarters (given by the Richardson family),
February 1, 1938, the attendance at the gallery has
been 66,000; the school 12,000; special events,
7,000; a total of 85,000 persons reached by the
center.[15]

Centers in Asheville, Winston-Salem, and Greenville
also attracted wide community participation, although each
patterned its activities to fit individual community needs.
Winston-Salem, for instance, under the guidance of Mrs.
Chester Marsh, had an Arts and Crafts Workshop, but
emphasized exhibitions for North Carolina artists and honored

them with receptions. One such event, the Piedmont Art
Festival, attracted ranking painters and art teachers through-
out the state. Among them were Manuel Bromberg, Robert
Broderson, James T. Diggs, Ben F. Williams, Callie Braswell,
Anne Wall, Elizabeth Mack, and Susan Moore.16

Indeed, exhibitions became the reputable hallmark of the
Winston-Salem Center. Defenbacher's assessment in April
1936 stresses the community value of exhibition activity and
keeps the average citizen in constant focus.

> The Art Center is the first agency ever to place
> before the people of Winston-Salem continuous ex-
> hibitions of the work of prominent artists.... Within
> a few short months it is possible for any person to
> review the entire scope of art media to become con-
> versant through the same objects that heretofore none
> could see without an extended visit to New York
> galleries....
>
> Although most of the exhibitions come from New
> York and from the permanent collections of the larger
> museums, the work of local and indigenous talent is
> not forgotten.... The exhibitions by local artists
> will continue to foster a greater market and a great-
> er inspiration for indigenous work.
>
> In connection with the exhibitions there is an impos-
> ing array of lecturers who will come to the gallery
> from New York and the larger cities.... These lec-
> tures are not intended to be formal talks on pon-
> derous themes. They are intended to present that
> non-critical approach to art which gives one contin-
> uous enjoyment without making art a religion of in-
> tellectual pursuit.17

In November of 1941, the Federal Art Project crowned
its achievements by joining the National Council and the
American Artists Professional League in observing National
Art Week. Labeled "the biggest sales exhibition of art works
ever held in this or any other nation," its slogan was "Ameri-
can Art for American Homes."18 Under the chairmanship of
Dr. B. W. Wells, Professor of Botany at North Carolina State
College, North Carolina art centers burgeoned with the activity
and promotion of this celebration. And long after its source
was forgotten, local art groups, and some national ones, kept

National Art Week alive by inaugurating exhibitions in the public schools, on the streets, and in art centers.

In August of 1942, Fields resigned as Assistant State Director of the WPA Art Project and Director of the Raleigh Art Center to accept a scholarship in Boston. Clayton Charles succeeded Fields as Secretary of the State Art Society and Mrs. Ann Harris succeeded him as Director of the Raleigh Art Center. As the end of WPA was now in sight, no appointment was made to replace Fields as Assistant Director of the State Art Project.[19]

North Carolina's cultural outlook profited enormously from the foundations laid by the Federal Art Project, culminating in the building of several permanent centers and museums and the proliferation of art departments in colleges and universities throughout the state. Giant among the state's achievements is the North Carolina Museum of Art with its renowned collection, due in great measure to the indomitable spirit of the North Carolina Art Society, strengthened by FAP in those early trying days.

North Carolina can also look back with prideful nostalgia at the achievements of that first FAP center in Raleigh, which not only became the catalyst for other centers in this state but for other centers throughout America. For it was these first trials, these initial experiments, that provided cultural opportunities for all.

Notes

1. Raleigh News and Observer, December 11, 1938.
2. Proceedings; Conference of Regional and State Directors of the Federal Art Project, Washington, D.C., September 18, 1936.
3. Raleigh News and Observer, November 10, 1935.
4. Letter from William C. Fields to Ola Maie Foushee, February 3, 1966. Also, Raleigh News and Observer, op. cit.
5. Raleigh News and Observer, November 28, 1935.
6. Ibid., May 6, 1938.
7. Ibid.
8. Wilmington Star, December 21, 1938.
9. Thirty-Sixth Annual Convention of the North

Carolina Women's Clubs, April 29, 1938, Wilmington, North
Carolina.

 10. Sadie Root Robards, "Rapid Strides in North
Carolina's Projects," The Charlotte Observer, December 11,
1938.

 11. Raleigh News and Observer, December 3, 1939.

 12. Ola Maie Foushee, Art in North Carolina: Epi-
sodes and Developments 1585-1970, Chapel Hill, NC: Books
(N.C.), p. 104.

 13. Archives of the University of North Carolina at
Wilmington (North Carolina), established by Professor Claude
Howell.

 14. Proceedings, op. cit.

 15. Sadie Root Robards, op. cit.

 16. Report of the Winston-Salem Art Center, April
15, 1936.

 17. Ibid.

 18. Durham Herald Sun, November 16, 1941.

 19. Raleigh News and Observer, August 25, 1942.

COMMUNITY ART CENTERS AND EXHIBITIONS

Mildred Holzhauer Baker

There were no precedents for meeting the kinds of demands and problems that emerged in connection with the program to give employment to artists on the relief rolls. American ingenuity was put to the test. Creating projects that would enable artists to retain their skills and would be of benefit to the community was one of the challenges. The establishment of the community art centers which extended from Key West, Florida, to Gold Beach, Oregon, was one of the solutions.

These centers offered opportunity for employment not only to artists as teachers, directors, and designers but to skilled and unskilled labor in the construction and renovation of space to house the centers, and to clerical help as well. Not all the needs of the centers could be supplied by the community, however. One of these needs was exhibitions for the galleries which were considered an integral part of the centers and an important educational tool. These could not be supplied locally for the most part, and so there was established in the Washington office an Exhibition Section of which I was placed in charge in 1936. The state project directors had already been requested to reserve for the national office, the best of the works produced on their projects for allocation to federal offices, to the offices of members of Congress, and to other public institutions that qualified. This stock formed the source of supply for the art center exhibitions.

Housing this material was made possible in the summer of 1936 when Studio House belonging to Duncan Phillips, where art classes were conducted (adjoining his museum), was offered. During that summer Edith Halpert assisted with

the organization of the exhibition section. As owner of the
Downtown Gallery, she handled the work of many of the
leading artists of the time and also American Folk Art.

It was at this time also that Dorothy Miller, then Assist-
ant Curator of Painting and Sculpture at the Museum of
Modern Art in New York was selecting and organizing the
exhibition "New Horizons of American Art," which opened in
October of 1936. This formed a visual report of what had
been accomplished during the first year of operation of the
project. It was through this exhibition that several artists
were "discovered" by dealers and by critics, notably Jack
Levine, Morris Graves, Loren MacIver, Mitchell Siporin,
among others.

Comparable in importance for the prestige of the project
was the exhibition, "Frontiers of American Art" in 1939 at
the M. H. deYoung Museum in San Francisco. This exhibit
served to bring the accomplishments of the project before a
wide audience and was very favorably received. I had se-
lected the work and was responsible for its direction and in-
stallation, whereas the exhibitions at the World's Fairs of
1939 and 1940 in New York were more the responsibility of
the New York City Art Project.

Important as these large exhibitions were for bringing
the work of the project before the public, there remained the
need to supply the art centers with exhibition material. This
was handled by a staff which included an assistant director,
who supervised the framing, packing, and shipping with the
assistance of two carpenters, a framer, and a clerk; and my
secretary, who handled both exhibition schedules of the
centers and the routing of exhibitions with two clerical help-
ers. By 1939 more than 500 exhibitions had been circulated
in 3,000 individual showings. These were routed by rail at
the lowest possible rate.

For this active a program there grew the need for
larger quarters. Following the brief period at Studio House
in 1936, there were several moves in Washington until 1942,
when the Exhibition Section was moved to Chicago and was
responsible for the final allocation of works in its charge be-
fore liquidation of the Federal Art Project in June of 1943.

As for the exhibitions themselves, over a period of time

more than 100,000 works of art and handicrafts were handled
by the section from which exhibitions were selected. The
types of exhibitions varied greatly. There were prints from
the collection of Lessing Rosenwald (including works by
Duerer, Rembrandt and other Old Masters), lithographs by
Daumier, and Japanese prints. Process exhibitions included
the making of a silk screen print, fresco painting, and cast-
ing of sculpture. There were also theme exhibitions on flower
paintings, the city, and portraiture. And no less important,
there were exhibitions of work produced on the projects
across the country. These project exhibitions ranged in size
from small shows of fifteen items to the large museum shows
described above. The type of exhibition each center received
was determined by its size, of course, but also by the type
and needs of the community it served. Because of the educa-
tional aspect of the program, explanatory labels were essential
and these accompanied the exhibitions, as did suggested pub-
licity releases. Sources of loans were varied and included
private collectors, dealers, and such government agencies
as the Library of Congress and the Farm Security Adminis-
tration.

We attempted to meet the needs of the communities
served by the program, but that did not always happen as
I learned when I scheduled as the opening exhibition for one
of the art centers in Mississippi, the Old Masters Prints from
the collection of Lessing Rosenwald. (I believe it was the
Mary Buie Museum in Oxford.) The reaction was one of dis-
appointment. Those attending had hoped to see original oil
paintings--not black and white prints. And so one learned.

APPENDIX: WPA COMMUNITY ART CENTERS AND EXTENSION ART GALLERIES

This listing is compiled from two sources: 1) a listing available in Community Art Center records of September, 1940 (which provides many street and building locations) and 2) Appendix D, "List of Community Art Centers," in Francis V. O'Connor's Art for the Millions. The latter listing was compiled with the assistance of Mildred Holzhauer Baker. In a body, the listing provides the many parent and extension galleries which were organized between 1935 and 1941. Since certain institutions were reorganized as WPA/FAP facilities, the original dates of organization are provided first.

I wish to again express my gratitude to Francis V. O'Connor, whose editorship of Art for the Millions was an inspiration to many and who thus provided an early vital resource for community art center investigation.

Alabama	MOBILE ART CENTER, 1936; Public Library Building, Mobile Henley School Art Gallery, Birmingham, 1936
Arizona	PHOENIX ART CENTER, 1937; 710 East Adams Street, Phoenix
Northern California	SACRAMENTO ART CENTER, 1423 H Street, Sacramento
Florida	JACKSONVILLE ART CENTER, 1936; 311 West Duval Street, Jacksonville Jacksonville Negro Art Gallery, 1936; Jacksonville

Jacksonville Beach Art Gallery, 1936, Jacksonville Beach

MIAMI ART CENTER, 1936; 1737 North Bayshore Drive, Miami
Coral Gables Art Center, 1938; Coral Gables

ST. PETERSBURG ART CENTER, 1936; 415 Third Avenue South, St. Petersburg
Jordan Park Negro Exhibition Center, 1941

KEY WEST COMMUNITY ART CENTER, 1938; Front & Whitehead Streets, Key West

OCALA ART CENTER, 1936; City Auditorium, Ocala

PENSACOLA ART CENTER, 1938; 37 East Garden Street, Pensacola
Pensacola Negro Art Gallery, 1939; Pensacola
Milton Art Center, 1940; Pensacola

DAYTONA BEACH ART CENTER, 1937; 130 Broadway, Daytona Beach

NEW SMYRNA BEACH ART CENTER, 1941; Community Cultural Building, New Smyrna Beach

BRADENTON ART CENTER, 1938; Memorial Pier, Bradenton

TAMPA ART CENTER, 1939, 1605 Grant Central Street, Tampa
West Tampa Negro Art Gallery, 1941

Illinois SOUTH SIDE COMMUNITY ART CENTER, 1940; Chicago

Iowa SIOUX CITY ART CENTER, 1941/1938; 613 Pierce Street, Sioux City

MASON CITY COMMUNITY ART CENTER, 1941

OTTUMWA ART CENTER, 1939; 122 East Third Street, Ottumwa

Kansas

TOPEKA ART CENTER, 1940; 715 Jackson Street, Topeka

Minnesota

WALKER ART CENTER, 1925/1940; 710 Lyndale Avenue South, Minneapolis

Mississippi

DELTA ART CENTER, 1939; Elks Building, Greenville

OXFORD ART GALLERY, 1939; Mary Buie Memorial Museum, Oxford

SUNFLOWER COUNTY ART CENTER, 1939; Moorhead

Montana

BUTTE ART CENTER, 1938; 111 North Montana Street, Butte

GREAT FALLS ART CENTER, 1940

New Mexico

ROSWELL MUSEUM ART CENTER, 1937; Spring River Park, Roswell

MELROSE ART CENTER, 1938; P.O. Box 256, Melrose

GALLUP ART CENTER, 1938; P.O. Box 1146, Gallup

New York City

CONTEMPORARY ART CENTER, 1936; YMHA Building, 92nd Street and Lexington Avenue

BROOKLYN COMMUNITY ART CENTER, 1936; 502 First Street, Brooklyn

HARLEM COMMUNITY ART CENTER, 1937; 290 Lenox Avenue

QUEENSBORO COMMUNITY ART CENTER,
1936; 129 Woodward Avenue, Ridgewood,
Queens

North Carolina RALEIGH ART CENTER, 1935; Supreme
Court Building, Fayetteville and Morgan
Streets, Raleigh
 Cary Gallery, 1940; Needham Broughton
 High School, Raleigh
 Crosby-Garfield School, Raleigh

WILMINGTON ART CENTER, 1938; 225
Princess Street, Wilmington

GREENVILLE ART GALLERY, 1939; Shep-
pard Memorial Library, Greenville

Oklahoma OKLAHOMA ART CENTER, 1936; Municipal
Auditorium, Oklahoma City
 Clinton Art Gallery, 1938; Wilson
 Junior High School, Clinton
 Claremore Art Gallery, 1938
 Will Rogers Public Library, Claremore
 Skiatook Art Gallery, 218½ East Main
 Street, Skiatook
 Sapulpa Art Gallery, 1940; Public
 Library Building, Sapulpa
 Shawnee Art Gallery, 1940; Junior High
 School, Shawnee
 Bristow Art Gallery, 1940; Roland
 Hotel, Bristow
 Edmond Art Gallery, 1940; Central
 State Teachers College Library,
 Edmond
 Marlow Art Gallery, 1940; Public Li-
 brary Building, Marlow
 Stillwater Art Gallery, Public Library
 Building, Stillwater
 Cushing Art Gallery, 1940; Public
 Library Building, Cushing
 Okmulgee Art Gallery, 1940; Creek
 Council House, Okmulgee

Oregon SALEM ART CENTER, 1938; 460 North
High Street, Salem

CURRY COUNTY ART CENTER, 1939;
Gold Beach

GRAND RONDE VALLEY ART CENTER,
1940; 10 Depot Street, La Grande

Pennsylvania SOMERSET ART CENTER, 1940; 398
Patriot Street, Somerset

Tennessee UNIVERSITY OF CHATTANOOGA ART
GALLERY, University of Chattanooga

PEABODY ART GALLERY, 1936; Peabody
College, Nashville

LEMOYNE ART CENTER, LeMoyne College,
Memphis

ANDERSON COUNTY ART CENTER,
Norris

Utah UTAH STATE ART CENTER, 1938; 59
South State Street, Salt Lake City
 Provo Community Gallery, 1939; Li-
 brary Building, Provo
 Helper Community Gallery, 1939;
 Auditorium Building, Helper
 Price Community Gallery, 1940; Price

Virginia LYNCHBURG ART ALLIANCE, 1936; 1331
Oak Lane, Lynchburg
 Alta Vista Extension Gallery, Alta Vista
 Middlesex County Museum, 1936;
 Saluda

BIG STONE GAP ART GALLERY, 1936;
102 East Franklin Street, Richmond

CHILDREN'S ART GALLERY, 1939; 102
East Franklin Street, Richmond

Washington SPOKANE ART CENTER, 1938; 106 North
Street, Spokane
 Washington State College, Pullman
 Lewis County Exhibition Center, Bush
 Building, Chehalis

West Virginia HUNTINGTON ART CENTER, 1941

 MORGANTOWN ART CENTER, 1940; 10
 Pietro Street, Morgantown
 Scott's Run Art Gallery, Scott's Run

 PARKERSBURG ART CENTER, 1938;
 317 Ninth Street, Parkersburg

Wyoming LARAMIE ART CENTER, 1936; University
 of Wyoming, Laramie
 Rawlins Art Gallery, 1941; Rawlins
 Riverton Art Gallery, 1938; Riverton
 Rock Springs Art Gallery, 1938; Rock
 Springs
 Torrington Art Gallery, 1937; Torring-
 ton
 Newcastle Art Gallery, 1938; New-
 castle
 Sheridan Art Gallery, 1938; Sheridan
 Casper Art Gallery, 1938; Casper
 Lander Art Gallery, 1938; Lander

District of CHILDREN'S ART GALLERY, 1937; 816
Columbia Independence Avenue, SW, Washington

NOTES ON CONTRIBUTORS

MILDRED HOLZHAUER BAKER was Director of the Exhibition Section of the Federal Art Project from its inception in 1936 until the end of the program in 1943.

DAN E. BURKE is Visual Arts Coordinator for the Utah Arts Council in Salt Lake City. He holds graduate degrees in English and Art History from the University of Utah. He is widely active in community cultural activities and is a past president of the Utah Museums Association. He researched and edited Utah Art of the Depression, which was published in 1986.

MARGARET GOSS BURROUGHS was one of the founders of the South Side Community Art Center. She is a graduate of the Art Institute of Chicago and has been active in Chicago's cultural life for over fifty years. She was the founder and is a past Director of the DuSable Museum of African-American History. She is the recipient of many honors and is currently a member of the Chicago Park District Commission.

DR. NICHOLAS A. CALCAGNO is Chairman of Art at Northeastern Oklahoma A & M College. He has researched New Deal art in Arkansas, Kansas, Missouri, and Texas and his work New Deal Murals in Oklahoma was published in 1976 through a grant from the Oklahoma Foundation for the Humanities. He has also developed slide/tape programs on New Deal murals, Regionalism, Art Appreciation, and Oklahoma artist Charles Banks Wilson. Dr. Calcagno is also an artist and conducts summer workshops in painting and sculpture in Miami, Oklahoma.

OLA MAIE FOUSHEE is a professional artist and regional historian in Chapel Hill, North Carolina. She is the

author of Art in North Carolina: Episodes and Developments 1585-1970, Avalon: A Town of Joy and Tragedy, and Sutterfield: A Sentimental Journey. She is a regular contributor to regional magazines. Mrs. Foushee has brought much attention to the accomplishments of North Carolina artists through television programs and "Art on North Carolina," a regular Sunday column that ran in many of the state's newspapers.

DANIEL A. HALL is an art historian and painter who lives in Tempe, Arizona. He has graduate degrees from the University of Arizona. He works in a variety of media and focuses heavily on landscapes of the Southwest and mythological subjects. He has special interest in commercial art and art education.

SUE ANN KENDALL is a former art critic for The Seattle Times, and has contributed to local and national art publications. She is now Midwest Regional Director for the Archives of American Art/Smithsonian Institution. She recently implemented a documentation project in Chicago which is identifying, collecting, and/or microfilming art-related materials, including any Illinois Federal Art Project materials. Her interests include modern art criticism and its impact on art. She is currently doing research on Clarence J. Bulliet, an early twentieth-century critic in Chicago.

BARBARA KERR SCOTT is Professor of Art History at Cameron University, Lawton, Oklahoma. She has researched and written about New Deal Art and has done much to call attention to American art in the Southwest. Her publications include topics in eighteenth-century European art and in twentieth-century art criticism.

MARTIN G. TOWEY is a Professor of History at St. Louis University, a position he has held for twelve years. Prior to this he held an appointment in the Department of History at the University of Missouri-St. Louis. Professor Towey is co-author of From Paddy to Studs: The Irish-Americans at the Turn of the Century Era, author of Historic Architecture of Gasconade County, Missouri, and numerous articles. He is a frequent contributor to Gateway Heritage, the journal of the Missouri Historical Society, one article in which was "Hooverville: St Louis Had the Largest."

He is a consultant to the Missouri Historical Society and archivist of the Catholic Archdiocese of St. Louis.

JOHN FRANKLIN WHITE is a Dean at Northern Kentucky University. He holds graduate degrees from the University of Minnesota and is active in many professional associations. His research interests include New Deal cultural history, American public address, and German-American studies. He contributed to Studies in Creative Partnership: Federal Aid to Public Libraries During the New Deal (Scarecrow Press, 1980) and is currently completing a lengthy study of the New Deal cultural experience in Minnesota.

INDEX